Terror Post 9/11
and the Media

Simon Cottle
General Editor

Vol. 4

PETER LANG
New York • Washington, D.C./Baltimore • Bern
Frankfurt am Main • Berlin • Brussels • Vienna • Oxford

David L. Altheide

Terror Post 9/11
and the Media

PETER LANG
New York • Washington, D.C./Baltimore • Bern
Frankfurt am Main • Berlin • Brussels • Vienna • Oxford

Library of Congress Cataloging-in-Publication Data

Altheide, David L.
Terror post 9/11 and the media / David Altheide.
p. cm. — (Global crises and the media; v. 4)
Includes bibliographical references and index.
1. Terrorism and mass media. 2. Terrorism in mass media.
3. Terrorism—Political aspects. I. Title.
P96.T472A48 070.4'49303625—dc22 2009022307
ISBN 978-1-4331-0366-7 (hardcover)
ISBN 978-1-4331-0365-0 (paperback)
ISSN 1947-2587

Bibliographic information published by **Die Deutsche Bibliothek**.
Die Deutsche Bibliothek lists this publication in the "Deutsche
Nationalbibliografie"; detailed bibliographic data is available
on the Internet at http://dnb.ddb.de/.

Cover design by Sophie Boorsch Appel

The paper in this book meets the guidelines for permanence and durability
of the Committee on Production Guidelines for Book Longevity
of the Council of Library Resources.

© 2009 Peter Lang Publishing, Inc., New York
29 Broadway, 18th floor, New York, NY 10006
www.peterlang.com

Printed in the United States of America

For our grandchildren—Karl, Aksel, Kyla, and Davin—
to help them live without fear

■ Contents

■ Preface and Acknowledgments

It is a privilege to contribute to this important series, Global Crises and the Media. As the most global institution, the mass media shape the form and content of experiences throughout the world. My general project for several decades has been with media logic and the ecology of communication—how information technology interacts with communication formats to affect social action. My specific project is to understand how the "fear frame" works with terrorism to alter discourse, social meanings, and our sense of being in the world. Accordingly, this monograph examines how the mass media, including news and popular culture, have cast terrorism, propaganda, and social control post 9/11. The aim is to delineate institutional accounts told by agencies, organizations, and individuals oriented to the main narratives. The emphasis is on the way that the media tell institutional stories that reflect and help keep a sense of order. Increasingly, these stories are about fear, and the most recent variety of fear: terrorism. The terrorism story has become dominant for media institutions, although alternative media have told a different story, mainly because many are oriented to providing counter-narratives to what is being presented in the dominant media. I argue that post 9/11 we witness the emergence of new communication formats that not only constitute counter-narratives, but also shape future communicative experience.

I study the mass media because I am interested in social power, or how social situations get defined. Power is about defining situations and acting on those meanings. This book tells an institutional story about how a new narrative, the terrorism narrative, emerged from the actions of social institutions.

I agree with those sociologists who argue that the most important thing you can know about someone is what he or she takes for granted. Increasingly, much of this is due to the mass media. Other sociologists have noted that the major export of the United States is popular culture. Increasingly, the language, discourse, and nuances of terrorism are part of this culture. I offer some modest suggestions about how even the conduct of deadly warfare is now contextualized and symbolically joined with terrorism. The Israeli invasion of Gaza in December 2008 provided numerous examples that help to clarify the global reach of terrorism discourse and how it defies accountability.

This book is part of a 25-year project on the investigation of fear, the mass media, and social control. Many colleagues and students have contributed to this work. More recently, I have benefited from conversations and research with John Johnson, Gary Marx, Gray Cavender, and Pat Lauderdale. My modest attempts to help reshape media studies through such concepts as media logic, qualitative content analysis, and an ecology of communication have benefited immensely from a career with Robert Snow. Norman Denzin has been immensely supportive. The late Richard V. Ericson's friendship and work are gratefully acknowledged, and now missed. Several graduate assistants and collaborators have helped collect data and, more important, clarify ideas, particularly Michael Coyle, Chris Schneider, Jennifer Grimes, and Tim Rowlands. Students in several graduate seminars, including "Justice and the Mass Media" and "Qualitative Media Analysis," helped me see more clearly. I am also grateful for the support, encouragement, and conversations with colleagues at The Evergreen State College and St. Martin's University, particularly David Price and Jeff Birkenstein.

Invitations to lecture provided opportunities to sharpen theoretical constructs. I thank Shing-Ling Sarina Chen and the Midwest Sociological Association for permitting me to deliver an earlier draft of Chapter 2, "Terrorism and Propaganda," as the Peter M. Hall Lecture in 2008. I am also thankful for the invitation to address the 2008 World Social Summit in Rome on Global Fear and Anxiety. My paper "Creating, Framing, and Amplifying Fear" helped shape portions of the Introduction and concluding chapter of this book.

Most important, I thank Carla for everything, our happiness, our children, and now wonderful grandchildren.

Drafts of several of the chapters of this book appeared elsewhere. Chapter 3, "Terrorism and the Politics of Fear," is reprinted courtesy of Sage Publications from Cultural Studies <=> Critical Methodologies 6: 415–439. Chapter 4, "Terrorism and the Problem of Evidence," appeared as "Reconceptualizing Qualitative Evidence" in Qualitative Inquiry and the Politics of Evidence,

edited by N.K. Denzin and M.D. Giardina (Walnut Creek, CA: Left Coast Press), and is reprinted courtesy of Left Coast Press.

■ Global Crises and the Media

We live in a global age. We inhabit a world that has become radically inter-connected, interdependent and communicated in the formations and flows of the media. This same world also spawns proliferating, often interpenetrating, 'global crises.'

From climate change to the war on terror, financial meltdowns to forced migrations, pandemics to world poverty and humanitarian disasters to the denial of human rights, these and other crises represent the dark side of our globalized planet. Their origins and outcomes are not confined behind national borders, and they are not best conceived through national prisms of under-standing. The impacts of global crises register across 'sovereign' national territories, surrounding regions and beyond, and they can also become subject to systems of governance and forms of civil society response that are no less encompassing or transnational in scope. In today's interdependent world, global crises cannot be regarded as exceptional or aberrant events only, erupt-ing without rhyme or reason or dislocated from the contemporary world (dis)order. They are endemic to the contemporary global world, deeply enmeshed within it. And so too are they highly dependent on the world's media.

How global crises are signaled and defined, staged and elaborated in the media proves critical to wider processes of recognition and response, entering into their future course and conduct. In exercising their symbolic and com-municative power the world's media variously inform processes of public understanding, but so too can they dissimulate the nature of the threats that confront us and marginalize those voices that seek to mobilize forces for change. The scale of death and destruction involved or the potentially cata-strophic nature of different global threats are no guarantee that they will

TERROR POST 9/11 AND THE MEDIA

register prominently, if at all, in the world's media, much less that they will be defined therein as 'global crises.' So-called hidden wars and forgotten disasters still abound in the world today and, because of their media invisibility, go unnoticed, commanding neither recognition nor wider response.

The series Global Crises and the Media sets out, therefore, to examine not only the media's role in the communication of global threats and crises but also how the media can enter into their constitution, enacting them on the public stage and thereby helping to shape their future trajectory around the world. More specifically, the volumes in this series seek to: 1) contextualize the study of global crisis reporting in relation to wider debates about the changing flows and formations of world media communication; 2) address how global crises become variously communicated and contested in the media around the world; 3) consider the possible impacts of global crisis reporting on public awareness, political action and policy responses; 4) showcase the very latest research findings and discussion from leading authorities in their respective fields of inquiry; and 5) contribute to the development of positions of theory and debate that deliberately move beyond national parochialisms and/or geographically disaggregated research agendas. In these ways the specially commissioned books in the Global Crises and the Media series aim to provide a sophisticated and empirically engaged understanding of the media's role in global crises and thereby invigorate academic and public debate about some of the most significant global threats, conflicts and contentions in the world today.

On September 20, 2001, nine days after the 9/11 atrocities in the US, President George W. Bush announced in his state of the union address his intentions to engage in a global 'War on Terror.' He stated, 'Our war on terror begins with al Qaeda, but it does not end there. It will not end until every terrorist group of global reach has been found, stopped and defeated.' This ill-defined but globally elastic definition of War on Terror was put to work in the invasions of Afghanistan (2001) and Iraq (2003) that caused the deaths of many thousands of combatants and countless thousands more of innocent civilians. The improbable links alleged between Saddam Hussein and al Qaeda, like the existence of Iraqi weapons of mass destruction (WMD), prominent justifications for the 2003 Iraq invasion, all proved without foundation. The insurgencies in Afghanistan and Iraq, following the ousting of the Taliban and Hussein regimes, has unleashed further acts of terror including mediatized scenes of hostages being beheaded, targeted assassinations and indiscriminate suicide bombings. The coalition, for its part, has become ensnared in deadly military operations aimed at quelling the insurgencies and amidst revelations of torture by military personnel in Abu Ghraib prison and elsewhere, and the incarceration of over 600 terrorist suspects without trial in defiance of inter-

national law at Guantanamo Bay. Meanwhile acts of indiscriminate terror continue around the globe including bombings in Bali (2002), Madrid (2004), Jakarta (2004), London (2005), Casablanca (2007) and Mumbai (2008).

9/11 and the US government's self-declared War on Terror, it seems, has decisively moved the world into a new and dangerous phase of globalized terror. State sanctioned or 'wholesale' terror has always accounted for the bulk of political killings in comparison to insurgency or 'retail' terror that includes, but is not confined to (much less explained by) the terrorism tactic of deliberately producing scenes of human carnage designed to shock, disseminate fear and mobilize state responses. But the War on Terror and its aftermath are in many respects unprecedented and speak to a new era best characterized perhaps as the global migration of dreams and nightmares. The US War on Terror, as much as the tactics of its asymmetric enemies, has positioned 'terror' at the centre of the new world (dis)order—and global news agendas.

Terror Post 9/11 and the Media, by David Altheide, provides a critically engaged and distinctive theoretical perspective on mediatized terror in the wake of 9/11 atrocities; it encourages us to think through the cultural impacts and policy prescriptions that flow from a media logic and communications environment that symbolically constructs 'terrorism' through a prism of fear. At its core is an argument about how the new media ecology intersects with and informs the discourses and symbols of terror in the modern age. Developing on his influential approach that conceptualizes media in terms of an 'ecology of communication,' 'media formats' and 'media logic,' Altheide argues that to understand how terror has become symbolized and politically mobilized post 9/11 we need to understand how modern communications have ingratiated themselves into the institutions, activities and indeed social fabric of daily life. When 'terrorism engagement,' or the symbolic recognition and validation of terrorism as a major threat, is communicated in and through media formats and a media logic that thrive on simple narratives, episodic moments, drama and fear, then 9/11 and subsequent events, can become filled with meanings and emotions that are not only culturally discomforting but politically consequential. This pervading culture of fear premised on the discourse of terror not only reverberates in North America but plays out world-wide—such is the hegemonic position occupied by the United States in the global War or Terror.'

It is on this basis that Altheide acutely suggests: 'the critical question is neither "why 9/11" nor "what is 9/11," but rather, "how is 9/11 used?"' In other words, how does 9/11 become a vessel filled with meanings and a vehicle for discourses and projects that are mobilized after the event? This is key to his critical take on terror post 9/11 and it helps to unlock how a wide

range of seemingly disparate discourses and struggles become publicly symbolized and narrativised in terms of fear. Terrorism post 9/11, argues Altheide, has become a 'dominant frame' surrounding many cultural and institutional narratives and infused in the media's forms and formats that communicate diverse public issues and events—some exhibiting extreme violence such as the Columbine massacre, others eliciting social anxieties such as the perceived threat of illegal immigrants—but all for the most part having little or no formal resemblance to either 'terrorism' as commonly understood or the War on Terror. When conditioned by today's media logic and established media formats this construction makes for exciting talk and entertaining media programming, but it also becomes susceptible to political manipulation.

When 'terrorism' is transformed from an act to a condition, argues Altheide, it can become a context for understanding and (mis)understanding, especially when used to inform public discussion of national and international affairs and foreign policy. Numerous studies of the media's role and discourses of terror in legitimizing military invasions of Afghanistan and Iraq add weight to this claim. But Altheide also contributes new discussion to this debate when analyzing news coverage of the Israeli invasion of Gaza in December 2008. This documents how in this more recent military invasion a new discourse of terrorism became widely reported and was seemingly accepted as the rationale for both describing and planning state action and reactions—a military action that produced appalling human consequences in terms of children, women and non-combatants killed and maimed and one entirely disproportionate to the original loss of life caused by preceding acts of terror.

The discourse of terror post 9/11 has become globalized, both in the flows and formations of the world's news media and now also in the lingua franca of international relations and conduct of geo-political ambitions. How actions and policies conducted under this new rubric of terror enter into the imaginations and actions of those around the globe who find themselves, their families and communities on the receiving end of military violence or their homes turned into the killing zone, have yet to be explored with the same level of intensity and depth insights found in David Altheide's penetrating study of US media. Looking ahead we have also yet to examine the capacity of distant others to enter today's global media ecology, voice their fears from inside the maelstrom of violence, and challenge the Western media's dominant frame and symbolic constructions of terror.

Terror Post 9/11 and the Media provides us with a core reading for this more expansive exploration of terror post 9/11 and it does so from the media heartland of the war on terror. His analysis deserves to become a key point

of reference in the study of mediatized terror around the globe in the years ahead.

Simon Cottle
Series Editor

■ Introduction

"I was crying the whole time. I didn't know what to do," Pena said. "We didn't know what was happening because everyone started running. Some people thought it was a bomb but then we figured out it was immigration."

—Young mother with child after
an immigration raid in Mississippi

The young woman was reacting to an immigration raid in Mississippi to find and deport illegal immigrants. The U.S. Department of Homeland Security developed this program in the aftermath of the 9/11 attacks and the near-hysterical calls to "protect us" and keep our borders safe. The mass media transmitted and helped shape this propaganda of fear, hate, and control. Part of my project is to understand how this has happened, describe the social and communication processes through which this continues to occur, and to suggest some remedies. This is critical, since policies and police actions like the one that terrorized the young mother are constructed and promoted by the mass media and popular culture.

We have more media and less information today. This is one of several paradoxes that I wish to address in this book. Both the media and the information are increasingly complicit in promoting fear that has been nurtured by an expansive information technology as well as entertaining formats that draw users/audiences. The guiding orientation or key concept that shapes

many of my comments is a perspective tied to an ecology of communication that refers to the structure, organization, and accessibility of information technology, various forums, media, and channels of information (Altheide 1995). The basic argument is that information technology interacts with new communication formats that in turn inform, change, and create social activities, including everyday life routines and the language that we use—what we call things. One of these activities is "terrorism engagement," or the symbolic recognition and validation that terrorism is a major threat. Terrorism has become a dominant frame surrounding many cultural and institutional narratives, including the perceived threat of illegal immigrants, which is really a code for "fear of the other." All of this makes for exciting talk and media programming.

We have seen even more advances in communication technology that have promoted new communication formats, including variations of entertainment, the more pervasive orientation to modern communication. A lot of content and activities have changed along the way. I will explain how the following chapters examine some aspects of this problem a bit later in these introductory remarks, but the first task is to provide an overview of how I regard changes in communication, organizations, technology, formats, and content.

A key feature of the new media environment is the emergence of media logic, which is defined as a form of communication, and the process through which media transmit and communicate information. Elements of this form include the distinctive features of each medium, the formats used by these media for the organization, the style in which it is presented, the focus or emphasis on particular characteristics of behavior, and the grammar of media communication (Altheide and Snow 1979; Snow 1983). This logic—or the rationale, emphasis, and orientation promoted by media production, processes, and messages—tends to be evocative, encapsulated, highly thematic, familiar to audiences, and easy to use. Media logic represents another generation of media studies. A previous listing of communication phases (Altheide 1995) has been updated. McQuail's (McQuail 1983 p. 176) insightful demarcation of "phases of media effects" lists the following approximate dates and focus:

- Phase 1 (1900 to late 1930s). The emphasis was on the nature and impact of the mass media to shape public opinion.
- Phase 2 (1930s to 1960s). Attention turned to the role of film and other media for active persuasion or information, including some of the unintended consequences of media messages.
- Phase 3 (1960s to 1980s). Interest centered on studies of media effects, but with a shift toward long-term social change, beliefs, ideologies,

cultural patterns, and "even institutional forms." (This was the period of the rise of "cultural studies" approaches [Williams 1982], interest in structural and rhetorical uses of the mass media, and also a renewed interest in semiotics, deconstruction, and critical literary criticism.)

With the exception of a few works represented in Phase 3, the overwhelming majority of significant works examined media as content and tended to focus on individual effects, e.g., voting behavior, violence, prejudice, and susceptibility to messages. It is really in the latter part of Phase 3 that attention began to shift to cultural and especially institutional analyses, but even here—including some of my previous work—the focus was on content, ideology, and how messages can be "biased."

◻ Phase 4 (1990 to 2000). The contemporary focus is on cultural logics, social institutions, and public discourse (Ferrarotti 1988; Gronbeck et al. 1991). This phase focuses on media and modes of representation as significant features of social life. Drawing on a breadth of theory and research, the latest phase of mass communication studies assumes that since all "messages" are constructed, there will be different interests represented in the content, including those made by social scientists about the biases of others! It is axiomatic that all statements contain and reflect some features of the cultural and ideological context and perspective in which they are offered. While such pronouncements are useful to inform the lay public about, say, news programs, my understanding of media effects is hardly enhanced by spinning my conceptual wheels on such forms of bias. The reason, of course, is that the problem is not solved by merely altering the "content" or by having one news source replace another. Rather, what is needed to move ahead is a fresh approach to the nature of communication basics, especially cultural forms.

During this phase of media analysis, attention shifts decidedly away from the content of communication to the forms, formats, and logic of order. Formats of communication and control are central elements of this phase. Communication modes are no longer regarded merely as "resources" used by powerful elements; rather, they become "topics" in their own right, significant for shaping the rhetoric, frames, and formats of all content, including power, ideology, and influence. In this period, significant social analysis is inseparable from media analysis. Here the key concept is "reflexivity," or how the technology and logic of communication forms shape the content, and how social institutions that are not thought of as "media arenas"—such as religion,

sports, politics, the family—adopt the logic of media and are thereby transformed into second-order media institutions.

☐ Phase 5 (2000 to 2009). More attention is paid to cyberspace and the impact of digital media on personal identities, relationships, activities, and social institutions. This book is about Phase 5 and seeks to clarify key social processes and consequences of this expanded information technology and formats for understanding how the mass media operated after 9/11, as well as significant changes that have occurred across other social institutions and how these have been reported. All major social institutions, including finance, have changed and are continuing to adjust and reflect the non-linear and virtual features of digital media.

This phase is largely defined by the ecology of a communication process involving technology, formats, and social activities. Social science concepts and theory lag behind the technological curve and related social activities that increasingly are partially played out in cyberspace, "on line," and involve constant computer-aided updates and interaction. This is the period in which more social science theory pertaining to social change had to attend to the role of the mass media in social and political life (Altheide 2003b; Kamalipour and Snow 2004; Meyer and Hinchman 2002; Norris et al. 2003). I devote a few more comments to this phase, since it is still emerging and was influential in—and influenced by—the events of 9/11, including a flurry of sites offering "alternative explanation" for the terror attacks, as well as a host of views critical of the Bush Administration, on the one hand, while spurring on significant political changes—such as the election of the United States' first black president—on the other.

Significant changes include information technologies that operate in cyberspace, rapid individual-group interaction for recreational, affective, and consumption purposes—marketing and advertising are major developers. Many of these changes involve the Internet and include numerous blogs, which users—especially younger people—prefer. This expanded use and mining by marketers has led to the rapid decline in traditional media such as newspapers, which, in turn, are scrambling to attract Internet users. Massive multiple-player Internet games now exist (e.g., "World of Warcraft" with 10 million participants), along with cyber playgrounds such as "Second Life," where surrogate actors known as avatars are constructed and instructed to play at social life in simulations of both real and fantasy experiences. Individual behavior, organizational processes and goals, and social movement programs and agendas are being planned and carried out through interactive formats

such as cell phones (e.g., texting) that open up Internet access to games, information, and personal Web spaces (e.g., Facebook, MySpace, YouTube). Consider that President Barack Obama's 2008 presidential campaign cultivated webbing and blogging in unprecedented numbers. For example, one on-line supporter, "Obama Girl," was viewed more than 20 million times during the campaign. As one observer noted: "The Obama video is the only one that all age groups have heard about in roughly equal numbers" (http://pewresearch. org/pubs/539/campaign-web-video, accessed December 10, 2008). Let us turn to some of the basic information changes.

■ Information Changes

Our news has changed since 9/11 in several important ways. Exactly what is 9/11? If we are to chart changes and make claims about impacts, we should have a handle on what this means. While much of this book is devoted to answering this question, suffice it for now to say that 9/11 is not just a series of events, but is a series of meanings so diverse that it is best conceived as emergent, still under construction, and varies widely by the situation and the social occasion of its use. I suggest that the critical question is neither "why 9/11?" nor "what is 9/11?" but rather "how is 9/11 used?" or how is it played out? Indeed, 9/11 is now used throughout the world, but especially in North America, as a symbolic vessel that is only partly full; it contains some basic meanings (e.g., crashing airliners into buildings), but it is a space for the interpretation of new events and for any speaker (or writer) to associate themselves (or their project) with some unspecified values and concerns. To share 9/11 integrates and legitimizes individual behavior, social policies, and institutional practices. Searching massive information bases such as Lexis/ Nexis, Westlaw, etc., shows that 9/11 is invoked in a kind of global unity, but mainly as either a justification or an excuse for certain policies and practices. Terrorism oozes from this phrase, but it is mainly the reaction and rationale for more social control and wariness of threats from a seemingly endless source of "others," typically immigrants. These uses of 9/11 may be as diverse as the European Union trying to forge a common military force (beyond NATO), or Middle Eastern countries proposing and tempering policies of defending-against-terrorism that closely resemble attacking old threats with new language.

9/11 means something different in southern Asia, where decades of hostilities involving Hindus, Muslims, Buddhists, and many other religious/ethnic/ tribal/regional groups struggle to survive against collective memories of atrocities, victimization, injustice, and a thirst for revenge. Consider Mumbai, India,

where in November 2008 terrorists attacked people in the most popular hotels, killing 170 local and international travelers, setting fires, and commanding the attention of the world's news media for more than a week. Headlines throughout the world proclaimed that "Mumbai is India's 9/11." This resonated, but it was deceptive, and it distorted not only prior attacks that were worse but also the complexity of the situation in India, the motivations of the attackers, etc. India had experienced far worse, but few Americans were aware of those attacks:

> India's experience of terrorist attacks, on the other hand, far predates 2001. Although this year has been one of the worst in recent history, 1984 was arguably worse still. That year an insurgency in the Punjab culminated in the assassination of Prime Minister Indira Gandhi by her Sikh bodyguards. This in turn led to riots that took the lives of some 2,000 Sikhs. (Ghosh 2008)

Part of the confusion is that there has been so much simplistic media coverage and certainty in treating terrorist attacks as the equivalent of war, where sides are clear-cut and the objects of attack are directly related to an overall strategy. The nuances of terrorism, including shifting meanings and boundaries of appropriate and inappropriate acts of violence—particularly the possibility that all sides in a conflict are likely to engage in various acts of terror—all cloud the issue. But this simplicity has been programmed continually by the majority of the news media. There are, of course, dissenting voices, but as we shall see later in this book, most of those are shut out from the established "big" news media. Options have increased drastically in the last six years as digital technology has opened up many outlets to at least voice one's views that may or may not be supported with any defensible evidence. (It is estimated that 50,000 blogs are started each day!) As I note in a later chapter on evidence, the nature of "support" for one's argument and position has been greatly compromised, in my view, during the last decade, as more people have access to the Internet and its voluminous libraries of bad information and inflated rhetoric. Current news practices have contributed to this cascading reach for better information, on the one hand, while news also promotes such practices and plays to a wide-ranging array of "points of view" on the other hand. This, too, is related to how news has changed.

First, the organization of news ravishingly consumes new twists in entertainment and expands old ones. Newscasts, ostensibly devoted to "newsworthy information" that is presumed to be important to citizens in free societies, gushes with fun and entertainment. One way to penetrate the morass is with an institutional and personal story. As I write this chapter, I learn that ABC News's *Nightline*—a show that originated with the Iranian hostage crisis in 1979—will include an interview with Britney Spears, a pop music star and dysfunctional mother of two, to discuss her "redemption song" and how her

life is going (ABC *Nightline*, December 2, 2008). *Nightline*'s original host, veteran journalist Ted Koppel, left ABC for the Discovery Channel and produced some 15 hours of quality documentaries, including insightful coverage about China, that was viewed by a very small audience. But that three-year tenure ended in late 2008, when Koppel and his staff did not fit into the plans for the Discovery Channel's future. Koppel's late career changes are emblematic of the media changes and emphases that this book addresses.

Entertainment is king. Some readers may recall that Koppel, despite his fine journalistic credentials, was one of the enthusiastic news workers who became "embedded" with U.S. troops as they began to invade Iraq in 2003. Media ethics expert Charles Davis likened embedded reporting to "watching a war through a straw" (Davis 2003). That coverage, and the accompanying war, was part of the terrorism story. The embedded journalists were part of a massive propaganda campaign to sell the Iraq War to American audiences by letting them see "first hand" what the troops were going through. The task also enabled the military to co-opt the press and get them to be more sympathetic to the military operations that would ravage Iraq indefinitely. Having the press sworn to maintain military secrets and not endanger operations did something else, too: It made the press feel like they were part of the action. They were wedded to the military units, and many reporters filed stories about how they depended on their soldiers to protect them. The upshot of this embeddedness was that it permitted the military not only to censor reports, but to call the shots about the news reports, to basically manage the news during the coverage of the reputed "shock and awe" campaign.

Ted Koppel was part of this; he was eager, according to some reports, to be part of the story, even though he was prescient enough to know that he and his colleagues were being used. It is old news to say that the government and other news sources often use journalism. This has become quite common as press releases, press conferences, and especially the "photo ops"—which is what the embedded reporting was all about—are the norm. Alternative media shows in the United States, such as *The Daily Show* and *The Colbert Report*, parody the artificial distinctions that are made of the reporter-specialist covering managed news on a daily basis. Of course, this did not begin with 9/11; it had been underway for nearly three decades. Indeed, when I was completing field work for my PhD dissertation on the organization of TV news, I watched Ted Koppel, who was a young reporter for ABC News, and his colleagues cover the 1972 Republican Convention in Miami. The title of my first book, *Creating Reality*, reported on the news process and the news perspective, including chapters on both the 1972 Democratic and Republican Conventions. One of ABC's big stories was obtaining an advance copy of the

orchestrated script of the Republican National Convention for the TV audience. This was my account of what occurred:

> The news situation was so grim that the lack of news became news when a misplaced Republican schedule found its way to ABC's newsroom. A reporter did a story emphasizing that "our suspicions" of planned "spontaneous events" were now confirmed. He went on to note the precise times that certain activities would occur, including the chairman's request to "clear the aisles." (Altheide 1976 p. 134)

Such programming was just coming into its own at this convention but would become institutionalized in future conventions and political campaigns during the next three decades.

Ronald Reagan, a "B-movie" actor who became president of the United States, was adept at orchestrating photo ops and sound bites. He was aided by one of the most manipulative staff propagandists of the modern era, Michael Deaver. Deaver was very straightforward, and one gets the sense that he was actually quite proud of his symbolic constructions. In an editorial in the *Washington Post* entitled "Sound-Bite Campaigning: TV Made Us Do It" (October 30, 1988), Deaver spelled out how professional image managers learned from the media to produce an image. Deaver's pronouncement signaled the death of organized journalism, because he clearly articulated how the "source" and "channel" were no longer separate. The world of one had entered that of the other, and both were transformed.

> My own contribution to campaign innovation resulted from observing the medium as we prepared for the 1976 presidential race. I noted how the people who run television news were reducing a candidate's thoughtful and specific speech on an issue, say, an upturn in the economy, to a 10-second sound-bite, which was then followed on the screen by an effective visual of someone, usually in the Midwest, "whose life remains untouched by the prosperity claimed by President Ford," as the voice-over told us. The point is that rather than inventing the effective visual or the 30-second sound bite, we simply adapted an existing TV news technique that was already widely used. That's why it always amuses me to watch someone like Tom or Peter or Dan sitting in a million-dollar set, their physical appearance the envy of every undertaker in the nation, criticizing a politician for trying to control his or her image…. There's nothing mystical about what I and others in the Reagan White House did with television. A good illustration might be a story about an increase in home construction starts. In my judgment, this was a major story, of importance and interest to the American people. So, in our morning issues conference, a meeting much like those held in the editorial offices of newspapers and television networks and stations all over the country, I decided to "lead" with the housing story. But rather than have White House Press Secretary Larry Speakes hold up charts or issue a press release, and thereby bury the story in the business segment, we took the president to a construction site. There, wearing a hard hat and standing in front of homes under construction, he announced the housing start numbers and what that meant to

the American people and the national economy. Naturally, the story played big on the evening news. An enduring shibboleth is that a skilled practitioner can make someone appear to be other than what he really is…. (Deaver 1988)

In short, Deaver made it clear once and for all that it was no longer news-worthy to claim, as many critics of the media have done, that "The objective was…to transform [the press] into an unwitting mouthpiece of the government" (Hertsgaard 1988 p. 31). This was not accomplished through fear and intimidation, but by using the codes, language, logic, and formats of the news media.

Our most recent wars are but an extension of the communications logic that has been celebrated throughout much of popular culture in general and, as Deaver's comment above suggests, American politics. The communication process is a production that is guided, in the case of television, by entertainment considerations, including visuals (seeing is more important than hearing), emotion, drama, and action.

It is programming logic that has directed the public presentation—and public reaction—to this war. This means that a sense of fun, familiarity, enjoyment, and participation are involved. It is a program in keeping with the entertainment perspective: there is a cast of characters, including heroes, villains, and fools; there is theme music played over rolling logos and icons.

Koppel knew about these changes in reporting practices and how they were prescribed by the changing news landscape that was ravaged by conglomerate jaws hungry for more profits and the "bottom line." This did not start with 9/11, but it was greatly exacerbated by "market forces," as well as government deregulation that basically eviscerated the Federal Communication Commission's oversight of electronic media, leading it to grant media giants even more power, control, and even monopolization of media markets, including ownership of multiple news outlets in the same market. The new cable and satellite technology offered global markets that could be directed by centralized programming for broadcasting, on the one hand, while also spawning a multitude of niche outlets for narrowcasting, on the other. Common to both was a more sophisticated approach using institutional narratives to tell common stories. Even the "counter-narratives" proposed by some niches (e.g., numerous Web sites devoted to blaming the 9/11 attacks on the Bush Administration) reiterated common themes.

■ Institutional Narratives

We are increasingly fed institutional narratives about fear and threats to social order. The news narrative differs from the movie narrative, which, with few

exceptions, is oriented to reassuring audiences. News narratives promote challenges to institutional forces that are dedicated to protecting us. The strongest attacks are against individual criminals who harm us and government agencies that fail to protect us from individual threats. These narratives are captured in reports about crimes that are presumed to be more or less motivated by drugs and/or greed (Surette 1998). There has been an increase in such narratives since the late 1990s, but this has increased even further since 9/11. Ericson (2007) argued that neo-liberal governments promoted insecurity and risk directly and indirectly by offering programs and policies to protect citizens, mainly from crime, but also from terrorists—internal and external—with an emphasis on surveillance, including the use of TV programs such as "real crime programs" to encourage citizen awareness and participation in surviving numerous threats. Heretofore routine harms and inconveniences were recast in the discourse of victimization and abuse. One consequence was to heighten citizen-audience fears, but another was to increase criminalization by adding more rules and potential violations, i.e., disobeying more security personnel and rules. Since 9/11 we see more crimes portrayed as versions of terrorism in which victims are said to be terrorized. This is examined in Chapter 6, with an analysis of school shootings since 9/11.

■ Fear, Corruption, and Abu Ghraib

Safety and security from fear-inducing individuals, acts, and countries resonate throughout the institutional narrative. Integrity and positive values also strike chords in the mass media and popular culture. Morality can be politically demonstrated by dramatically protesting against evil and our enemies. Outrage against wrongdoing plays very well in the mass media. Entertaining news formats prefer black-and-white stances and abhor shades of gray. The 9/11 attacks galvanized media opinion against terrorism and any marginal supporters. France was pilloried in media reports when it did not agree to join the U.S.-led coalition forces to attack Iraq. Demonstrations were held at which people poured French wine into drains, and "patriotic" congressmen altered their Capitol Hill menu by changing French fries to "Freedom Fries." The power of news formats does not stop with terrorism.

Corruption is another form of idealized opposition to purity and goodness. Notwithstanding the historical accounts of corrupt congressmen and other government officials, a nation's wrath was seemingly dumped on Illinois Governor Rod Blagojevich when he was indicted in late 2008 for trying to sell the Senate seat that was vacated when Barack Obama became President-

elect Obama. The governor was quoted as saying, among other things, "the Senate seat is a bleeping valuable thing. You just don't give it away.... I've got this thing and it's bleeping golden." A chorus of calls for his resignation filled the headlines, network newscasts, and talk shows for more than a week amid speculation about when he would resign. U.S. attorney Patrick Fitzgerald, who was in charge of the wiretapped evidence that documented Governor's Blagojevich's offers, added to the outrage by referring to the governor's conduct as a "truly new low," and stated that "The conduct would make Lincoln roll over in his grave" (Staff Report December 9, 2008, http://www.chicago-breakingnews.com/2008/12/us-attorney-fitzgerald-press-conference-blagojevich.html, accessed December 16, 2008). Print and electronic journalists hammered on the theme of "another corrupt Illinois politician" as President-elect Obama joined the call for his resignation, while the Illinois attorney general and others pleaded with the Illinois Supreme Court to declare the governor unfit for office so that he could be more readily impeached.

The Illinois corruption story was easy pickings for journalists, who could invoke righteous indignation at an offer to sell a U.S. Senate seat for personal gain. They were confident that most of the public and elected officials, including those in the U.S. Congress, would support this dramatic storyline, and play their part in a classical morality tale of good over evil, with evil being banished. It is an old story, a predictable and entertaining one to tell and follow over a period of several weeks.

There was less support for telling the story of a corrupt Bush Administration that lied to the American public about events leading up to the Iraq War and awarded no-bid, multi-billion-dollar contracts to corporations such as Halliburton. Only a few muted voices called for President Bush to resign and asked for his impeachment. Even the Speaker of the house, Democrat Nancy Pelosi, was reluctant to bring articles of impeachment against the disgraced president. There was very little media outcry about this, and there were no calls for Mr. Bush's or his appointees' resignations when other egregious violations of national and international law were revealed. These included the indefinite imprisonment of international prisoners held at Guantanamo Bay, Cuba, in the CIA's international kidnapping and torture program referred to as "extraordinary rendition" (Luban 2008; Satterthwaite forthcoming 2009); the Abu Ghraib prison scandal; and later revelations that the Bush Administration had illegally conducted blanket wiretapping and surveillance of U.S. citizens' telephone, banking, and Internet communications. Internet blogs deploring the abuses blossomed and quickly attracted tens of thousands of visitors, mostly young people. Some popular culture opposition was apparent in "comedy TV" (*The Daily Show* and *The Colbert Report*), music (the Dixie Chicks, Green Day, and Neil Young), and selected movies (*V is for Vendetta*). But apart

from mentioning the incidents and showing some photos of Abu Ghraib, the major U.S. media were quite "complicit" (McClellan 2008). The contrast in the major media's moral outrage and the selective opposition to government action is perhaps most apparent with Abu Ghraib abuses.

A major embarrassment to the U.S. and coalition forces in the Iraq War occurred when photos of prisoner abuse at Abu Ghraib prison were provided to some journalists in 2004 and were eventually publicized (by, for example, *60 Minutes* and Seymour Hersh). These actions and the international documentation of the abuses gave the Iraqi opposition and guerilla fighters a major propaganda victory over the United States. After all, Abu Ghraib prison was used by Saddam Hussein, the former demonized leader of Iraq, to torture political prisoners. The sexual displays and humiliation of Iraqi prisoners signaled another chapter in the U.S. "secret" condoning of torture of prisoners that could not have occurred on such a widespread scale without the authorization of officers and their superiors. Very few established media outlets vigorously pursued this story, and virtually no one made a consistent call for the resignation or impeachment of President Bush or his appointees (including Secretary of Defense Donald Rumsfeld and Vice President Dick Cheney). The commanding officer, Janis Karpinski, was demoted, although she claimed no knowledge of the abuses since many of the interrogation, torture, and humiliation activities were carried out by contract workers. Eleven men and women were prosecuted for the practices at Abu Ghraib, while several panels and commissions conducted hearings to get to the root of the problem and assign responsibility.

It took four years for the most definitive report to come forth in December 2008. "The Senate Armed Services Committee Inquiry into the Treatment of Detainees in U.S. Custody" was issued by Senators Carl Levin (MI) and John McCain (AZ), the latter a former prisoner of war in Vietnam who was also the Republican candidate for president in 2008. The report was very direct in claiming that:

> ...top Bush administration officials, including Donald H. Rumsfeld, the former
> defense secretary, bore major responsibility for the abuses committed by American
> troops in interrogations at Abu Ghraib in Iraq; Guantánamo Bay, Cuba; and other
> military detention centers.... The abuse of prisoners at Abu Ghraib was "not
> simply the result of a few soldiers acting on their own" but grew out of interroga-
> tion policies approved by Mr. Rumsfeld and other top officials, who "conveyed
> the message that physical pressures and degradation were appropriate treatment
> for detainees.... By the time of the abuses at Abu Ghraib, Mr. Rumsfeld had
> formally withdrawn approval for use of the harshest techniques, which he
> authorized in December 2002 and then ruled out a month later. But the report
> said that those methods, including the use of stress positions and forced nudity,
> continued to spread through the military detention system, and that their use

"damaged our ability to collect accurate intelligence that could save lives, strength-
ened the hand of our enemies, and compromised our moral authority." (Shane
and Mazzetti 2008)

This major story received very little news coverage in the United States,
appearing on page 10 of the *New York Times*, page 15 of the *Los Angeles Times*,
and—while it was mentioned in the Associated Press and United Press
International wire services—was hardly featured on major network newscasts.
Foreign newscasts (in Germany, for instance,) did pay more attention to the
report, including Web pages of Al Jazeera, which used a report by a blog,
"Balkinization."

There was little mention of the story on network TV news, although it
was indirectly discussed on ABC's *Sunday with George Stephanopoulos* (December
14, 2008) during an interview with Senator John McCain about the economy,
the presidential political campaign, and his opinion about whether the gov-
ernor of Illinois should resign following charges being brought against him.
The Levin and McCain report was one of the last things discussed in the
interview. Comparing Senator McCain's comment about the anticipated
resignation of Governor Blagojevich with his disavowal of holding anyone
accountable for the Abu Ghraib scandal illustrates not only political "niceties,"
but also, I suggest, a politician's reading of public concerns and outrage. In
the transcript below, McCain first replies to the question about the Illinois
governor. Next, Stephanopoulos refers to the Levin/McCain report and asks
if the people in charge of the Abu Ghraib abuses should be held
accountable.

George Stephanopoulos: (Off-camera) Good to have you. Absolutely. And there's
so much to talk to you about since the campaign, but let's begin with the news
of the week. You saw that joke about Governor Blagojevich in Illinois. Fifty
Democrats in the Senate have called on him to resign. Do you think he should
resign?

Senator McCain: Oh, I'm sure that he should have. President-elect Obama also
called for that. He should. You know, there's a lot of corruption amongst
Republicans and Democrats, and this kind of thing doesn't help in these kind of
difficult economic times. So I would hope that he would resign, but we also
look—ought to look at—systems that breed this kind of corruption, and unfor-
tunately it isn't confined to one city or one state.

...

George Stephanopoulos: (Off-camera) Some look at that [the Abu Ghraib abuses]
and say, because of that, there should be a special prosecutor looking into all the
crimes that were committed. No one should be exempted from that.

Senator McCain: Well, that's not my job. If overwhelming evidence indicates that, that's fine. But the point is, I thought and Senator Levin did that we should carry out our responsibilities in the Senate Armed Services Committee and do a thorough and complete investigation. I'm not that interested in looking back. What I am interested in and committed to is making sure we don't do it again. We're in this long twilight struggle here. And so America's prestige and image as we all know was damaged by the stories of mistreatment, and we've got to make sure the world knows that that's not the United States of America that they knew and appreciated for centuries.

■ The Terrorism Narrative

We are still telling the terrorism story—I offer some more chapters on it later in this volume. More than ever before, we focus on terrorism, disaster, and the impending doom that awaits us. Even presidential candidates who offer alternatives—as Barack Obama did—warn us of the dangers ahead if we do not change. President Bush restated the "threat" more than seven years after the 9/11 attacks. In a speech to West Point military cadets, he reiterated the connection between 9/11 and the "terrible attack in Mumbai" in November 2008 that serves as a reminder of the serious challenges posed by terrorists, adding that his successor (Barack Obama) should continue. He stated: "In the years ahead, our nation must continue developing the capabilities to take the fight to our enemies across the world...we must stay on the offensive" (Savage 2008).

Institutional stories about fear are promoted by and benefit social control agencies that are called on to regulate our lives in order to protect us. In effect, we begin to worship at the altar of terrorism, giving whatever is required to placate it, to keep us safe. This soon becomes accepted not just as part of our lives, but as the nature of reality. We make allowances for excesses, as we have seen with infringements on civil liberties. Everyday life begins to change as, for example, surveillance and control efforts are sharpened. The media bombardment offers us "security as salvation." An apt analogy is how impoverished silver miners in Bolivia construct their spiritual reality to help deal with the harsh conditions they face. Their religious ideology accommodates a powerful devil. A documentary film, *The Devil's Miner* (aired on Independent Lens, KCTS, August 8, 2006), captured Bolivian mine workers' perspectives on fear and dread:

> Silver miners in Bolivia worship God on the surface, but worship the Devil inside the mine; God controls the outside world, but they believe that the Devil, or Tio, controls what goes on inside the earth. A priest explains the conundrum:

On the day of the sacrifice, the miners first pray to God in church and then return to the mine to decorate the Devil.... They live in a world of fear.... They come to mass and just to be safe, worship more so nothing bad happens. They are doubling their reinforcement. They go back to the mine, but with double reinforcement.... Nobody can grasp what they are going through.... What has to change is that they don't believe in a God...who they fear.... Because if not, their God will always be the Tio and not Jesus. In the end they have believed in the Tio but their lives are destroyed. The outside world belongs to God. At the mine, the crucifix is further outside than the Tio, who is deep within the mine. The cross makes sure that the Devil is locked inside the mine. But when you enter deep into the mine, God doesn't reach there anymore. So they are afraid. If God can't protect them, who will protect them? It must be the Tio.

The miners and their families sacrifice a llama and throw some of the blood on the crucifix, and also paint their faces. Then the miners' wives prepare a barbecue of llama. And then the offering begins. A man is quoted as saying: "Tio, lord of the mountain...we give this offering...so that you reveal your minerals and spare our lives." The people believe that without these sacrifices the Tio will kill you. He would take the sacrifice from your own flesh. "That is why we bathe the entrance of the mine with blood so that the Tio drinks it and doesn't drink our blood," states a 14 year old boy, who, with a friend, is going to work in the mine in order to earn some money ($4 a day) for school.

The point here is that understanding social control and security efforts relies on the participation of the controlled. Consider the airport security ritual where passengers stand in line, take off shoes, open their belongings, and, when summoned, even submit to physical "wandings" and pat-downs by workers. The ritual that is enacted, that is, standing in line, holding one's arms out for search, and opening up luggage for inspection, precedes getting cleared to proceed, being selected for inclusion, being passed, and being allowed to enter the aircraft for one's journey. The potential passengers participate in order to be protected, but they must give up something. They must demonstrate compliance—indeed, passivity—as they pass through the portal of security, the electronic device(s) that scan their bodies for metal and other substances. (These might include X-ray photographs of bodies, essentially stripping them of clothing.) I suggest that this is tantamount to the supplication of religious rituals, including presenting one's body for inspection. But there are also offerings, giving up one's personal things. A recent—and extreme—example of this followed the August 2006 announcement that British authorities had arrested several dozen people involved in a plot to blow up international airliners. The explosives would be a combination of various liquids carried on board by separate individuals, who would then mix the explosive brew in flight. Almost immediately, liquids, gels, and many personal items were banned from airliners. Tens of thousands of items were thrown away or confiscated at the door of security portals during the next few days.

While many people resisted the efforts by consuming such things as water, wine, and whiskey, most willingly dropped the offerings in trash bins or gave them to airport employees. Airport trash workers reported that it was like Christmas! Several travelers who were interviewed indicated that they did not mind at all if this would keep them safe. I wish to explore the utility and implications of considering religious metaphors for understanding the discourse of fear and the accompanying politics of fear that pervades modern life.

The sources of public information still shout about terrorism, but they have added topics such as global warming and, more recently, immigration threats. Using the latter, they paint a portrait of our shores and borders being overrun by aliens who not only enter illegally but—according to many Websites that discuss Hispanics—plan to take over the United States. The specter of citizenship rights is apparent. But it is just not the United States that is reacting strongly to immigrants. Headlines, Websites, and blogs saturate the globe denouncing immigrants and advocating for "our citizens." The refrain is familiar: crime, drugs, disease, and—since 2007—the economic downturn are used to justify more extreme measures. Scandinavia and virtually the entire European Union are altering immigration policies, including checking identification papers and deporting illegal immigrants. This emphasis is born of the discourse of fear, a topic that I will address in a later chapter.

■ Format Changes

This introduction has focused on the changing nature of news content about terrorism. A second way in which news has changed involves technology and formats. News content, as noted above, has changed somewhat, but the biggest changes are in the speed and rhythm of news. There are many more news outlets today than before 9/11, and far more than there were in the 1990s. This is due to technological changes, including the Internet, as well as more powerful cell phones that connect us to an expanding array of digital media. These information machines have contributed to a plethora of information sources, including new formats for information. Consider how quickly the world has adjusted to the widespread adoption of the Web "blog," or personal news channel, podcasts, visual Internet sources such as Facebook, Youtube, etc. Now nearly everyone can post comments, offer analytical insights, and even rehash reports that were originally produced by conventional news sources such as the *New York Times*, CBS News, and others. And this can be done globally.

As I write this, several dozen newspapers in the United States have filed for bankruptcy including the *Chicago Tribune*, the *Los Angeles Times, Rocky*

Mountain News. News is more evocative and less referential today. Audiences are more oriented to simple and brief encapsulated news reports, information that is interesting, entertaining and fun. Audiences read fewer newspapers, view more internet—and occasionally view news briefs there—and as a consequences the major sources of investigative reporting in the United States—newspapers—are going out of business. Publishers are trying to compete on the Internet as journalists now spend some of their valuable time writing blogs to reach the internet users.

Assumptions about audiences have also changed since 9/11. While these were ongoing over the last two decades, the emphasis on terrorism and the toying of fear and danger by various leaders led to the emerging of a master narrative of impending doom that could simply be glossed over with a lot of content, or news reports about various problems and issues. This can be seen in the visual introductions to U. S. network news reports, which reflect angular streaming images across a TV screen a lot of motion and continuity of a rivlet of color, set to music announcing the start of another day's encapsulated reports that will also become part of the dancing flow of color that is our past, present and future. It really is set forth as one thing after another, but they are all of the same spectrum. But what is it? Is it a band of events, natural catastrophes, decisions by human agents—there are images of anchorpersons included, propaganda campaigns, or marketing missions to entice consumers? It is all this. And, as I will suggest in the pages to follow, that is part of the problem. There is less discerning, separation, analysis, context, and genuine curiosity since 9/11. Consider the CBS News "eye," open and focused, and presumably seeing; it is not blinking, just looking. What would it see if it looked at the NBC logo, a comet-like tail of light and images moving in front of us, images of chaos, terrorism, celebrities, and fun? And what are the consequences of this shift to simple storylines and institutional narratives? This book tries to answer that question.

■ An Overview

The chapters that follow address the logic, rhetoric, discourse, and accounts/ disclaimers for shaping the national and international arenas after 9/11. The general argument is that terrorism justifications altered the meaning and logic of national and international relations. Chapter 2 makes the case that terrorism has been transformed from an act to a condition, even a context for understanding national and international affairs. Chapter 3 examines the news media's emphasis on terrorism and the politics of fear and how after 9/11

terrorism in public discourse began to be more associated with victimization and fear, even surpassing linkages with crime. Chapter 4 looks at the fundamental problem of evidence in a postmodern era that promotes evocative content and praises personal interpretation as superior to claims about facts, objectivity, and "convincing arguments." Terrorism is clearly associated with an expanding anti-intellectual and non-rational basis for thinking and feeling. In Chapter 5, I argue that terrorism is not easily viewed as a "moral panic," like many "social crises" that are promoted by interest groups and moral entrepreneurs engaged in promoting or rejecting social change. Rather, terrorism is a more enduring orientation of fear than other social problems and issues that come and go. This strength of terrorism-as-fear is examined in Chapter 6, which examines how school shootings after Columbine, as well as other student behaviors, have been cast as terror. Chapter 7 examines how "Terrorism Programming" emerged to define military actions to combat terrorism as legitimate and changed the international discourse. Chapter 8 treats terrorism and popular culture as inextricably linked and suggests that entertainment contextualizes politics and national security. An analysis of news coverage of the Israeli invasion of Gaza in December 2008 shows that a new discourse of terrorism has been constructed and accepted, by and large, as the standard for describing and planning state action and reactions. Terrorism as accounts and disclaimers have altered the symbolic landscape and language. Chapter 8 further suggests that terrorism trumps genocide as an issue; indeed, concerns about genocide soon came to be linked with genocide in a self-fulfilling way to cast certain issues as worthy of attention and intervention. Terrorism helped link human rights to specific government policies and uncouple it from murder, including mass murder and genocide. Genocide, like child abuse, came to refer to a broader class of acts; it is bandied about as a condemnation, but not one as deplorable as terrorism. State military action has been legitimated and sold by propaganda campaigns. This includes what counts as evidence, severity of human rights violations—genocide is not enough, and genocide-as-terrorism becomes more important. Other countries (for example, England and Turkey) use terrorism discourse as a symbolic device to define and control opposition groups, actions, and policies. Fear is stressed and developed as state policy. Finally, Chapter 8 proposes key research questions for understanding how media logic in our technologically transformed social life can take us beyond terrorism to the next threats.

■ Terrorism and Propaganda

The mass media provide one record of culture, but that record consists of various parts, including different stories that resonate with dominant narratives and themes. This chapter provides an overview of how popular culture narratives about terrorism have intersected with other issues that were mediated by changing entertainment formats.

Some items from popular culture narratives:

1. Between 2001 and 2008 the Congress of the United States, and most of the nation's news organizations, were complicit in the Bush Administration's malfeasance, misfeasance, nonfeasance—and lies—in carrying out two wars and draconian limitations on civil liberties, all of which resulted in the loss of tens of thousands of lives, cost billions of dollars, lost irreparable global good will, and contributed to a recession. Congress did not hold investigative hearings, censor, or bring articles of impeachment against an administration that misled the American people and the world.

2. On February 14, 2008, pitcher Roger Clemens and several others were called before a congressional panel, in what was described as "a dramatic showdown," to look into charges of steroid and other drug use. One congressman said, "It's hard to believe you, sir." Front-page photos and reports were accompanied by network news headlines for several days. (An Arizona sportswriter commented on the emphasis that baseball was receiving compared to the war.)

3. Millions of Americans still believed in 2007 that Iraq was responsible for the 9/11 attacks, while many fellow citizens cited evidence that

the administration was responsible and was covering up the conspiracy.

I want to tell a sociological story about these related events, which were constituted and shaped by the mass media, as political performances took into account relevant audiences' expectations. This requires unpacking the communication context and process used in defining situations and constructing social reality in order to clarify how the mass media—including the Internet—contributed to new propaganda that reflected and shaped two narratives. But first, a little history. In November 2001, I was honored to be asked to contribute to a session of the National Communication Association dedicated to Peter Hall's immense sociological contributions. I struggled with that task and elected to use Peter's work on the negotiated order, meso-structure, and meta-power as a way of making sociological sense of the quick passage of a major policy change brought about by the Congressional approval of an "anti-terrorism" bill (HR 3162) that foreshadowed major fissures in civil rights, the rule of law, and an accelerated decline of the United States as a moral leader. That essay, "Communication as Power" (Altheide 2003a), was published, but the events under consideration were not completed. I attempt to finish that project in this chapter by discussing how propaganda and terrorism were joined through fear in constructing a major cultural narrative, and then, in a brief "Part II," I discuss how counter-narratives to the dominant propaganda also strive to be coherent and retain symbolic boundaries.

I will suggest two things about propaganda: first, that the propaganda campaign was successful because of "new propaganda" akin to "public diplomacy" that was used "against" other countries but was turned on citizens of the United States; second, that propaganda narratives both "pro" and "con"—in our case, the Bush Administration and an opposing view such as 9/11 Truth—not only distort reality, but are being shaped by new information technologies, e.g., videos and the Internet, that play off members' experience with popular culture and entertainment media, on the one hand, while promoting sub-plots that reaffirm the dominant narrative and counter-narrative on the other. Missing, as usual, is the sociological narrative, about how reality gets constructed through symbolic meanings that are routinized and flow into the culture stream of myth and "what everyone knows." I will try to tell that, too.

As noted in Chapter 1, the communication order is a critical foundation for constituting social and political changes, and the logic of this order underlies how power is communicated (Couch 1984; Hall 1988; Hall 1997). Numerous studies have shown how the mass media influence the form and content of public messages and events (Bennett 1988; Edelman 1971; Edelman 1988; Gitlin 1980). As actors have become more familiar with the news formats

and their logic, they have incorporated media logic into planning events. This logic, or the rationale, emphasis, and orientation promoted by media production, processes, and messages, tends to be evocative, encapsulated, highly thematic, familiar to audiences, and easy to use. We saw in Chapter 1 how media managers, producers, actors, and audiences share an awareness of media perspectives. Indeed, "postjournalism" refers to the blurring of lines between journalists and news sources (Altheide and Snow 1991). Media logic in the postjournalism era fundamentally changed the way in which journalists conduct their work, the kind of information that audiences receive, and the way that politicians and "leaders" lead. This is all consistent with a grand theory of the mass media and social change, an "ecology of communication," which refers to the structure, organization, and accessibility of information technology, various forums, media, and channels of information. Chapter 1 set forth a statement and ecology of communication perspective. This chapter elaborates on that perspective. It provides a conceptualization and perspective that joins information technology and communication (media) formats with the time and place of activities. In our day, propaganda is as much a derivative of entertainment formats and information technologies as it is a feature of cunning manipulation. I am speaking about the role of the "new propaganda" as marketing. Consider political propaganda.

Most politicians are propagandists, possessing varying media and performance skills. But performance it is. Major political actors, like Blumberg's (Blumberg 1967) prosecutors and defense attorneys, are involved in a confidence game and manipulate truth and reality for strategic purposes. And, like Blumberg's "officers of the court," politicians have common investments in the institutions that give them identity and authority to bless or burn. One of their key platforms involves mass-media forums. Congress, for example, plays to its various audiences, albeit with varying skills. Always mindful of the audience and implications of a "bad review," they tend to vote along party lines—often drawn by big-spending lobbyists—and, when that isn't safe, will cast the emotional vote to show their basic values and support as "good Americans." Selected votes and foci involving the Iraq War illustrate the point. Only one senator (Feingold, WI) opposed HR 3162 (the "Homeland Security Bill" noted above), although other politicians would offer accounts about the meanings of "my vote" over the next five years. This strategy reflects emerging information technologies, especially 24-hour news on cable, which permits assertions, denials, clarifications, and—rarely—confrontations over lies. Thus, the political and propaganda logic in vogue is based on media logic.

A key aspect of media logic is the emergence of "new propaganda" and information control, also referred to as total information dominance by some scholars (Kamalipour and Snow 2004). Akin to bureaucratic propaganda

(Altheide and Johnson 1980), it is somewhat different, the emphasis being on broad-ranging promotional information. New propaganda goes beyond simply being "on message" for particular tasks or audiences but rather comprises pervasive, repetitive, and overlapping symbolic messages, including images, across various media, cross-cutting formats, and connecting types of genres and programs, for example, news, entertainment, marketing, and, in general, popular culture. Largely developed during the Cold War as another weapon in the global battle for political allegiance, this approach has been extended to other cultures, especially those of our enemies. It is referred to as "public diplomacy" and has several definitions, but this one by the U.S. Information Agency will suffice: "Public Diplomacy seeks to promote the national interest of the United States through understanding, informing and influencing foreign audiences." Established as a better alternative to conventional propaganda, public diplomacy was heralded as a way of letting other nations experience the broad-based truth about the United States of America through non-governmental organizations, cultural exchanges, business, and, of course, other popular culture. Even individuals of the stature of Edward R. Murrow worked for it and through it. As head of the USIA he stated, in 1963:

> American traditions and the American ethic require us to be truthful, but the most important reason is that truth is the best propaganda and lies are the worst. To be persuasive we must be believable; to be believable we must be credible; to be credible we must be truthful. It is as simple as that. (http://www.publicdi-plomacy.org/1.htm#propaganda)

Readers may recall that 1963 was about the time that the United States was already deeply embroiled in massive deception in Indochina. So my point is simply that communication was seen as more strategic—and perhaps more believable—than conventional propaganda, e.g., "The Enemy Is Evil," which is still in vogue, but not as effective as more carefully "spun" sugar about U.S. goodness, fairness, and virtue. Nancy Snow, who earlier worked for the USIA, became very critical of U.S. foreign policy (Kamalipour and Snow 2004).

> A crucial part of the US foreign policy apparatus, USIA likes to call its particular branch of foreign affairs *public diplomacy, a euphemism for propaganda*. The encyclopedia definition of the latter term is *instruments of psychological warfare* aimed at influencing the actions of human beings in ways that are compatible with the national interest objectives of the purveying state. But USIA prefers the euphemism, because it doesn't want the US public to think that its government actively engages in psychological warfare activities, and because, among the general public, propaganda is a pejorative catch-all for negative and offensive manipulation. (http://www.hartford-hwp.com/archives/27c/553.html; my emphasis)

Public diplomacy was not working well in Arab countries, especially when alternative media sources such as Al Jazeera were broadcasting counter-propaganda about U.S. atrocities against civilian populations. To counter these "distorted views," "real fake news" was created by public-relations people in the field, but that also became known. Even if successful, that would not have been enough to neutralize the images of torture, humiliation, and sado-masochism from Abu Ghraib prison. New technology (for instance, cell phones with cameras, and digital cameras) was too enticing for the participants not to record activities and to promote identity—either for or against the practices—by posting photos on the web. The soldiers had fun, the world was shocked, Muslims were outraged, and even the Israeli Massad suggested that they would not do such things because of the rage and resistance they engendered. Congress looked into it and was satisfied—along party lines—that it was being dealt with. Congress also looked into torture and bantered with administration officials about "waterboarding" for some three years, while permitting public and secret prisons to continue operating. Another scandal was the egregious policy of "extraordinary rendition," or the CIA kidnapping of suspects who would then be taken to "friendly" countries (such as Egypt) and tortured.

But wait! The shock was not so strong as, say, baseball players cheating. Notwithstanding the Italian government's issuing of warrants for 22 CIA agents, these gross violations of international law and human rights did not warrant the kind of attention that Roger Clemens received for allegedly shooting steroids. The political campaign for the next election continued. Speaker of the House Nancy Pelosi focused on the Democrats' winning the next election and opined—along with others—that impeachment proceedings would rally the opposition and could cost the election. *This is public diplomacy*.

Thus, the great Murrow had it wrong. Governing in a postmodern world requires neither truth nor credibility; entertainment and perceptions about truth matter, or as comedian Steven Colbert would say, "truthiness," what one's "gut" says is truthful. Above all, it matters how truth appears. This is where fear comes into play.

Mass-media entertainment formats contribute to meta-power, another Peter Hall term that refers to the shaping of social relationships, social structures, and situations by altering the matrix of possibilities and orientations within which social action occurs. Our media age, especially with new media such as the Internet, trades on truthiness at the expense of critical thinking and accountability: there is no one "authorized" to warrant validation of one's assertions, beliefs, and attendant actions. Authority is not just decentered; it is explicitly constituted by the technology and formats that carry it. Power

is enacted through communication. The "War on Terror" communicated very well, even as it became redundant. For example, Homeland Security Secretary Michael Chertoff said on December 3, 2008, that the threat of terrorism and weapons of mass destruction remained "the highest priority at the federal level." Some two weeks later (December 18), in commenting on a report that projected terrorist threats for five years, Chertoff said, "The threat of terrorism and the threat of extremist ideologies has not abated" (Sullivan 2008).

The propaganda of terror is all about fear. It is also about consuming things, keeping up appearances, staying strong, not repeating prior mistakes of "cutting and running," and "supporting our troops," honoring "fallen heroes," and not letting others "sacrifice in vain." And then there is more consuming, but as audiences, rather than critical publics trying to iron out the numerous contradictions of market strategies and gaining the good life with widely recognized stealth and deceit by government officials. The propaganda trades on audience members' beliefs, attitudes, and experiences with various sources of fear, including crime, but mainly it trades on mass-media reports about threats and dangers that have pervaded news and entertainment fare for decades. I argue that the propaganda of fear that has pervaded our country for the last six years—ostensibly concerning "terrorism"—is actually a continuation of several decades of crime control and ultimately social control. Much of this has been systematically communicated through the mass-media entertainment formats, and a staple of that format is fear. These programs have been fairly consistent, especially in the dominant narrative: *There is danger everywhere, and it looks like crime (e.g., drugs, gangs, random killings, domestic violence, child abuse, etc.). Formal agents of social control (FASC) can save you, but they have to contend with courts and "technicalities" (e.g., illegal search and seizure, entrapment, and related civil rights issues). Still, trust them/us.*

Extensive study of news reports and entertainment programs suggests that during this period fear expanded greatly and moved from being an emotion to a communication style, or discourse of fear, that may be defined as the pervasive communication, symbolic awareness, and expectation that danger and risk are a central feature of the effective environment (Altheide 2002). The word itself increased by several hundred percent in news reports from the mid-1980s to the late 1990s. Fear came to be closely linked with crime, drugs, gangs, immigrants, and—after the horrendous Columbine school shootings—it became even more closely linked with schools and children (see Chapter 5). This was part of the context for the attacks of 9/11, which were quickly folded into it, except that the language quickly shifted from crime to "war." The playing to fear continued into 2008, when President Bush argued that the House of Representatives should reauthorize the administration's National Security Act, which permitted blanket communication surveil-

lance without even the most perfunctory checking with a special court that was created three decades before under the Foreign Intelligence Surveillance Act. "At this moment," Mr. Bush stated, in defense of extending this authorization, "somewhere in the world terrorists are planning new attacks on our country. Their goal is to bring destruction to our shores that will make Sept. 11 pale by comparison" (Lichtblau 2008b).

The expanded domestic surveillance program was initiated without congressional or legal approval. Agents of the regime simply went to major communications companies (such as AT&T) and asked them to allow the government access. Virtually all complied, and when this became known several years later, clients of the communications magnates filed multi-billion-dollar lawsuits. Granting amnesty and protecting the communications industries from lawsuits was a key part of the legislation. Thus, fear not only exacted a civil liberties cost; it could also penalize giant conglomerates billions of dollars.

As noted previously, terrorism became a perspective, orientation, and a discourse for "our time," the "way things are today," and "how the world has changed." The subsequent campaign to integrate fear into everyday life was consequential for public life, domestic policy, and foreign affairs (Kellner 2003).

> ...terrorism discourse singles out and removes from the larger historical and political context a psychological trait (terror), an organizational structure (the terrorist network), and a category (terrorism) in order to invent an autonomous and aberrant realm of gratuitous evil that defies any understanding. The ironic dimension of terrorism discourse derives from its furthering the very thing it abominates. (Zulaika and Douglass 1996 p. 22)

Terrorism discourse referred to a general worldview. Terrorism defined reality, and audiences were reminded of this through repeated showings of the falling twin towers, which quickly became an icon representing constant enemies in a changed world. (As I will note a bit later, these buildings also became an icon for a counter-narrative of alleged government deceit—indeed, culpability—if not the actual planning of the attacks.)

The U.S. position extended well beyond the attacks and those who were responsible, encompassing a redefinition of domestic and international order. Domestic life became oriented to celebrating/commemorating past terrorist acts, waiting for and anticipating the next terrorist act, and taking steps to prevent it.

Seemingly all sides of the terrorism matrix are involved through the Internet. Using blogs enables them to communicate with each other, monitor each other, and even study each other. The Internet, including thousands of blogs, reflected and promoted changes in everyday life and language that

reflected terrorism (and terrorist) disclaimers (for example, "since 9/11...," "...how the world has changed," "...in our time," etc.). International order and conduct consistent with the domestic definition of a "terrorism world," as well as an expansive claim that the "new world" was governed by evil terrorists rather than political gamesmanship. Indeed, there were blogs about blogs (see, for instance, http://terrorism.about.com/od/blogs/Blogs_on_terrorism_the_War_on_Terror_Homeland_Security_and_Iraq.htm) where Web surfers could harness hundreds of blogs on topics ranging from "arms control" to "counter terrorism" to "in case of emergency." Other reports suggest that terrorists are using blogs to plot future attacks. Conversely, the U.S. military and government, in their ever-expanding surveillance operations, plan to monitor blogs to look for key words and other clues (e.g., purchases of large amounts of fertilizer) to thwart future attacks. Indeed, the government has provided research grants and continues to solicit academics and independent contractors to develop monitoring software. While some skeptics contend that a lot of postings are fantasy and role playing, others adopt the surveillance script being written by control agents charged with peering through online formats and information. The creative capacity to respond to such requests and harness ample research support led one Internet sleuth to claim that he had identified 500,000,000 terrorist pages and postings (Frank 2008). This is a clear indication of the reflexive character of information technology and how it has been infused with the quest for terrorists and terrorism.

Good and evil turned on terrorism. International borders, treaties, and even U.S. constitutional rights were mere symbols that could interfere in the struggle against the single greatest threat to civilization and "good." Such evil was to be feared and constantly attacked. To be against terrorism and all that it entailed was a mark of legitimacy and membership that would be demonstrated in various ways. Using similar symbols and expressing opposition to terrorism promoted communalism by putting the good of the citizenry over any group or individual (Cerulo 2002).

My argument is that fear, consumption, and war were cast in the emerging and expanding meaning of terrorism (Altheide 1997; Garland 1997; Goffman 1974; Schwalbe 2000). Audience familiarity with terrorism traded on decades of news and popular culture depictions of crime myths about the "crime problem," crime victims, and the drug war (Kappeler et al. 1999).

(1) Fear supports terrorism as a condition.

Fear played an important role in the social construction of terrorism. The meaning of the attacks was constructed from the context of previous domestic and international events and especially well-established cultural narratives surrounding fear, justifying it, and the place of fear in the lives of many citi-

zens. While most popular culture accounts of fear have been linked to crime, especially various drug wars, the 9/11 attacks offered an alternative enemy, terrorists. President Bush initially referred to the attackers as "those folks," then "evil ones"; he referred to the hijackings as a "terrorist attack" and, later, an "act of war." The 9/11 attacks inspired political decision-makers to generalize and promote simplistic definitions of the situation in the mass media in answer to the questions: what has happened, who is to blame, what should be done about it, who should do it, who should support such action, and, most important, how will life change as a result of each of these definitions.

A history of numerous "crises" and fears involving crime, violence, and uncertainty was important for public definitions of the situation after 9/11. A major source of insecurity was a pervasive fear that was promoted in news reports, popular culture, and politicians' mantras about the "cure" for what ails America (Shapiro 1992).

During the critical eight-month period between the 9/11 attacks and the U.S. invasion of Iraq, the American news media essentially repeated administration claims about terrorism and Iraq's impending nuclear capacity (MacArthur 2003). Rarely has television functioned so poorly in an era of crisis, generating more heat than light; more sound, fury, and spectacle than understanding; and more blatantly grotesque partisanship for the Bush Administration than genuinely democratic debate over what options the country and the world faced in the confrontation with terrorism (Kellner 2003 p. 69).

With few exceptions, the criticism was directed at the detractors. Academics and other commentators were targeted for their critical comments, even though they were not well publicized. One non-profit group, the American Council of Trustees and Alumni (one of its founding member is Lynn Cheney, wife of Vice President Dick Cheney), posted a Web page accusing dozens of scholars, students, and a university president of unpatriotic behavior, accusing them of being "the weak link in America's response to the attack..." and of invoking "...tolerance and diversity as antidotes to evil" (Eakin, 2001).

(2) Consumption and giving were joined symbolically with terrorism.

Unlike reactions to previous "external attacks" (for example, Pearl Harbor) that stressed conservation, personal sacrifice, and commitment, a prevailing theme of consumption-as-character and financial contributions as commitment and support pervaded mass-media messages surrounding the 9/11 attacks. Advertising and programming served to normalize the terrorist condition. These messages made giving and buying commensurate with patriotism and national unity (Espeland 2002). A nation's grief was directed toward giv-

ing and spending dollars. Cultural scripts of generosity and sympathy were processed through organizational entertainment formats emphasizing market participation and consumption (Kingston 2002 p. CP1).

(3) The absence of a clear target for reprisals contributed to the construction of broad symbolic enemies and goals referred to as "terrorism."

The politics of fear was central to commensuration practices in forging a national identity. This was accomplished symbolically by expanding the tragic events into an interpretive scheme that connected attacks with renewal, revenge, and deference to leaders who would attack the enemy and save us from other attacks. The communal reaction was informed by drawing on national experiences of fear, consumption, and the role of national leadership in molding a response that would also constitute and justify future actions and relationships with other nations.

While the military-media complex familiarized audiences with coalitions against evil, the collective response to the terror attacks was framed as a communal patriotic experience that provided opportunities to "come together" and be "united" in a "coalition of war and humanitarianism" (Shapiro 2002). Numerous messages also appealed through nostalgia to a U.S. past of moral and military dominance, authentic life styles, and traditional values (e.g., family, respect), as well as institutions of social control (e.g., police, fire departments, and military).

National symbols were renewed through the mournful language of victims and vengeful promises of future action by the military on our behalf. Leaders, with the aid of the mass media, repeatedly bolstered the assertion that the moment of attack and tragedy was an opportunity for Americans to renew their commitments to freedom and the American way of life. As noted above, this could be demonstrated by giving, identifying with the "9/11 victims," and becoming even more resolute in taking action to promote Americanism, avenge the deaths, and—above all—attack "evil" so that these events would never be repeated.

Patriotism was connected to an expansive fear of terrorism and the enemies of the United States. The term "terrorism" was used to encompass an idea, a tactic or method, and, ultimately, a condition of the world. The waging of the "War on Terror" focused on the "idea" and "the method," depending on the context of discussion and justification. The very broad definition of terrorism served the central authorities' purposes while also justifying the actions of others (for example, Israel) in their own conflicts (Robin 2002). The mass media were key contributors.

Numerous public opinion polls indicated that audiences were influenced by news-media reports regarding the attacks as well as the interpretations of

the causes, the identification of the culprits, and, ultimately, the building of support for various U.S. military actions. For example, one study of the perceptions and knowledge of audiences found that gross misperceptions of key facts were related to support for the war with Iraq. Misperceptions were operationalized as stating that clear evidence was found linking Iraq to Al Qaeda, that weapons of mass destruction had been found, and that world opinion favored the Iraq War. Many of these misperceptions were found to correspond with the content of news reports, particularly those of Fox News. The authors of that study conclude:

> From the perspective of democratic process, the findings of this study are cause for concern.... What is worrisome is that it appears that the President has the capacity to lead members of the public to assume false beliefs in support of his position.... In the case of the Iraq War, among those who did not hold false beliefs, only a small minority supported the decision to go to war.... It also appears that the media cannot necessarily be counted on to play the critical role of doggedly challenging the administration. (Kull 2002 p. 596–597)

The White House's influence on news content was aided by other government and military officials who also dominated news reports about terrorism and fear.

> ...But how men and women interpret and respond to their fear—these are more than unconscious, personal reactions to imagined or even real dangers. They are also choices made under the influence of belief and ideology, in the shadow of elites and powerful institutions. There is, then, a politics of fear. Since September 11, that politics has followed two distinct tracks: First, state officials and media pundits have defined and interpreted the objects of Americans' fears—Islamic fundamentalism and terrorism—in anti-political or non-political terms, which has raised the level of popular nervousness; and, second, these same elites have generated a fear of speaking out not only against the war and US foreign policy but also against a whole range of established institutions. (Robin 2002)

■ Terrorism and the Drug War

The drug war and ongoing concerns with crime contributed with terrorism to the expansion of fear. Messages demonizing Osama bin Laden, his Taliban supporters, and "Islamic extremists" linked these suspects with the destructive clout of illegal drugs and especially drug lords. News reports and advertisements joined drug use with terrorism and helped shift "drugs" from criminal activity to unpatriotic action. As the destructive acts were defined as "war" rather than "attacks," it became apparent that the propaganda about one war would replicate propaganda about the other. By this I refer to the demonization of drugs/terrorists, the call for harsh measures against both, and the

unanimity—especially among news media—that force was the (*Dallas Morning News*, March 14, 2002, KO487, [reprinted in *The Arizona Republic*, March 14, 2002, p. A8). A $10-million ad campaign promoted the message from President Bush, "If you quit drugs, you join the fight against terror in America."

The rhetoric was strong and the media loved it, but interdiction was tempered by political considerations. The connection of terrorism to drugs was repeated often after 9/11, but very little action was taken to stem the flow of hard drugs from Afghanistan, where nearly 90% of the world's heroin is produced. And notwithstanding the excerpts below, there was very little media coverage about the way in which the United States was all but turning its back on the production of this deadly crop. There was little doubt that the bountiful crop of heroin produced year after year could be destroyed by coalition firepower, but this destruction would deprive war lords of tremendous profits and power, because opium is Afghanistan's major cash export. The U.S. and coalition forces needed to gain favor with these drug growers and dealers, so they had to be very cautious, offering cash and other incentives to discourage production. The result at the end of 2008 was the largest stockpiling of heroin in decades:

> Afghan opium poppy cultivation grew 17 percent last year, continuing a six-year expansion of the country's drug trade and increasing its share of global opium production to more than 92 percent, according to the 2008 World Drug Report, released Thursday by the United Nations.
>
> Afghanistan's emergence as the world's largest supplier of opium and heroin represents a serious setback to U.S. policy in the region. The opium trade has soared since the U.S.-led 2001 overthrow of the Taliban, which had eradicated almost all of the country's opium poppies. The proceeds from the illicit trade are helping finance a resurgent Taliban that is battling U.S. and allied troops.
>
> The Taliban earned $200 million to $400 million dollars last year through a 10 percent tax on poppy growers and drug traffickers in areas under its control, Antonio Maria Costa, executive director of the U.N. Office of Drugs and Crime, said in an interview. He estimates that Afghan farmers and drug traffickers last year earned $4 billion, half of the country's national income. (Lynch 2008)

The irony was not lost on coalition forces, which tried to understand the contradictions of global warfare in the context of global markets. A rare article on what amounts to the coalition support of the heroin trade noted that the Taliban were making millions of dollars a year by providing protection for the farmers and transport of their deadly crop, adding:

> Yet the Marines are not destroying the plants. In fact, they are reassuring villagers the poppies won't be touched. American commanders say the Marines would

only alienate people and drive them to take up arms if they eliminated the impoverished Afghans' only source of income. Many Marines in the field are scratching their heads over the situation.... "It's kind of weird. We're coming over here to fight the Taliban. We see this. We know it's bad. But at the same time we know it's the only way locals can make money," said 1st Lt. Adam Lynch, 27, of Barnstable, Mass. (Straziuso 2004).

Many of these reports were still framed as part of the war on terrorism, and protecting farmers from growing poppies for heroin was tagged as a tactic in this ongoing battle.

■ The Expanding Definition of Terrorism

Many countries supported the proposition that terrorism is a condition. Numerous "internal" conflicts and revolutionary movements were classified as "terrorism," and any government that opposed them would, presumably, be joining the United States in its fight against global terrorism. Within a matter of days, countries dealing with revolutionary movements within their own borders, including Colombia, Peru, and Israel, vowed to join the United States in its fight against terrorism (Bennett 2001). Placing virtually all "opposition" forces in the terrorist camp was consistent with the military-media script of pervasive fear and opposition. The serious opposition that disappeared with the end of the Cold War was reconstituted worldwide as "global terrorism." And it was working well. For example, in 2008, border conflicts in South America involving Colombian forces chasing rebels into Ecuador and Venezuela, which responded by mobilizing their troops, were condemned by the Organization of American States (OAS), with the United States being the only nation that did not condemn Colombia.

> The Venezuelan mobilization drew a rebuke from the Bush administration, which has portrayed Colombia as an ally in need of a trade deal that has been delayed because of concerns over killings of Colombian trade union officials.

> "We do think it's curious that a country such as Venezuela would be raising the specter of military action against a country who was defending itself against terrorism," said Dana Perino, the White House spokeswoman. "I think that says a lot about Venezuela." (Romero 2008)

Casting terrorism as a condition of the world not only led to an expanded use and application of the word "terrorism" to a wide range of activities; it also contributed to associating terrorism more closely with victims and victimization.

With network and local nightly newscasts draped in flag colors, lapel flags, and patriotic slogans reporting events primarily through the viewpoint

of the United States (that is, "us" and "we"), news organizations presented content and form that was interpreted by the publisher of *Harper's* as sending "...signals to the viewers to some extent that the media are acting as an arm of the government, as opposed to an independent, objective purveyor of information, which is what we're supposed to be" (Rutenberg 2001).

The impact of media coverage of terrorism on everyday language is examined in more detail in Chapter 3, which documents how terrorism became more closely linked to victimization through extensive news reporting. A study of news reports from five newspapers 18 months prior to 9/11 and 18 months after 9/11 showed that the terms "crime," "victim," and "fear" are joined with news reports about terrorism to construct public discourse that reflects symbolic relationships about order, danger, and threat that may be exploited by political decision-makers. For now, it is important to stress that terrorism was a relatively new and bold connection for fear. This included a few articles that were critical of the government's use of fear to exact more social control, but the overwhelming majority demonstrated that terrorism was bonded to the discourse of fear.

The world of popular culture and news that stresses crime and victimization promotes the pervasive awareness of "victimage" that is easily cultivated by officials who respond to terrorist acts. Victims abound in American life. Victims are but the personal side of crisis; a crisis is where victims reside (Chermak 1995; Chiricos et al. 1997; Dubber 2002; Ferraro 1995; Warr 1987). A personal crisis may affect "one victim," but "crisis" more generally refers to "social crisis," involving many people. All take place in a time of fear. All of this requires that citizens have information about and constant reminders of the pitfalls and hazards of life, whether potential or realized (Ericson and Haggerty 1997). News reports, talk shows, newsmagazine shows, and a host of police and "reality crime dramas" seem to proclaim that everybody is a victim of something, even though they may not know it. The notion that "life is hard" and that things don't always work out the way we'd like seems to be lost on popular culture audiences who clamor for "justice," "revenge," and, of course, redemption, often in the form of monetary reward. And it is not just in the United States.

> It is in the USA that victimhood is most developed as an institution in its own right.... Victimhood is one of the central categories of the culture of abuse.... Celebrities vie with one another to confess in graphic detail the painful abuse they suffered as children. The highly acclaimed BBC interview with Princess Diana symbolized this era of the victim. (Furedi 1997 p. 95)

Victimization was linked to terrorism in order to promote more fear and gain compliance with government directives, but such propaganda efforts are not easily sustained, at least not for an educated and critically thinking minor-

ity of citizens. This disenchantment with government explanations and the identification of clear propaganda ploys, ranging from exaggeration to distortion to lies, began to raise many doubts among citizens. Such doubts were supported and, I shall argue, were largely constituted and shaped by narratives produced through alternative media.

Victimization was not the only emerging subtext about terrorism. There was also conspiracy, grounded in numerous claims and interpretations of the collapsing towers, leading many to scan the web for alternative media sites that would provide the "truth" about what happened on 9/11. I now turn to this counter-narrative and how it was shaped by entertainment-oriented media.

■ News Narratives and Conspiracy

The propaganda project of the Iraq War was profoundly successful, but like all such projects, it ran its course, a route largely configured by mass media formats and content. The events of 9/11 not only became part of the Bush propaganda campaign, but also the counter-narratives. Propaganda invites counter-propaganda and delegitimation. First, I would like to provide an overview of how propaganda can change; second, I will offer a framework for understanding how some of the counter-propaganda of the Iraq War— including 9/11 Truth—is actually organized and configured by the same media logic that was the groundwork for the initial propaganda.

There is a temporal boundary for event propaganda: soon the event changes, the propagandists change (leave office), claims makers may successfully promote counter-claims that receive attention (e.g., no WMDs), and audiences may lose some of their enthusiastic support. Also, other issues are likely to arise, especially since the mass media are always open to fresh crises that instill fear—for example, immigration. While many of the new fear-inspired issues will mix easily with previous scary matters—all oriented to keeping us safe—some divergence can occur, especially with focus and intensity. Immigration is a current example. It is domestic, and even though the symbolism of borders and "invasion" are quite compatible with fear of more attacks by "foreigners," there is clearly a shift in emphasis. Thus, in the run-up to the 2008 presidential election, opinion polls suggested that voters were as concerned about undocumented workers (cast in the U.S. media as "illegal immigrants" or even "aliens") as they were about Al Qaeda.

It is apparent that propaganda is not always successful and that its effects certainly do not last forever. On the one hand, there are individuals with access to different information sources than the established canons that are

aimed by the official soldiers of public information, broadly referred to as the "established media," or more recently the "corporate media." They reject the ideology of the established voices and are predisposed to think critically, and often quite negatively, about the motives and outcome of the hegemonic leaders. Historically, these are the founders of the underground movements, which usually have their own media, conveniently formatted to challenge virtually every statement and supposition of the official voice. This becomes more widespread as communication opportunities expand. The plethora of electronic communication and information devices, channels, and formats for both accessing and disseminating information (e.g., the Internet), greatly expands opportunities for creating information, convincing others, and checking out other points of view.

On the other hand, counter-propaganda appears to follow routinized lines, much like the propaganda narrative it rejects. Indeed, the interaction between the two suggests that the dominant propaganda message provides the hubs, so to speak, on which the opposition turns. The counter-propaganda to the Iraq War appears to have followed suit, although there is yet another consideration. Culture, and particularly dominant narratives, contextualize communication behavior and themes that resonate key points.

The entertainment media in the United States, for example, include numerous renditions of counter-heroes—or anti-heroes—who challenge authority, and by implication the "party line" about priorities, as well as some details about events. Couch et al. (1996) stressed that media were enduring or ephemeral, referential or evocative.

> The fundamental fact of human experience is that when people communicate they construct shared experiences…. What is needed are transactional perspectives which can discover the current forms of communicative conduct and depict the extent and depth of influence the electronic media has had on contemporary societies. (Maines and Couch 1988, pp. 6, 12)

Indeed, in the last decade there have been several popular TV dramas that juxtapose "official" truth with the "real" truth. One is *The X-Files* (with a forthcoming movie), which focuses on corrupt officials in collusion with aliens. A special FBI team—Agents Mulder and Scully—dance through episodes of governmental lying and coverups, kidnapping, and murder, sprinkled with sexual tension. Scully, the skeptical scientist, tries to amass evidence, while her more mystical sidekick, Mulder, has the insights (partly because he had "personal" experience with the protagonists). Of course, Mulder is right. But the key point is that science is hard to please in the movie, especially when it becomes clear just how distorted science is made to appear:

"In the entertainment media, just short of sex and violence, conspiracy- mongering and paranormal fantasy sells," says Paul Kurtz, member of the coordinating committee for the Council for Media Integrity and Professor Emeritus of Philosophy at the State University of New York at Buffalo. "*The X-Files* taps into the fascination market, feeding on viewer gullibility. Science is portrayed as weak and critical thinking is pushed aside."

Magical thinking became a national pastime last summer during the mythological 50th anniversary of the crash of an alien spacecraft at Roswell, New Mexico. According to a Gallup poll, 31% of Americans believed an *actual* alien craft had crashed in 1947. In a previous poll, 71% of Americans indicated a belief in some kind of U.S. government cover-up of UFOs. (http://csicop.org/articles/x-files-movie/)

Another very popular show is the seven seasons of *24*, or 24 hours of "real time" in the adventures of Counter Terrorism Agent Jack Bauer, who battles terrorists but must also contend with corrupt officials—including the president of the United States—who are in cahoots with evildoers. (MI-5 is a similar show that is popular in the UK, Erickson, 2008.) For Jack to stop the impending attacks—and he does not always succeed—it is necessary to bribe, kill, and torture—yes, torture!—many suspects, including fellow agents, who are suspected of being on the dark side. The controlled psychopathology of this media hero is a fascinating topic in its own right, but that's another study.

My project is to clarify how media logic and coherent narratives that manifest that logic, such as *24* and *The X-Files*, contribute to "real-life" support for conspiracy theories about events surrounding 9/11. I will argue that while both propaganda and counter-propaganda are compatible with entertainment-oriented narratives, the latter is particularly intriguing—and usually quite entertaining—because it adds the element of betrayal and intentional misleading. Moreover, I will suggest that the official propaganda of an initial event becomes the foil and standpoint of "them" that counter-propaganda leans on for support, including scripting some details (e.g., "'they' said that all officials were here, but we now know that is not true").

Another observation is that while the two narratives just described gain many supporters, both are distorted, and a third narrative, the sociological account, is not honored by anyone precisely because (in whatever other ways it may be lacking) it is not simple and consistent with media logic and the entertainment perspective. My aim is not to discredit conspiracy theories or to argue against all the various assertions that adherents support, but rather to offer a theoretical framework for understanding its popularity in our mass-mediated age that blends fantasy and reality into something that we are still trying to understand.

My argument in this book is that our media culture favors coherent narratives that may, for our purposes, be encapsulated as "official" and "the truth." Basically, it is an account that has a simple beginning, middle, and end, with clear facts stated that show, for example, that in the case of war, intentional damage was done, we were attacked, and now we must defend ourselves. Righteously. And justly. The official version is coherent but always incomplete, and usually contains many points that are false, and that are toppled from credibility with the emergence of new evidence. I must stress evidence because, as I note in Chapter 4, evidence itself is subject to numerous contexts and contingencies. But I will leave that for now. The official versions—whether of the attack on Pearl Harbor in World War II, the John F. Kennedy assassination, the Vietnam War, or the 2004 presidential election—are generally shown to be more or less incomplete, more or less false, and usually created to mislead the public. The accounts that follow such events are textbook cases of propaganda: an evil enemy is blamed for death and damage to an innocent and righteous victim—us! Neither context, contingency, uncertainty, nor ambiguity is discussed; reports are very coherent and scripted. Incidents that might challenge the dominant narrative are either easily dismissed or shaped by "spin" to be consistent with the major frame. For example, the Iraq War is cast in the major media as a legitimate affair, carried out by well-meaning and disciplined troops who do not kill or maim unnecessarily, and its operations as well planned and rational.

Counter-narratives are also coherent, but they include a basic proposition that the government report is not only inaccurate; it is a lie, intentionally concealing information and "facts" either to protect some people and/or to help justify an action, such as wage war, that might otherwise not be supported. Moreover, research often uncovers that the government was culpable, that is, directly involved in either the planning of a "precipitating event" (such as the fictitious attacks in the Gulf of Tonkin that precipitated the Vietnam War) or played a leading role in covering up information that would compromise or challenge the official version. Of this, there can be no doubt. This poses a paradox: Counter-narratives are decisive in the short run for many audiences (though not all), but they are not carried over to the next similar event (e.g., a precipitating event like the 9/11 attacks) by the mass media, or to the official version of history (Zinn 2003). Stated differently, the dominant narrative takes precedence and starts off the next round of disputes and counter-narratives.

The Iraq War provides what I will call a heuristic case study of counter-narratives. Beginning a few weeks after the 9/11 attacks, a small but steadily growing body of information emerged and expanded over the next six years on numerous alternative media (Internet) sites suggesting that the attacks

were not simply due to "blowback" by Al Qaeda for brutal U.S. policies, particularly the Middle East, but were actually an "inside job" (e.g., 9/11 Truth Commission). Accounts about the nature of the "inside job" varied, but it was heralded as the work of a combination of the CIA, the Bush Administration, and Israel. While it may not be a surprise that a large percentage of the "Arab street" believes this, it is challenging to provide a sociological explanation of why so many Americans believe it as well. The extent of "skepticism" ranges from those who tell pollsters that they do not believe that all of the facts have come out to those who believe that it was planned and carried out by agents of the U.S. government. Wikipedia's summary is illustrative of the claims:

> Many 9/11 conspiracy theorists identify as part of the "9/11 Truth Movement," and their claims often suggest that individuals in the government of the United States knew of the impending attacks and refused to act on that knowledge or that the attacks were a false flag operation carried out by high-level officials in winning the allegiance of the American people in order to facilitate military spending, garner support for Israeli policies towards the Palestinians, the restriction of civil liberties, and/or a program of aggressive and profitable foreign policy... Most members of the 9/11 Truth Movement claim that the collapse of the World Trade Center was the result of a controlled demolition and/or that United Airlines Flight 93 was shot down. Some also contend that a commercial airliner did not crash into the Pentagon; this position is debated within the 9/11 Truth Movement, with many who believe that AA Flight 77 did crash there, but that it was allowed to crash via an effective stand down of the military. (http://en.wikipedia.org/wiki/9/11_conspiracy_theories)

There are numerous 9/11 truth organizations in local communities across the United States. My interest is in the logic in use and the affinity with a simpler coherent counter-narrative.

I attended a conference in Santa Cruz, California (The Santa Cruz Media Strategy Summit, January 25–27, 2008), that dealt primarily with the 9/11 Truth Commission issues, and where I spoke on fear and the media. It was an interesting gathering of about 300 people, some of whom were affiliated with independent media, and some who were well-known film and documentary makers. I found it to be a very worthwhile conference with many interesting, creative, and highly educated people, including several professors from other institutions. There were numerous items available for purchase, including DVDs, CDs, books, posters, and bumper stickers. Informal interviews and observations provided data that inform this analysis.

I was struck by the widespread agreement that not only was there a lot that we did not know about the 9/11 attacks, but that there had been massive deception and a coverup of the basic plot. This was seen as an inside job that was—as noted above—designed to justify various military and foreign policy actions, tighten control by the government in the United States, and lead the

country to world domination. What was most surprising to me was the nearly unanimous view about a conspiracy. Several people whom I specifically asked if anything would convince them that it was not all planned answered an assertive "No." As several people told me—offering an explanation that is in some of the literature—the proof is in the way that all the dots line up, and we just have to connect them. These dots include the lack of adequate warning of the planes en route, the administration not heeding intelligence cautions about the possibility of such an attack, allegations that some people did not go to work in the World Trade Center towers that day, the destruction of the buildings (which are claimed to have been blown up with demolition charges), and so forth. None of these are accepted as coincidence, incompetence, contingency, or half-truths. Rather, one dot is said to confirm the connection of the others. As one man told me, "All you need to do is connect the dots" (or words to that effect). Of course there are unanswered questions. There always are, and I am not naïve enough to suggest that we have learned all the relevant facts involved. My point is that the "theory" is accepted because it is consistent with a coherent narrative. For example, virtually nowhere in the published material and conversations is there an account of how the demolition of the buildings was accomplished, including the following questions: How did the tons of explosives get transported, planted, and concealed over a period of several weeks or longer? Is it possible that this could have gone undetected? Why has no one come forward after all these years? This material is lacking, for the most part, because it is not essential to the narrative.

The focus on counter-propaganda as coherent narrative is also relevant to understanding so-called conspiracy theories, although that is not my main concern. I wish to clarify how popular culture intervenes and shapes actors' perspectives about evidence and accountability and, indeed, offers them some assurance from audiences that they are "making sense," are not "crazy" or "paranoid," etc. Some conceptual separation may be offered by delineating just a few of the characteristics of "conspiracy" theory. While there is a rich literature dismissing "conspiracy theorists" as paranoid, several recent essays offer, in my view, more conceptually integrating analyses. Waters's caricature of articulated counter-beliefs as "ethnosociologies" emphasizes perspective and opposition:

> Whereas there are few amateur physicists or chemists in our society driving taxicabs, running elevators, and hosting radio shows, one may notice that there are many, many amateur sociologists. These individuals have ideas about why the divorce rate is high, why kids drop out of school, why the rich are rich and the poor are poor, and, most important here, why Whites have so much and Blacks have so little. The explanations or theories that these everyday people hold to make sense of their social worlds are what I call ethnosociologies.

Conspiracy theories may be understood as one class of ethnosociology. *They explain social misfortunes by attributing them to the deliberate, often secretly planned, actions of a particular group of people.* (Waters 1997 p. 113; my emphasis)

Actually, with apologies to Professor Waters, there are also many amateur physicists who contribute to numerous blogs and/or engage in millions of conversations daily about the true cause of the collapse of the World Trade Towers.

Other scholars take an additional step and focus on the framing of conspiracy theorists as a rhetorical strategy used to discredit an opposing point of view. Husting and Orr see a labeling process at work that excludes and reframes critical arguments about power, corruption, and motive, while calling into question the competence of the questioner (Husting and Orr 2007). Such discrediting of a contrary view is quite commonly executed by such descriptors as "nuts," "kooks," and worse. These are very important concerns, and in order to avoid any untoward characterization, I will not refer to some opposition here as "conspiracy theorist" but will prefer the term "counter-narrative."

I wish to suggest that popular culture, and especially the kinds of programs I noted above (such as *The X-Files* and *24*) contribute to coherent counter-narratives, although they certainly did not sire them. As noted, there have been many events in U.S. history that, in retrospect, were conspiratorial. And mass-media depictions of these events document them in an entertainment format suited for mass consumption. "Watergate," for example, quickly became part of the U.S. lexicon, and "-gate" was added to dozens of suspected corruptions and scandals (such as Lancegate, Milkgate, Contragate, Irangate, and Spygate [NFL football's "spying charges"]). Audiences can share this reproduced history through media technologies. Indeed, counter-narratives are offered today in bits and pieces through electronic media, including the Internet, but are also available for purchase or free distribution on CDs, DVDs, and podcasts. I met several people at the 9/11 Truth Conference who gladly shared copies of DVDs and CDs. Indeed, one man made 100 copies of a DVD to provide to fellow workers and casual acquaintances. Meaning is provided by the visual nature of the material, along with the edited narrative linking discrete pieces together. It all fits.

The mass media and popular culture contribute to the definition of situations and audience expectations and criteria for self-presentations for themselves and others. As audiences spend more time with these formats, the logic of advertising, entertainment, and popular culture becomes taken for granted as a "normal form" of communication. As Carl Couch (1995) noted, evocative rather than referential forms of communication now dominate the meaning landscape. The referential forms fall before the electrified rolling formats that

change everyday life with the look and swagger of persona, entertainment, and action. Entertainment media are evocative rather than referential, and entertainment media—including music— are increasingly visual. The challenge is to take seriously the implications of "believing is seeing" (rather than the converse) for social order. Visual meaning is intriguing and often convincing, especially if it is about something that we already support. Images are convincing, especially if they are placed in the context of Internet images, wherein even words are images on a screen, produced with keyboards and packaged in grammatically correct sentences. The format is truth-lending and credible, if not itself convincing; it looks right. The truth of the matter is implicit, especially when packaged in coherent narratives, authored by experts. This seems to be particularly true when the experts are scientists with PhDs in physics and engineering. Their credentials reinforce the credibility of the narrative.

Narratives move and change, and as some members either doubt or are accused of doubting part of the dominant narrative, they become suspect by others still committed to the overarching themes. The effect of the commitment to disregard any evidence that challenges the dominant narrative can be seen both within the Bush Administration and the counter-propagandists, including some affiliated with 9/11 Truth and related organizations. Thus, previous Bush stalwarts such as Richard A. Clarke, who served four presidents as a counter-terrorism expert, broke ranks with the Bush Administration's handling of the Iraq War (Clarke 2004) and was roundly castigated by former superiors. In a related development, David Kubiak, an early organizer for 9/11 Truth, was quoted as saying that he did not believe that 9/11 was an inside job, although he continued to work very diligently for full disclosure about many details of the 9/11 attacks and the government's response. He was vehemently criticized for breaking ranks, and one blog suggested that he was a plant to subvert the movement:

> First, we have proof that the "truth movement" in general is controlled at the highest levels by COINTELPRO forces. The single most identifiable fact of that proof is David Kubiak. The executive director of "911truth.org" is on record as telling the NY times that Sept 11 was *not* an inside job. How does an openly declared supporter of the *full* official story, become executive director of an organization which claims to be the umbrella movement for all those seeking the "truth" of the event? (http://www.veronicachapman.com/nyc911/Jones-Kubiak.htm)

Thus, truth splintered or fractured is truth broken, and any who bear witness to such revisions are repulsed.

One way in which power is manifested is by influencing the definition of a situation. Cultural logics inform this process and are therefore powerful,

but we are not controlled by them, and certainly not determined, particularly when one's effective environment contains meanings to challenge the legitimacy, veracity, and relevance of certain procedures. Resistance can follow, but it is likely to be formatted by ecologies of communication. Indeed, the contribution of expanded discourses of control to the narrowing or expansion of resistance modes remains an intriguing area of inquiry:

> We must locate the modes in which believing, knowing, and their contents reciprocally define each other today, and in that way try to grasp a few of the ways believing and making people believe function in the political formations in which, within this system, the tactics made possible, by the exigencies of a position and the constraints of a history are displayed. (Couch 1995 p. 185)

In sum, different narratives were presented about 9/11. This chapter has suggested that there was administration propaganda, the counter-narrative(s), and the sociology narrative (story), which is usually neglected. The post-9/11 mass-media developments are consistent with an ecology of communication perspective that posits a relationship between information technology, communication formats, and social activities, including message content. As part of the "sociology story" about 9/11 and beyond, an ecology of communication framework seeks to find consonance in what appear to be greatly disparate accounts of events, if not completely different versions of reality. After 9/11, the mass media initially framed terrorism in very simplistic terms that promoted government propaganda campaigns. However, the expansion of new technologies (i.e., the Internet—especially its capacity for videos) and the emergence of new formats (e.g., blogs), contributed to counter-narratives that challenged the official statements and helped spawn publics that became more organized and politically active in their opposition (e.g., 9/11 Truth). The dense flow of these messages—and the discussions that they generated in the United States and throughout the world—"fed back" to established media channels and, in some cases, were discussed and challenged in talk shows. Mistrust and charges of deceit, if not conspiracy, were underlying themes of the counter-narratives. Competing claims about truth and evidence were central to the three narratives. The challenge of understanding the human dimensions and practical uses of evidence and interpretation will be addressed in Chapter 3.

3

■ **Terrorism and the Politics of Fear**

"Al Qaeda is to terror what the Mafia is to crime."

—*George W. Bush*

"If we make the wrong choice, the danger is that we will get hit again, that we'll be hit in a way that is devastating."

—*Dick Cheney*

"He has conviction.... He's taking the fight to the terrorists.... I love my kids. I want my kids to be safe."

—*Undecided voter "leaning" toward Bush*

One of the most important effects of the mass-media coverage of 9/11 was a change in public perceptions about fear and danger that is partially reflected in changes in public discourse, or what people call things.

George W. Bush's reelection in 2004 was preordained when his handlers were able to convince true believers (Hoffer 1951) that citizens killed in the 9/11 attacks were victims of Al Qaeda-aided-by-Iraq-that-had-weapons-of-mass-destruction. This chapter shows how news reports about terrorism in five nationally prominent U.S. newspapers reflect the terms and discourse associated with the politics of fear, or decision-makers' promotion and use

of audience beliefs and assumptions about danger, risk, and fear in order to achieve certain goals. Qualitative data analysis of the prevalence and meaning of the words fear, victim, terrorism, and crime 18 months before and after the attacks of September 11, 2001, shows that terrorism and crime are now linked very closely with the expanding use of fear and victimization.

Many Americans—and the majority of Bush supporters—continued to believe that Iraq was involved in the 9/11 hijackings and was prepared to use stockpiles of weapons of mass destruction against the United States, despite incontrovertible evidence to the contrary (Kull 2004; Kull et al. 2002). It was not evidence that drove Bush supporters; it was emotions consonant with the mass-mediated politics of fear nurtured by decades of crime-control efforts. The architect of the 9/11 attacks, Osama Bin Laden, remains free (at this writing), while an estimated 15,000 to 100,000 Iraqis, mostly women and children, have been killed (BBC 2004). As Vice President Cheney's comment (above) indicates, the Bush campaign celebrated the victims of 9/11 and warned that more U.S. citizens would die if the Iraq War did not continue. Fear has great political utility in joining terrorism with non-conformity, deviance, and crime as threat (Hornqvist 2004). The politics of fear has transformed terrorism as a tactic to terrorism as a world condition, and now, as Giroux suggests, "the rhetoric of terrorism is important because it operates on many registers to both address and inflict human misery" (Giroux 2003 p. 5).

This chapter examines these events as products of the politics of fear, or decision-makers' promotion and use of audience beliefs and assumptions about danger, risk, and fear in order to achieve certain goals. The particular focus is on how fear as a topic was presented in news reports about terrorism and victimization and, more generally, how news reports about terrorism in five nationally prominent newspapers reflect the terms and discourse associated with the politics of fear. I wish to examine the conceptual and empirical support for the politics of fear thesis, which may be stated as follows: The terms *crime, victim,* and *fear* are joined with news reports about terrorism to construct public discourse that reflects symbolic relationships about order, danger, and threat that may be exploited by political decision-makers.

The news media's use of these terms is tied to a long-standing linkage of fear and victimization with crime and insecurity. As (Hornqvist 2004) suggests, terrorism is constructed as an indication that law alone is not enough to provide security.

> The law is being replaced by other steering mechanisms. Force is being implemented according to a new model. Interventions are taking place against undesirable behaviours that do not constitute crimes and on the basis of a different objective than ensuring that people act in accordance with the law. The security mentality has ruptured the law; or, more correctly, the law has been undermined

from two directions, from above and below. It may seem absurd that a single area of policy should cover everything from truancy and drug sales to acts of terror. (Hornqvist 2004 p. 37)

Giroux (2003) and others have argued that governmental actions against terrorism are consistent with policies against youth and their problems that challenge the very assumptions on which law rests.

> The greatest challenge Americans face does not come from crazed terrorists, but in the ongoing battle to expand and deepen the principles of justice, freedom, and equality on behalf of all citizens—especially young people, who are quickly becoming an abandoned generation. (Giroux 2003 p. xx)

Propaganda research shows that decision-makers, who serve as key news sources, can shape perceptions of mass audiences and promote acquiescence to state control measures (Ellenius and Foundation 1998; Gerth 1992; Jackall 1994). The public information about the need for extraordinary measures to combat fear has been fueled by government and police officials, who serve as dominant news sources, and therefore are significant actors in defining problems and setting political agendas (Chiricos 2000; Kappeler et al. 1999; Surette 1998). An expansive use of the word fear in news reports has been documented (Altheide 2002; Altheide and Michalowski 1999; Furedi 1997; Glassner 1999). Indeed, the extensive use of fear to highlight crime news has produced a discourse of fear, which may be defined as the pervasive communication, symbolic awareness, and expectation that danger and risk are a central feature of the effective environment, or the physical and symbolic environment as people define and experience it in everyday life. Journalistic accounts about terrorism reflect news organizations' reliance on official news sources to provide entertaining reports compatible with long-established symbols of fear, crime, and victimization about threats to individuals and the United States in the "fight against terrorism." I argue that tying terrorism coverage to an expansive discourse of fear has contributed to the emergence of the politics of fear, or decision-makers' promotion and use of audience beliefs and assumptions about danger, risk, and fear in order to achieve certain goals. This research tracks the results of these efforts 18 months after the September 11, 2001, attacks and compares this usage of fear with results 18 months prior to those attacks in order to describe shifts in public discourse about fear. An overview of the discourse of fear will be followed by an elaboration of the politics of fear and a discussion of the materials and content analysis of news reports. Data about the emerging politics of fear and how it is manifested in news coverage involving fear, victimization, terrorism, and crime will then be presented. A major point of this research is that news

organizations' reliance on government officials as news sources promoted reports that joined fear to terrorism and victimization.

■ News and the Discourse of Fear

The common thread for most scholarly and popular analysis of fear in American society is crime and victimization. Social constructionist approaches to the study of social problems and emergent social movements stress how mass-media accounts of crime, violence, and victimization are simplistic and often de-contextualize rather complex events in order to reflect narratives that demonize and offer simplistic explanations (Best 1999; Best 1995; Ericson et al. 1991; Fishman and Cavender 1998; Johnson 1995) that often involve state intervention, while adding to the growing list of victims.

The discourse of fear has been constructed through news and popular culture accounts. The main focus of the discourse of fear in the United States for the last 30 years or so has been crime. News reports about crime and fear have contributed to the approach taken by many social scientists in studying how crime is linked with fear. Numerous researchers link crime, the mass media, and fear (Chiricos et al. 1997; Ericson 1995; Ferraro 1995; Garland 1997; Pearson 1983; Shirlow and Pain 2003). There is also an impressive literature on crime, victimization, and fear (Baer and Chambliss 1997; Chiricos et al. 1997; Ferraro 1995; Warr 1987; Warr 1990; Warr 1992). Other researchers have examined the nature and consequences of fear in connection with crime, but also in relationship to political symbols and theories of social control (Altheide 2002; Furedi 1997; Garland 1997; Glassner 1999; Massumi 1993; Moehle 1991; Naphy and Roberts 1997; Russell 1998).

Crime and terrorism discourses are artfully produced. The most pervasive aspect of this "victim" perspective is crime. Giroux argues that a sense of urgency prevails such that time itself is speeded up, in what he refers to as "emergency time." "Emergency time defines community against its democratic possibilities, detaching it from those conditions that prepare citizens to deliberate collectively about the future and the role they must play in creating and shaping it" (Giroux 2003 p. 8).

Criminal victimization, including numerous crime myths (e.g., predators, stranger-danger, random violence, etc.) (Best 1999) contributed to the cultural foundation of the politics of fear, particularly the belief that we were all actual or potential victims and needed to be protected from the source of fear— criminals or terrorists (Garland 2001). Politicians and state control agencies, working with news media as "news sources," have done much to capitalize

on this concern and to promote a sense of insecurity and reliance on formal agents of social control—and related businesses—to provide surveillance, protection, revenge, and punishment to protect us, to save us (Chiricos et al. 1997; Ericson et al. 1991; Surette 1992). Hornqvist suggests that a security perspective overrules mere law, especially as numerous instances of deviance and violations are perceived to be threatening social order.

> First, the central factor is not what acts an individual may have committed, but rather which group an individual may belong to. Is he a drug addict? Is she an activist? Refugee? Muslim? Arab?... Second, according to security logic, it is not the behaviour itself that is of interest, but rather what this might be perceived as indicating: does it mean that the individual constitutes a risk?... Finally, an intervention against an individual or group need not be preceded by any court determination. Instead, a decision made by an individual civil servant is sufficient. The intervention constitutes an administrative measure based on a general assessment of risk, with the question of guilt being only one of many factors weighed in the decision. (Hornqvist 2004 p. 39)

The mass media and popular culture are best conceived of as key elements of our symbolic environment, rather than independent causes and effects. News does not merely set agendas (Iyengar 1987; Shaw and McCombs 1977); rather, consistent with symbolic interaction theory, news that relies on certain symbols and promotes particular relationships between words, deeds, and issues also guides the perspectives, frameworks, language, and discourse that we use in relating to certain problems, as well as related issues. My focus in this chapter is on news that guides discourse.

Social meanings are constructed through news reports by associating words with certain problems and issues. Repeated use of certain terms is linked to public discourse (Altheide and Michalowski 1999; Beckett 1996; Ekecrantz 1998; Fowler 1991; Gamson et al. 1992; Potter 1987; van Dijk 1988; Zhondang and Kosicki 1993). Tracking the emergence of new "connections" over a period of time is one way to assess the process of the social construction of reality. Research documents how fear and crime have been joined. Crime and threats to the public order—and therefore all good citizens—are part of the focus of fear, but the topics change over time. What they all have in common is pointing to the "other," the outsider, the non-member, the alien. However, Schwalbe et al. (2000) have shown that "othering" is part of a social process whereby a dominant group defines into existence an inferior group. This requires the establishment and "group sense" of symbolic boundaries of membership. These boundaries occur through institutional processes that are grounded in everyday situations and encounters, including language, discourse, accounts, and conversation. Knowledge and skill at using "what everyone like us knows" involves formal and informal socialization so that members acquire the coinage of cultural capital with which they can purchase accep-

tance, allegiance, and belonging. Part of this language involves the discourse of fear.

> Discourse is more than talk and writing; it is a way of talking and writing. To regulate discourse is to impose a set of formal or informal rules about what can be said, how it can be said, and who can say what to whom.... Inasmuch as language is the principal means by which we express, manage, and conjure emotions, to regulate discourse is to regulate emotion. The ultimate consequence is a regulation of action....
>
> When a form of discourse is established as standard practice, it becomes a tool for reproducing inequality, because it can serve not only to regulate thought and emotion, but also to identify Others and thus to maintain boundaries as well. (Schwalbe et al. 2000 pp. 433–434)

Fear, crime, terrorism, and victimization are experienced and known vicariously through the mass media by audience members. Information technology, entertainment programming, and perspectives are incorporated into a media logic that is part of the everyday life of audience members.

It is not fear of crime, then, that is most critical. It is what this fear can expand to, what it can become. Sociologists have observed that we are becoming "armored." Social life changes when more people live behind walls, hire guards, drive armored vehicles (e.g., sport-utility vehicles), wear "armored" clothing—No Fear!—(e.g., "big-soled shoes" etc.), carry mace, handguns, and take martial arts classes. Indeed, many symbolic interactionists would assert that acting in certain ways provides the meaning or interpretation of fear. The problem is that these activities reaffirm and help produce a sense of disorder that our actions perpetuate. We then rely more on formal agents of social control (FASC) to "save us" by "policing them," the "others," who have challenged our faith.

The major impact of the discourse of fear is to promote a sense of disorder and a belief that "things are out of control." Ferraro (1995) suggests that fear reproduces itself, or becomes a self-fulfilling prophecy. Social life can become more hostile when social actors define their situations as "fearful" and engage in speech communities through the discourse of fear. And people come to share an identity as competent "fear realists," as family members, friends, neighbors, and colleagues socially construct their effective environments with fear. Behavior becomes constrained, community activism may focus more on "block watch" programs and quasi-vigilantism, and we continue to avoid "downtowns" and many parts of our social world because of "what everyone knows." In short, the discourse of fear incorporates crime reflexively; the agents, targets, and character of fear are constituted through the processes that communicate fear.

Fear is part of our everyday discourse, even though we enjoy unprecedented levels of health, safety, and life expectancy. And now we "play with it." More of our "play worlds" come from the mass media. News reports are merging with TV "reality programs" and crime dramas "ripped from the front pages" that in turn provide templates for looking at everyday life (Cavender 2004; Fishman and Cavender 1998). The increase in "false reports" is an example. We have long known that some officials use fear to promote their own agendas. The expanding interest in fear and victim also contributes to: (1) audiences who play with the repetitive reports as dramatic enactments of "fear and dread in our lives," and (2) individual actors who seek roles that are accepted as legitimate "attention-getters" in order to accomplish favorable identity *vis-à-vis* particular audience members.

Stories of assaults and kidnappings blasted across headlines—even when false or greatly distorted—make it difficult for frightened citizens to believe that schools are one of the safest places in American society. It is becoming more common to "play out" scenarios of danger and fear that audiences assume to be quite commonplace. Researchers find that many of these hoaxes rely on stereotypes of marginalized groups, e.g., poor people and racial minorities. The oppositions that become part of the discourse of fear can be illustrated in another way as well. Repetitious news reports that make connections between fear, children, schools, and suspected assailants who fit stereotypes are easy to accept even when they are false. Katheryn Russell's (1998) study of 67 publicized racially tinged hoaxes between 1987 and 1996 illustrates how storytellers frame their accounts in social identities that are legitimated by numerous reports and stereotypes of marginalized groups, e.g., racial minorities. For example, in 1990 a Washington University student falsely reported that another student had been raped by two black men with "particularly bad body odor," in order to "highlight the problems of safety for women."

Examples of crime hoaxes abound, but so do false terrorism reports. I have more in mind than the hundreds of "false reports" of anthrax that followed the 9/11 attacks on the United States. "When people 'pretend' that they have been assaulted, abducted, or in some way harmed by strangers, they are acting out a morality play that has become part of a discourse of fear, or the notion that fear and danger are pervasive. Indeed, a student's project in New York City involved placing 'black boxes' in the subway in order to elicit citizens' concerns" (Kimmelman 2002).

> At the same time it turned out that those 37 black boxes with the word "Fear" on them, which mysteriously turned up attached to girders and walls in the Union Square subway station last Wednesday, were, as you may have guessed from the start, an art project. The boxes, which spread panic and caused the

police to shut the station for hours and call in the bomb squad, turn out to be the work of Clinton Boisvert, a 25-year-old freshman at the School of Visual Arts in Manhattan, who surrendered Monday to the Manhattan district attorney's office, which intends to prosecute him on charges of reckless endangerment.... (Kimmelman 2002 p. 1)

■ Methods and Materials

This chapter draws from several research projects that used qualitative content analysis (QCA) to track the discourse of fear over time and across different topics (e.g., crime, drugs, children, immigrants, etc.) presented in various newspapers (Altheide 1996; Altheide 1997; Altheide and Michalowski 1999). One way to approach these questions is by "tracking discourse," a qualitative document analysis technique that tracks words, themes, and frames over a period of time, across different issues, and across different news media.

The aim in this study was to compare coverage of terrorism with crime and victim and note how these may be related to use of the word fear. The project examines the conceptual and empirical support for the politics of fear thesis, which may be stated as follows: The terms *crime, victim,* and *fear* are joined with news reports about terrorism to construct public discourse that reflects symbolic relationships about order, danger, and threat that may be exploited by political decision-makers. The research design called for comparing several newspapers' coverage of fear, crime, terrorism, and victim (in headlines and reports) at two 18-month time periods: Time 1 was from March 1, 2000, to September 10, 2001; Time 2 was from September 12, 2001, to April 1, 2003. Eighteen months before and after September 11, 2001, provides sufficient time to track a change in discourse while avoiding brief spikes in reporting that may be associated with any event. The research design also called for including several major newspapers. The first newspaper examined was *The Los Angeles Times* (LAT). Subsequently, students in a seminar project obtained data from the *New York Times* (NYT), the *Washington Post* (WPost), the *San Francisco Chronicle* (SF Chron), and *USA Today*. News reports were selected using Lexis/Nexis materials and were selected according to search criteria that would identify articles with the words fear, victim, crime, and terrorism in various relationships, or within several words of one another. For example, we examined reports with "fear" in headlines and "victim" in the body of the article.

The politics of fear thesis can be demonstrated by examining the nature and extent of news coverage of fear, crime, terrorism, and victim before and after the attacks of 9/11/01. The discourse of fear is considered to be expanded to incorporate the politics of fear if terrorism and victimization appear closely

associated with fear in a substantial number of news reports after 9/11/01 (Time 2). While some qualitative materials will be presented, the emphasis in this chapter is on the changes in the extent of coverage in news reports linking fear with terrorism and victimization that occurred after 9/11. The way in which news sources contributed to the politics of fear will be followed by an analysis of the increased use of *fear, victim,* and *terrorism* in news reports after 9/11.

■ News Sources and the Politics of Fear

A politics of fear rests on the discourse of fear. The politics of fear serves as a conceptual linkage for power, propaganda, news, and popular culture, and an array of intimidating symbols and experiences such as crime and terrorism. The politics of fear resides not in an immediate threat from an individual leader (e. g., Senator Joseph McCarthy [Griffith 1987]), but in the public discourse that characterizes social life as dangerous, fearful, and filled with actual or potential victims. This symbolic order invites protection, policing, and intervention to prevent further victimization. A public discourse of fear invites the politics of fear. It is not fear *per se* that is important in social life, but rather how fear is defined and realized in everyday social interaction that is important. The role of the news media is very important in carrying selective news sources' messages. News sources are claims-makers, and studies of crime news show that government and police officials dominate how crime is framed (Ericson et al. 1989; Ericson et al. 1987; Surette 1992).

Numerous public opinion polls indicated that audiences were influenced by news-media reports about the attacks as well as the interpretations of the causes, the culprits, and, ultimately, the support for various U.S. military actions. For example, one study of the perceptions and knowledge of audiences and their primary source of news found that gross misperceptions of key facts were related to support of the war with Iraq. Misperceptions were operationalized as stating that clear evidence was found linking Iraq to Al Qaeda, that weapons of mass destruction had been found, and that world opinion favored the Iraq War. Many of these misperceptions were consistent with news reports, particularly with Fox News. The authors conclude:

> From the perspective of democratic process, the findings of this study are cause for concern.... What is worrisome is that it appears that the President has the capacity to lead members of the public to assume false beliefs in support of his position.... In the case of the Iraq War, among those who did not hold false beliefs, only a small minority supported the decision to go to war.... It also appears that the media cannot necessarily be counted on to play the critical role of doggedly challenging the administration. (Kull 2002 p. 596–597)

The White House influence on news content was aided by other government and military officials who also dominated news reports about terrorism and fear.

> ...But how men and women interpret and respond to their fear—these are more than unconscious, personal reactions to imagined or even real dangers. They are also choices made under the influence of belief and ideology, in the shadow of elites and powerful institutions. There is, then, a politics of fear. Since September 11, that politics has followed two distinct tracks: First, state officials and media pundits have defined and interpreted the objects of Americans' fears—Islamic fundamentalism and terrorism—in anti-political or non-political terms, which has raised the level of popular nervousness; and, second, these same elites have generated a fear of speaking out not only against the war and US foreign policy but also against a whole range of established institutions. (Robin 2002)

Newspapers as well as TV network news relied heavily on administration sources that directed the focus and language of news coverage. This was particularly apparent with those persons interviewed. A study by the *Columbia Journalism Review* documented this trend.

> It exacerbates our tendency to rely on official sources, which is the easiest, quickest way to get both the "he said" and the "she said," and, thus, "balance." According to numbers from the media analyst Andrew Tyndall, of the 414 stories on Iraq broadcast on NBC, ABC, and CBS from last September to February, all but thirty-four originated at the White House, Pentagon, and State Department. So we end up with too much of the "official" truth. (Cunningham 2003 p. 24)

An analysis by Fairness and Accuracy in Reporting (FAIR) of network news interviewees one week before and one week after Secretary of State Colin Powell addressed the United Nations about Iraq's alleged possession of weapons of mass destruction found that two-thirds of the guests were from the United States, with 75% of these being current or former government or military officials, while only one—Senator Edward Kennedy— expressed skepticism or opposition to the impending war with Iraq (FAIR 2003).

The news media played a major role in promoting the politics of fear following the 9/11/01 attacks. Dan Rather, CBS anchorman, acknowledged the pressure to comply with propaganda and that many of the tough questions were not being asked. Rather told a British journalist:

> "It is an obscene comparison...but you know there was a time in South Africa that people would put flaming tyres around people's necks if they dissented. And in some ways the fear is that you will be necklaced here, you will have a flaming tyre of lack of patriotism put around your neck," he said. "Now it is that fear that keeps journalists from asking the toughest of the tough questions.

... It starts with a feeling of patriotism within oneself. It carries through with a certain knowledge that the country as a whole—and for all the right reasons—felt and continues to feel this surge of patriotism within themselves. And one finds oneself saying: "I know the right question, but you know what? This is not exactly the right time to ask it...."

"Limiting access, limiting information to cover the backsides of those who are in charge of the war, is extremely dangerous and cannot and should not be accepted. And I am sorry to say that, up to and including the moment of this interview, that overwhelmingly it has been accepted by the American people. And the current administration revels in that, they relish that and they take refuge in that." (Engel 2002)

Even news magazines like *Newsweek* concurred that the news was being managed:

News management is at the heart of the administration's shake-up of Iraq policy. The National Security Council recently created four new committees to handle the situation in Iraq. One is devoted entirely to media coordination—stopping the bad news from overwhelming the good. (*Newsweek*, October 27, 2003)

Very dramatically, journalists cried on camera, wore flag lapels, and often referred to those involved in planning and fighting the Afghanistan and Iraq Wars as "we." Moreover, they invoked routinely the claim that the "world is different," security and safety can no longer be taken for granted, and that many sacrifices would have to be made (Altheide 2004). Numerous observers raised serious questions about the role that journalism played in covering the attacks, the wars with Afghanistan and Iraq that followed, as well as the increased surveillance and control of United States citizens.

The major media fully ignored gangbuster stories reported exhaustively overseas. Among them were: (1). a manifesto that described the invasion of Iraq and pacification of the Mideast penned in 1998 by a think tank whose board included a raft of current administration hawks....In a rare case of breaking ranks, one news "celeb," NBC correspondent Ashleigh Banfield, took her industry to task in a speech at Kansas State University, averring that it had painted a "glorious, wonderful picture" of war that "wasn't journalism."

Quoting Robert McChesney (Professor of Communications at the University of Illinois) "If the Soviet Union cited reasons like this in their invasion of Afghanistan and Pravda reported nothing but what the government said, we would've dismissed it out of hand. Our press hasn't been much better. That sends a lot of Americans maybe not consciously but intuitively, looking for something our media is not offering." (Grimm 2003 p. 37)

The news reports that were published by a compliant press stressed fear of terrorism. The collective identity of victim of terrorist attacks was promoted by news reports stressing communal suffering, as well as opportunities to

participate in helping survivors and in defeating terrorism (Altheide 2004). More traditional and culturally resonant narratives about crime, drugs, and evil were transformed into the "terror story." Sorrow, suffering, empathy, and pain were merged with fear and vengeance. National character was played out in scenarios of heroics, sacrifice, suffering, marketing, and spending (Denzin and Lincoln 2003). Patriotic responses to the attacks were joined with commercialism and pleas for donations, as well as support for an ill-defined and nebulous "war on terrorism" that referred to an idea as well as a tactic or method. Building on a foundation of fear, citizens who saw the repetitive visuals of the World Trade Center attacks generously followed governmental directives to donate blood, supplies, and money to the immediate victims of the attacks. They were also urged to travel, purchase items, and engage in numerous patriotic rituals, while civil liberties were compromised and critics were warned by the attorney general not to "give ammunition to America's enemies." This was the context for constructing the politics of fear.

■ News and the Politics of Fear

As stressed in Chapters 1 and 2, the politics of fear did not begin with 9/11; the politics of fear was an extension of a long history of associating fear with crime. A central argument of previous research (Altheide 2002) was that fear is cumulatively integrated into topics over time, and indeed, becomes so strongly associated with certain topics that, upon repetition, it is joined with that term—as with an invisible hyphen—and eventually the term fear is no longer stated, but is simply implied. Examples from previous work include gangs, drugs, and, in some cases, even crime, although crime continues to be heavily associated with fear (Altheide 2002). Of course, fear is also connected to many other issues in social life, but the close connection with crime led to increased use and familiarity of fear in public discourse (Altheide 2002; Furedi 1997). My aim here is to show the continuity between major events—the attacks of 9/11—and a history of crime reporting emphasizing fear and social control. Victim and victimization are common to each (Chermak 1995).

The key questions for this project concerned the comparisons between Time 1 and Time 2. The changes in coverage were considerable, although varied. Building on previous work, I was interested in whether fear and terrorism were strongly associated with articles featuring "fear" in headlines. Of course, they were, but to varying degrees. Tracking changes in the use of fear, crime, terrorism, and victim in several newspapers 18 months before and after 9/11 reveals the following changes:

1. There was a dramatic increase in linking terrorism to fear.
2. Coverage of crime and fear persisted, but at a very low rate.
3. There was a large increase in linking terrorism to victim.

First, as Figure 3-1 shows, the five newspapers that provided data for this project varied considerably in the increases of fear in headlines, and crime in report. *The Los Angeles Times* (LAT), which already had a strong "base" in crime reporting at Time 1, showed the least increase during Time 2 (32%), while *USA Today* (73%), the *New York Times* (NYT) (85%), and the *Washington Post* (WPOST) (116%) all trailed the most massive increase in crime reporting by the *San Francisco Chronicle* (SFCHRON), from 16 to 45 reports, for an increase of (181%), although about one-third of these reports also dealt with terrorism. (It should be noted that SFCHRON had the smallest number of reports with fear in the headline and crime in report at Time 1.) The relevance of terrorism and sensitivity to crime can be illustrated by an editorial of October 15, 2002, "Media Feeding the Fear," which was about the "Tarot Card" serial killer who

Figure 3-1: Fear in Headlines, Crime in Report Changes (Percent), After 9/11/01

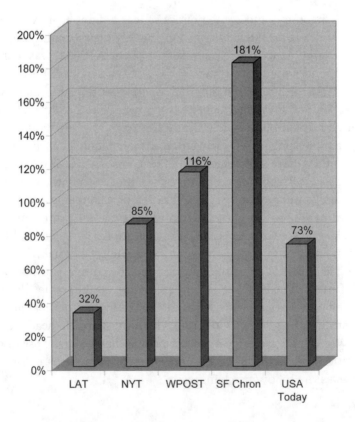

was shooting people, seemingly at random. In this and subsequent reports by other news media, shooting people is linked to terrorism, and the shooters are labeled as terrorists.

> This inexplicable string of murders has triggered yet another disappointing over-reaction from the media. But this is different from the Chandra Levy or O.J. Simpson overreactions. We are a different country from the one that weathered those stories. We feel more vulnerable to terrorism, and no matter how you cut it, this killer is a terrorist. His purpose, or at least one of them, is to spread terror. And the media is playing right into his hands, as if Sept. 11 never happened.

> "We may be entering a time when what has been ghetto-ized in Israel and the Middle East breaks its boundaries," says UC Berkeley dean of journalism Orville Schell, referring to suicide bombers and other acts of terrorism. "The unspoken thought is, 'What if this guy is a Muslim?' The media is feeding this most paranoid fear of all but without acknowledging it.... The national climate of fear, energized by this psycho sniper, demands that the media examine its decisions more critically than ever. What kind of coverage serves the public interest? What information helps, and more important what harms?" (Ryan 2002)

Next, Figure 3-2 shows the massive increase in reports that associated fear with terrorism. Fear in headlines and terrorism in news reports greatly exceeded the increases in fear and crime. Four of the five newspapers (the exception was the *Washington Post*) increased the linkage of fear with terrorism by more than 1,000%, with the *San Francisco Chronicle* exceeding 4,500%, due to having published only two reports of this nature before 9/11, in Time 1. Clearly, terrorism was a relatively new and bold connection for fear. This included a few articles that were critical of the government's use of fear to exact more social control, but the overwhelming majority demonstrated that terrorism was bonded to the discourse of fear.

A context of crime reporting proved to be consequential for the seemingly easy public acceptance of governmental proposals to expand surveillance and social control (Kellner 2003). The resulting measures reflected a foundational politics of fear that promoted a new public discourse and justification for altering everyday life and social interaction. While the following is informed by insights of others about social context and change (Shapiro 1992; Thiele 1993) and various studies about fear and the media (Furedi 1997; Glassner 1999), and especially fear and crime (Chiricos et al. 1997; Ferraro 1995), my focus is on political action that utilizes widespread audience perceptions about fear as a feature of crime, violence, deviance, terrorism, and other dimensions of social disorder.

The politics of fear is buffered by news and popular culture stressing fear and threat as features of entertainment that are increasingly shaping public and private life as mass-mediated experience has become a standard frame

Figure 3-2: Fear in Headlines, Terrorism in Report Changes (Percent), After 9/11/01

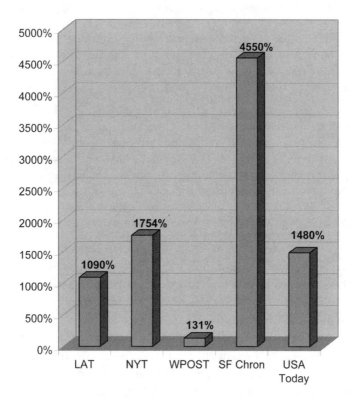

of reference for audiences, claims-makers, and individual actors (Best 1995). Similar to propaganda, messages about fear are repetitious, stereotypical of outside "threats" and especially suspect and "evil others." These messages also resonate moral panics, with the implication that action must be taken not only to defeat a specific enemy, but also to save civilization (Hunt 1997). Since so much is at stake, it follows that drastic measures must be taken, that compromises with individual liberty and even perspectives about "rights," the limits of law, and ethics must be "qualified" and held in abeyance in view of the threat.

In addition to propaganda effects, the constant use of fear pervades crises and normal times; it becomes part of the taken-for-granted world of "how things are," and one consequence is that it begins to influence how we perceive and talk about everyday life, including mundane as well as significant events. Tracking this discourse shows that fear pervades our popular culture and is influencing how we view events and experience. This is particularly

relevant for the use of victims and victimization, particularly in the context of 9/11.

Still another consequence of the emphasis on "fear" that foretells the emerging politics of fear is the rise of victimization. Entertaining news emphasizes "fear" and institutionalizes "victim" as an acceptable identity. Other work has shown that fear and victim are informed by perceived membership (Altheide et al. 2001).

While news reports strengthened the connection between terrorism and fear, a critical symbol in the politics of fear is victim and victimization. Figure 3-3 shows the relationship of fear, crime, and victim. This figure demonstrates that there was a much larger increase in the 18 months after 9/11 in reports with fear within two words of victim than with fear within two words of crime. Most striking for our argument about the expanded focus of fear and victim beyond crime after 9/11/01 were the clear increases in fear within two words of victim across the span of nationally prominent newspapers. On the one hand, *USA Today* increased reports with fear within two words of victim by 280%, while on the other hand, the LAT, NYT, and WPOST, often regarded as among the nation's most prestigious newspapers, saw increases of nearly 100%. Examining the five newspapers shows that each greatly increased reports with fear within two words of victim at Time 2: LAT: 108%; NYT: 89%; WPOST: 91%; SFCHRON: 33%; and *USA Today*: 280%. Moreover, three of the five newspapers published fewer reports with fear within two words of crime during the 18 months after 9/11. Indeed, all newspapers had either very little increase, or a decrease, in reports of fear within two words of crime at Time 2. For example, *USA Today* showed a 20% increase, and the NYT a 10% increase, while the LAT (-25%), WPOST (-8%), and SFCHRON

Figure 3-3: Changes (Percent) in Reports with Fear within 2 Words of Victim and Crime After 9/11

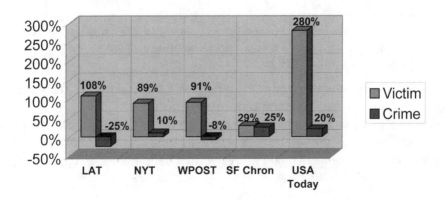

(-13%) presented less coverage about fear within two words of crime than they did prior to 9/11.

The world of popular culture and news stressing crime and victimization promotes the pervasive awareness of "victimage" that is easily cultivated by officials who respond to terrorist acts. Victims abound in American life. Victims are but the personal side of crisis; a crisis is where victims reside (Chermak 1995; Chiricos et al. 1997; Dubber 2002; Ferraro 1995; Warr 1987). A personal crisis may affect "one victim," but more generally "crisis" refers to "social crisis," involving many people. All take place in a time of fear. All of this requires that citizens have information and constant reminders of the pitfalls and hazards of life, whether potential or realized (Ericson and Haggerty 1997). Treating maladies and sources of harm as crimes and/or preventable happenings reflects a "politics of uncertainty" that promotes risk assessment, management, and legal action to hold accountable persons, organizations, and institutions deemed responsible—directly or indirectly—for the harm (Ericson 2007). The mass media help fuel the expansion and application of such claims. News reports, talk shows, news magazine shows, and a host of police and "reality crime dramas" seem to proclaim that everybody is a victim of something, even though they may not know it.

Just as our culture has become obsessed with fear, it has also become accepting of victim and victimization. My analysis of news and popular culture indicates that these two terms are linked. We even use the term victim when we don't have a victim, for example "victimless crime," although reports are far more likely to stress the "victim" status. And certain domestic violence "presumptive arrest" policies define people as "crime victims," even though they do not perceive themselves as such and refuse to press charges. We even have "indirect victim." As Michael Coyle argues (2007), the language of justice resonates through every use of victim.

> Victimhood has also been expanded through the concept of the indirect victim. For example, people who witness a crime or who are simply aware that something untoward has happened to someone they know are potential indirect victims.... With the concept of the indirect victim, the numbers become tremendously augmented. Anyone who has witnessed something unpleasant or who has heard of such an experience becomes a suitable candidate for the status of indirect victim. (Furedi 1997 p. 97)

Patriotism was connected with an expansive fear of terrorism and enemies of the United States. The term terrorism was used to encompass an idea as well as a tactic or method. The waging of the "War on Terrorism" focused on the "idea" and "the method" depending on the context of discussion and justification (Altheide 2004). The very broad definition of terrorism served

the central authorities' purposes while also justifying actions of others (e.g., Israel) in their own conflicts.

Figure 3-4 provides another important piece to the conceptual argument about the politics of fear. These data show that each of the newspapers substantially increased the number of reports with fear within two words of terrorism after 9/11. Indeed, fear continued to be used in close association with terrorism 18 months after the 9/11 attacks. Specifically: LAT: +1,467%; NYT: +986%; WPOST: +1,100%; SFCHRON: +1,620%; USA Today: +2,950%. Clearly, terrorism was strongly linked to the discourse of fear.

The discourse of fear now includes terrorism as well as victimization and crime. Terrorism and fear have been joined through victimization. Crime established a solid baseline in its association with fear, and it continues to grow, but it is terrorism that now occupies the most news space. The primary reason for this, as noted above in the discussion of news sources, is that government officials dominate the sources relied on by journalists. When journalists rely heavily on government and military officials not only to discuss an immediate war or military campaign, but also for information about the security of the country, rationale for more surveillance of citizens, and comments about related domestic and international issues, then the body politic is symbolically cultivated to plant more reports and symbols about the politics of fear. This is particularly true during periods of war, such as the ongoing war with Iraq. Messages that the war on terrorism, and the importance of homeland security (including periodic elevated "terror alerts") will not end

Figure 3-4: Changes (Percent) in Reports with Fear within 2 Words of Terrorism, After 9/11/01

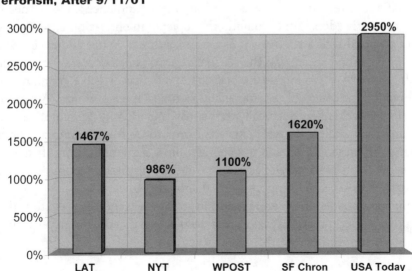

soon lead journalists to turn to administration news sources for information about the most recent casualties, operations, reactions to counter-attacks, and the omnipresent reports about soldiers who have perished and those who are still in peril. In this sense, news updates from authoritative sources quickly merge with orchestrated propaganda efforts.

Terrorism plays well with audiences accustomed to the discourse of fear, as well as political leadership oriented to social policy geared to protecting those audiences from crime. I am proposing, then, that the discourse of fear is a key element of social fears involving crime and other dreaded outcomes in the postmodern world.

Terrorism is more than a narrative, but its essence is the definition of the situation, one that extends beyond the present into a distant future, gray but known. The forebodingness of events, e.g., "9/11" attacks, are cast as a terrible trend, but the power comes from the uncertainty of "when" and "where." Like the prospective victims of crime in the future, citizens will similarly be made terrorist victims.

Terrorism—and especially the attacks of 9/11—enabled political actors to expand the definition of the situation to all Americans as "victims." Moreover, all those fighting to protect actual and potential victims should be permitted to do their work, unimpeded by any concerns about civil liberties or adding context and complexity to the simple analysis that was offered: evil people were attacking good people, and evil had to be destroyed.

Victims are a byproduct of fear and the discourse of fear. I contend that fear and victim are linked through social power, responsibility and identity. The linkage involves concerns about safety and perceptions of risk. Thus, President Bush was relying on more than skilled speech writers in connecting the mafia and terrorism; he was also relying on audience's acceptance of mythical mafia "dons" and "godfathers" depicted in entertainment to grease the conceptual slide of terrorism as a similar threat. What audiences were presumed to share, then, was the sense that terrorism, like crime—especially "Mafia Crime"—was a monstrous black hand that was invisible, omnipresent, all powerful, and could only be stopped by a stronger force if ordinary Americans were to survive. I refer specifically to the "role and identity of victim," as held by numerous audiences, who expect victims to perform certain activities, speak a certain language, and in general, follow a cultural script of "dependence," "lacking," and "powerlessness" while relying on state sponsored social institutions to save and support them. (Garland 2001)

Indeed, President Bush and his administration attached drugs to terrorism and promoted commercials advocating the position that drug users, especially youth, are supporting terrorists. As Giroux notes:

> Blaming the young for terrorism not only reproduces the worst forms of demonization, it also ignores the complexity of the problems that promote drug use among young people and adults, problems rooted in a culture of commodification and addiction, poverty, unemployment and deep-seated alienation. (Giroux 2003 p. 15)

This argument has no counter-proposal because of the symbolic links that are made between an event, a threat, the avowed character and purpose of the terrorists—who, like criminals, are constructed as lacking any reason, moral foundation and purpose except to kill and terrify. Not likely to be ravaged by childhood diseases or work-place injuries, post-industrial citizens are prime potential victims; viewing mass-mediated scenarios of crime, mayhem, and destruction, they have no option but to believe and wait, and wait:

> The most typical mode of terrorism discourse in the United States has been, indeed, one of Waiting for Terror.... That which captivates every mind is something so meaningless that it may never happen, yet we are forced to compulsively talk about it while awaiting its arrival. In the theater of the absurd, "no significance" becomes the only significance.... When something does happen, after decades during which the absent horror has been omnipresent through the theater of waiting, the vent becomes anecdotal evidence to corroborate what has intuited all along—the by-now permanent catastrophe of autonomous Terror consisting of the waiting for terror. (Zulaika and Douglass 1996 p. 26)

There can be no fear without actual victims or potential victims. In the postmodern age, victim is a status and representation and not merely a person or someone who has suffered as a result of some personal, social, or physical calamity. Massive and concerted efforts by moral entrepreneurs to have their causes adopted and legitimated as "core social issues" worthy of attention have led to the wholesale adaptation and refinement of the use of the problem frame to promote victimization (Best 1995). Often couching their "causes" as battles for "justice," moral entrepreneurs seek to promote new social definitions of right and wrong (Johnson 1995; Spector and Kitsuse 1977). As suggested above with the examples of hoaxes, victims are entertaining, and that is why they abound. They are evocative, bringing forth tears, joy, and vicarious emotional experience. But victim is more. Victim is now a status, a position that is open to all people who live in a symbolic environment marked by the discourse of fear (Chermak 1995). We are all potential victims, often vying for official recognition and legitimacy.

■ Conclusion

This chapter documents how fear and terrorism have been joined with victimization since the 9/11 attacks. I argue that expanding the discourse of fear to include terrorism is consistent with an emergent politics of fear. I suggest that the politics of fear is a dominant motif for news and popular culture. Moreover, within this framework, news reporting about crime and terrorism is linked with "victimization" narratives that make crime, danger, and fear very relevant to everyday experiences. Moreover, the changing social discourse is central to the process by which social problems are constructed (Best 1999).

The politics of fear as public discourse represents an emergent feature of the symbolic environment: Moral entrepreneurs' claims-making is easier to market to audiences anchored in fear and victimization as features of crime and terrorism. The politics of fear can be theoretically useful in understanding the relevance of mass-mediated fear in contemporary popular culture and political life. This concept is useful for clarifying the closer ties between entertainment-oriented news and popular culture, on the one hand, and media-savvy state officials on the other. The politics of fear joined crime with victimization through the "drug war," interdiction and surveillance policies, and grand narratives that reflected numerous cultural myths about moral and social "disorder." We are in the midst of an emerging politics of fear that discourages criticism, promotes caution and reliance on careful procedures to "not be hasty," to "cover oneself," to "not be misunderstood." The politics of fear promotes extensive use of disclaimers (Hewitt and Stokes 1975), those linguistic devices that excuse a comment to follow by providing an explanation not to "take it the wrong way," usually taking the form of "I am not unpatriotic, but…" or "I support our troops as much as anyone, but…." Very few politicians will stand up to the politics of fear because it is the defining bulwark of legitimacy.

Skillful propaganda and the cooperation of the most powerful news media enabled simple lies to explain complex events. Like entertaining crime reporting, anticipation of wars, attacks, and the constant vigilance to be on guard is gratifying for most citizens who are seeking protection within the symbolic order of the politics of fear. The skillful use of heightened "terrorist alerts" to demand attention to the task at hand is critical in avoiding any detractor. And that is the key point: an otherwise sensible or cautionary remark that signals one is aware, rational, and weighing alternatives marks one as a detractor, someone who is "against the United States."

The rituals of control are easier to accept as they become more pervasive and institutionalized. The politics of fear with a national or international justification is more symbolically compelling than "mere crime in the streets." Accompanying heightened terror alerts are routine frisks, intrusive surveillance, and the pervasive voyeuristic camera, scanning the environment for all suspicious activity. Fear is perceived as crime and terrorism, while police and military forces are symbolically joined as protectors. The key point about physical security, surveillance (Staples 2000), and body checking is to communicate the format of control to people as objects rather than subjects. They are objects to authorities, mere bodies that can be electronically wanded, asked to disrobe, patted down, felt up, and unveiled like produce.

The searchers are looking for evidence that is codified by a theory of terrorism and threat, namely that all are suspicious and likely to be hiding something. The sociological paradox is that this theory and practice of evidence is difficult to refute, because there is no place within the logic for counter-evidence. The nature of evidence in thought and action, particularly in a context of ubiquitous mass media, is examined in the next chapter.

4

■ Terrorism and the Problem of Evidence

■ Introduction

The mass-media coverage of terrorism since 9/11 reflects differences in standards of truth. The Bush Administration went to war with Iraq on the basis of fragments of erroneous information that were believed to be correct, accurate, and, in short, strong evidence of Iraq's impending threat to the United States. Journalists reported this evidence without questioning or challenging its validity, even though many were aware that administration officials had strong biases against Iraq and were not likely to critically evaluate the information at hand. Indeed, Colin Powell presented photographs to the United Nations of what were purported to be chemical weapons labs, storage, etc. This chapter addresses why some of these claims and the evidence on which they were based were not more strongly challenged. The problem is the nature of evidence itself.

People believe the strangest things. Many believe that the earth is flat, the earth is 5,000 years old, that angels (real creatures with wings) are all around us. Many people, including 12 jurors, believed that "O.J. didn't do it" (i.e., kill his wife and her friend). And even more people—as much as 40% of the American public—believe that the Bush Administration orchestrated the 9/11 bombings, while others disagree. A poll in September 2007 found that 33% of Americans believed that Saddam Hussein and his Iraqi friends were heavily involved in the planning and support of those attacks (Davies

2007) in spite of several official commission reports showing that this was not true. Moreover, many people in the Middle East, especially Iran, believe that the Bush Administration actually conspired with Al Qaeda to attack the United States (*FRONTLINE*, October 23, 2007; http://www.pbs.org/wgbh/pages/frontline/showdown/). Why do people believe such things, and what evidence would convince them otherwise? I wish to address the problem of knowledge and evidence from a symbolic interactionist perspective. This will entail offering a distinctive view of evidence-as-process, or what I call the "evidentiary narrative," but it also draws our attention to the ways in which credible information and knowledge are buffered by symbolic filters, including distinctive "epistemic communities," or collective meanings, standards, criteria that govern sanctioned action, including talk (e.g., scripts, accounts, disclaimers). This exploratory essay seeks to join identity/membership, information/knowledge/evidence, and propaganda/social control.

This chapter offers a conceptual formulation of the "evidentiary narrative," which emerges from a reconsideration of how knowledge and belief systems in everyday life are tied to epistemic communities that provide perspectives, scenarios, and scripts that reflect symbolic social and moral orders. Part of my task is to show the relevance of epistemic communities—and cultures—for evidence. I wish to "name" the parts, process, and symbolic array of considerations that inform evidence:

> An "evidentiary narrative" symbolically joins an actor, an audience, a point of view (definition of a situation), assumptions, and a claim about a relationship between two or more phenomena. If any of these factors are not part of the context of meaning for a claim, it will not be honored, and thus, not seen as evidence. Moreover, only the claim is discursive, or potentially problematic, but it need not be so.

Viewing evidence as part of a communication process suggests that evidence is not about facts *per se*, but is about an argument, a narrative that is appropriate for the purpose at hand. That means it is contextualized and part of a bounded project, with accompanying assumptions, criteria, rules of membership, participation, etc.

What is meant by "evidence" can be viewed as "information that is filtered by various symbolic filters and nuanced meanings compatible with membership." From a radical sociology of knowledge perspective, the active reception of a point "of information" is contingent on the "media logic" of legitimacy (acceptability) of the information source, the technology, medium, format, and logic through which it is delivered (Altheide and Snow 1979). Only then can the information be interpreted as evidence in juxtaposition with an issue, problem, or point of contention. Conversely, information that is not suitably configured and presented is likely to be resisted, if not rebuffed, within a prevailing discourse, typically guided by a folk concept that "...applies mate-

rial against which people judge whether what they see looks [right]…" (Turner 1969 p. 818) or is pertinent to the topic at hand (Altheide and Gilmore 1972; Turner 1957).

The symbolic meaning filters that are called forth all stem from various memberships (See Figure 4-1). Ultimately, evidence is bound up with our identity in a situation. I argue that the multiple memberships we hold in various epistemic communities are situationally shuffled and joined for a particular purpose, (e.g., when an assumption or value is challenged or called into question). I further suggest that documents (i.e., anything that can be retrieved or recorded for subsequent analysis about social meanings) provide a window into collective sentiments, preferences, and identity pronouncements about epistemic communities. Examples from various aspects of the Iraq War will be used to illustrate how evidence is meaningfully joined to such communities. I have some explaining to do.

Figure 4-1: The Evidentiary Narrative Process: From Information to Evidence

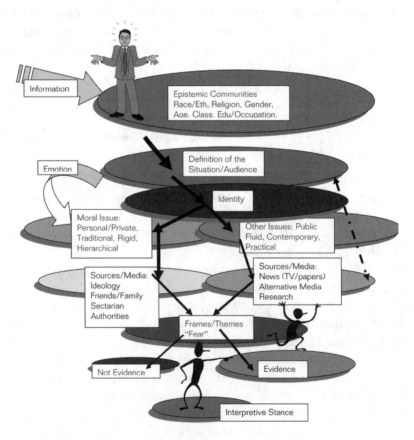

■ The Evidentiary Narrative in Perspective

I go back to my fundamentalist religious background. My brothers and I had long rejected the fundamentalist evidence for the existence of God. When my brother, Duane, and I were college freshmen, we liked to hone our reasoning and logical skills by competing against easy pickings, and none were easier, we thought, than the people who staffed the "Christian Businessmen" booth at the Western Washington Fair in Puyallup, Washington, near our home. We liked to argue with them about fundamental religious questions, (e.g., does God exist, and if so, does he care, and if so, why does he permit evil, or maybe an intellectually respectable God doesn't want us to fall for just anything). During one conversation a dear old man said, "Son, if God doesn't exist, then how can a brown cow eat green grass and make white milk." Well, he had me. I still puzzle over the ease with which people find confirming or disconfirming evidence.

Since that time I have reflected on the problem and conclude that evidence is processual, and hinges on what might be termed an "evidentiary narrative," which is reflexive of an ecology of knowing, or the spatial/temporal interaction of background assumptions or what anthropologist Lind refers to as the "culture stream" (Lind 1988). Lind explores cultural continuities and change, reflecting on the "mechanisms" and "institutional forms" that permit the past to be remembered in the present and passed along and then built on—even changed—in the future. The focus turns to cultural processes that are discovered, tested, altered, instituted, and then reified and soon "taken for granted" (Berger and Luckmann 1967; Schutz 1967).

The evidentiary narrative is informed by work that John Johnson and I did on criteria of validity for evaluating qualitative research (Altheide and Johnson 1994). We argued that a more encompassing view of the ethnographic enterprise would take into account the process by which the ethnography occurred must be clearly delineated, including accounts of the interaction between the context, researcher, methods, setting, and actors. The broad term that we offered, "analytic realism," is based on the view that the social world is an interpreted world, not a literal world, always under symbolic construction (even deconstruction!). We can also apply this perspective to understand how situations in everyday life are informed by social contexts and uses of evidence. This application illuminates the process by which evidence is constituted. I mention a few of these later in this chapter and will show their relevance for issues and disagreements pertaining to the Iraq War. A brief overview of analytic realism can help us approach evidence in a new way. It

is useful to consider the following when trying to understand evidence that is stated or affirmed in a situation:

1. the relationship between what is observed (behaviors, rituals, meanings) and the larger cultural, historical, and organizational contexts within which the observations are made (the substance);
2. the relationship between the observer, the observed, and the setting (the observer);
3. the issue of perspective or point of view—whether the observer's or the member(s)'—used to render an interpretation of the ethnographic data (the interpretation);
4. the role of the reader in the final product (the audience); and
5. the issue of representational, rhetorical, or authorial style used by the author(s) to render the description and/or interpretation (the style).

Each of these areas includes questions or issues that must be addressed and pragmatically resolved by any particular observer in the course of his or her research. As originally formulated, these five dimensions of qualitative research include problematic issues pertaining to validity. Indeed, we argued that the "ethnographic ethic" calls for ethnographers to substantiate their interpretations and findings with a reflexive account of themselves and the process(es) of their research (Altheide and Johnson 1993a).

I wish to shift the focus to what people regard or take for granted as validity or truth, and what relevance this has for evidence. Please note that my approach is quite different from classical varieties, i.e., evidence and the law (Anderson et al. 1991). Just as ethnographers honor the perspective of their subject, so, too, should we affirm the process of how people interpret the world *vis-à-vis* what we might term "evidence." My focus, then, is on how social order—indeed a social cosmology—is reflected in symbolic communication in everyday life. These worldviews are tacit and widely shared. They can be illustrated with two of the examples with which we began this essay, the views about the U.S. initiating the terrorist attacks of 9/11, and the outcome of the O.J. Simpson trial.

Many citizens in a host of Middle Eastern countries take for granted that the U.S. pro-Israel policy, which they see as opposed to the welfare of Palestinians and others, governs most actions involved with the Middle East. Indeed, there is a vast historical record of the role of U.S. interference in the affairs of many nations in this region, much of this captured in various news media (Adams 1982). That many citizens have a quasi-conspiratorial view of Middle Eastern life at the hands of the United States is hardly surprising, nor are most observers surprised that world views are colored by this taken-for-granted understanding of world affairs.

The outcome of the O.J. Simpson trial in 1995, when Mr. Simpson was found innocent of the murder of Nicole Brown and Ronald Goldman, surprised many Americans, partly because of what appeared to be very strong evidence. Simpson, former football star and widely recognized celebrity, was defended by a team of highly skilled attorneys, led by Johnny Cochran. The predominantly black jury found him innocent. Reaction, that is, agreement or disagreement with the verdict, was largely split along racial lines: white Americans disagreed; black Americans agreed. Indeed, the latter were quite elated. Numerous analyses and "follow-ups" about the cultural meaning and significance of this trial—and the ongoing reaction at this writing—suggest that black Americans' elation had as much or more to do with the symbolic significance of the trial outcome as a victory, not so much for Mr. Simpson, but for Mr. Cochran, the skilled black attorney. Centuries of racism have systematically denied black Americans justice in U.S. courts, meaning that they often lose. To win a court case mattered, especially a highly visible one like the O.J. Simpson case. The evidentiary narrative is apparent in the comment by one black man in a 10-year retrospective televised on *FRONTLINE*:

"If you're black and you lived in this town [Los Angeles] you've had some sort of run-in with law enforcement…it's just the nature of us being black men.… [Did you think he was guilty?] "Yeah, but *I liked the verdict*." (http:// www.pbs.org/wgbh/pages/frontline/oj/view/; my emphasis)

The perspective of many black people in Los Angeles at the time of the O.J. Simpson trial is relevant for another important part of the evidentiary narrative, the "epistemic community." We borrow the term "epistemic community" to capture the shared perspectives that promote evidentiary narratives (Miller and Fox 2001; Roth 2007). Not all encounters illustrate the evidentiary narrative, but many do. Evidentiary narratives are constituted by memberships—epistemic communities—which I will discuss more below, but they remain as binding, even if they are not as well articulated across the board, varying, say, between a scientific review of a colleague's paper, or a conversation with one's mother. And not all communication affirms or reflects an evidentiary narrative within a community. In general, an evidentiary narrative is called into question during interaction between people from dissimilar epistemic communities. During such encounters, one person's commentary and observations are likely to be noticed as different—even contrary—to one's own view, and thus they are "topicalized" and treated as referential, rather than evocative; relatedly, there may ensue a question, more information-seeking, or especially a challenge or disagreement with an assertion. Likewise, different evidentiary narratives are at work when a journalist scrutinizes a public official's proclamation and questions the veracity and relevance of a topic at hand. While the following materials—especially an analysis of news

reports—reflect such a questioning, my focus in this chapter is on the nature, process, and significance of evidentiary narratives in epistemic communities.

■ Epistemic Communities as Social Perspectives

The sociology of knowledge project—to identity the origin and impact of social meanings-- can be applied to all forms of human knowledge and belief (Berger and Luckmann 1967). In this chapter I relate epistemic community to the evidentiary narrative. I employ the notion of "epistemic community," which refers to member assumptions, beliefs, knowledge, and values about a social and moral order. This often unspecific corpus also becomes a way of knowing and participating in a perspective and even a project. This concept is borrowed from scholars (see below) whose work focused on quite limited and specific knowledge groups, e.g., researchers. As will become evident in the following pages, my heuristic use extends the scope to cover nascent social meanings and orientations to social life.

The evidentiary narrative is built on several arrays of meaning: what we know, who we are, and what we consider as evidence of either our most basic assumptions (e.g., that there is order in the world), or a specific claim about part of that order (e.g., my beliefs are legitimate and truthful). Prior to delving into my solution, let's attempt an overview of the problem. We live as social beings and are accountable to some people but not others. Why do we accept claims, reject others, and what would lead us to change our minds? In the modern era, this involved scientific authority about certain empirical truths that were based on "data" as evidence, or as a kind of fact-guided proof. The modernist project relied on rationality, including some formal rules of logic grounded in an objective view of things. This view has been seriously questioned by extensive research and writings encompassing such approaches as ethnomethodology, phenomenology, existential sociology, symbolic interactionism, feminism, literary criticism, performance studies, and autoethnography, to name a few (Denzin 1994). These approaches reflect and have contributed to the "reflexive turn" in the social sciences, and the examination of how the research process, including the "act of writing," partially produces the research result (Marcus et al. 1986; Van Maanen 1988).

The reflexive turn is central to the problem of evidence, not just why people believe "crazy things"—and won't easily consider evidence that would lead them to reject such beliefs—but more basically, why, and how, do researchers and scientists accept information as evidence for a particular mat-

ter. The subject matter under investigation still matters, but mainly as a "product" that is socially constructed.

But there is even more to consider in any effort to "unpack" how epistemic communities and cultures can contribute to evidence. Feminists and others have argued that language and other symbols that communicate also define, create, and can distort various possibilities and interpretations of not just social relations, but also facts, including what is "included" and what is "excluded" for consideration. More is involved than the reproduction of paradigms (Kuhn 1970); more is at stake than framing or guiding perceptions through familiar symbolic passageways (Lakoff 2004; Lakoff 2006; Pinker 2006). Feminist standpoint theories call into question the very source of knowledge; the individual knower shrinks in importance, but the community is given credit for setting the foundation, content, criteria, and logic. A standpoint is a position in social relations:

> "A standpoint is a collective effort, a collective understanding requiring both science (analysis) and political struggle on the basis of which this analysis can be conducted" (Hartsock 1998 p. 285).

There is an important implication for information, knowledge, and evidence: "Thus, in feminist standpoint theories it is communities, not individuals, who are the agents of knowledge production" (Tatman 2001). A news report from Angola about banishment—or worse—of boys who are believed to be witches suggests the power of context and community, epistemic communities that set the foundation and criteria of knowledge-as-action.

> Domingos Pedro was only 12 years old when his father died. The passing was sudden; the cause was a mystery to doctors. But not to Domingos's relatives.

> They gathered that afternoon in Domingos's mud-clay house, he said, seized him and bound his legs with rope. They tossed the rope over the house's rafters and hoisted him up until he was suspended headfirst over the hard dirt floor. Then they told him they would cut the rope if he did not confess to murdering his father.... Bantu culture that witches can communicate with the world of the dead and usurp or "eat" the life force of others, bringing their victims misfortune, illness and death. Adult witches are said to bewitch children by giving them food, then forcing them to reciprocate by sacrificing a family member.

> But officials attribute the surge in persecutions of children to war—27 years in Angola, ending in 2002, and near constant strife in Congo. The conflicts orphaned many children, while leaving other families intact but too destitute to feed themselves.

> "The witches situation started when fathers became unable to care for the children," said Ana Silva, who is in charge of child protection for the children's

institute. "So they started seeking any justification to expel them from the fam-
ily." (LaFraniere 2007)

(The reader's reaction to the above example is important to remember as
an example of your evidentiary narrative grounded in your shared epistemic
culture, especially in contrast to examples that follow about the ruthless
bombing of civilians, cast out as "collateral damage.")

The constitutive role of epistemic communities also extends to "science,"
the domain for many studies of "epistemic culture." For example, a highly
regarded ethnographic study of scientists in two projects—a high-energy
particle (HEP) accelerator study, and molecular biologists working in a lab—
argued that "knowledge" gained in each case is due to distinctive "epistemic
cultures," which refer to

> …those amalgams of arrangements and mechanisms—bounded through affinity,
> necessity and historical coincidence—which, in a given field make up how we
> know what we know. Epistemic cultures are cultures that create and warrant
> knowledge, and the premier knowledge institution throughout the world is, still,
> science…. (Knorr-Cetina 1999 p. 1)

A clear implication from this project, and others, is that not only is knowl-
edge discovered, and, by implication, constructed. It is also, in the case of
HEP research, collectively created, and what the scientists "know" is bounded
by teamwork, trust, and a sense that the whole project fits together and makes
sense, mainly because of the process of producing it. Since the molecular
biologists work more independently in a lab that is usually under the direc-
tion of one person, the knowledge is more individual, but it is still a feature
of the process. Indeed, Knorr-Cetina (1999) makes reference to "distributed
cognition" as well as the Durkheimian "collective consciousness," albeit a bit
imprecisely. Knorr-Cetina's imprecision bothered one philosopher who com-
mented on her scholarly effort.

> Perhaps Knorr-Cetina's most provocative idea is "the erasure of the individual
> as an epistemic subject" in HEP. One cannot identify any individual person, or
> even a small group of individuals, producing the resulting knowledge. The only
> available epistemic agent, she suggests, is the extended experiment itself. Indeed,
> she attributes to the experiment itself a kind of "self-knowledge" generated by
> the continual testing of components and procedures, and by the continual informal
> sharing of information by participants. (Giere 2002 p. 639)

Professor Giere argues that "distributed cognition" is a special case of
"collective cognition" but is preferable to "collective consciousness":

> The cognitive powers of both fields depend upon distinctive distributed cognitive
> systems. Yet in both, I have argued, we can reserve epistemic agency for the
> human components of these systems. We do not need to postulate new distrib-

uted cognitive agents, let alone ones exhibiting consciousness. (Giere 2002 p. 744)

While it is certainly the individual who displays the "agency" of epistemic claims, I argue below that the perspective, orientation, social support, and standpoint from which individuals address information-as-evidence is decidedly collective and social. This part looms much larger later in this chapter when we examine documents about the Iraq War that demonstrate the deadly playfulness of logic-in-use by the powerful ideologues.

A brief recap of the argument is helpful in launching the rest of this chapter. Evidence is aligned with epistemic cultures/communities. What people regard as evidence is contingent on symbolic processes and meanings that shape, guide, deflect, and construct boundaries (Schwalbe 2000). These are associated, acquired, and accompanied with various memberships (and identities) and components, some explicit (e.g., occupations and education), but most implicit, if not tacit (e.g., region, class, religion, ethnicity, religion, family structure, and functioning). These provide an evidentiary narrative through which people define, create, share, recognize, and reject information as relevant for a purpose at hand, including a topic that might be considered.

The situation and occasion is partially set by the audience, which calls forth the appropriate membership/identity (Blumer 1962) and, very importantly, a proper performance (Goffman 1959; Goffman 1963b). But if people have multiple memberships and, presumably, an array of evidentiary narratives that can be used singularly, or in combination, which ones will be used? For example, will "science" and rational reflection be appropriate, or will it be one's childhood perspective on the matter? With exceptions, as Jack Douglas has argued, the evidentiary narratives that accompany moral meanings in one's life are likely to trump less salient meanings (Douglas 1971; Douglas 1976; Douglas et al. 1988; Douglas and Johnson 1977). Douglas suggested that our General Cultural Understandings (GCU) learned in childhood, about life and morality, are often modified by Specific Cultural Understandings (SCU) gleaned from occupational and other experiences (Douglas 1976). An apt illustration is Karp and Yoels's (1986) lucid account of how upwardly mobile university professors are tormented by their working-class origins. This clarifies what an internationally renowned physicist believed the evidence showed about crime and punishment. He told me that an effective way to deal with those accused of rape is just to take them out and hang them, something he had witnessed as a small boy. He felt this version of the death penalty would deter future rapists, despite numerous studies to the contrary (Gerber and Johnson 2007). Apparently, his PhD and several honorary doctorates in physics did not carry forth the rationality to think critically about the social realms of life. He thought it was humorous when I replied to the effect

that "frontier justice is still alive." His evidentiary narrative concerning crime and deviance was not encumbered by reason. Clearly, there is a challenge before us, and it is not simply to provide more education.

The key is the interaction process wherein two or more people are engaged in arriving at and sustaining a definition of the situation. Such definitions usually reflect the context of the interaction and assumptions about order, reality, and normalcy. People in communication count on each other in a cooperative rather than an evaluative or competitive fashion. They work at presenting themselves in a convincing way to affirm an identity. I stress throughout this essay that people in everyday life seldom focus on evidence *per se*; they just say and do what seems appropriate to the situation at hand. In this sense, evidence is very pragmatic, and very interactionist; if it works with an audience at a specific place and time, it is not likely to be challenged. People do not respond merely to "facts"; rather, it is the meaning and context that makes a difference. People draw on epistemic cultures that provide the taken-for-granted perspective, knowledge, and frames. Moreover, information and facts are not the same as evidence; what matters is what is accepted as facts-for-the-purpose-at-hand. George Lakoff has argued that frames make significant contributions to thinking. In response to a scathing book review by Steven Pinker, an eminent psychologist of language, who argued that "people can evaluate their metaphors…[and] call attention to them…" (Pinker 2006), Lakoff argued that frames are crucial:

> One of my persistent themes is that facts are crucial, and that the right system of frames is often required in order to make sense of facts. With a system of frames that is inconsistent with the facts, the frames (which are realized in the brain) will stay in place and the facts will be ignored. That is why framing to reveal truth is so important. Here is what I say in *Don't Think of an Elephant!* [Lakoff 2004 pp. 109–110]: "Facts are all-important. They are crucial. But they must be framed appropriately if they are to be an effective part of public discourse. *We have to know what a fact has to do with moral principles and political principles. We have to frame those facts as effectively and honestly as we can.* And honest framing of the facts will entail other frames that can be checked with other facts. (Lakoff 2006; my emphasis)

Frames become part of the "culture stream" noted above; they help shape and "write" scripts, but there is more to the problem of evidence. By themselves, frames are incomplete. They must be compatible with an evidentiary narrative if they are to be invoked.

I suggest that the evidentiary narrative links frames and even broader domain assumptions about a topical field to a communication process in a specific situation. Our task is compounded by research findings that suggest that the interaction performance informs audience perceptions of veracity

and competence (Goffman 1959; Goffman 1963a; Goffman 1963b). This poses serious problems for social analysts since a plethora of popular culture offerings available assures that almost any position or belief will receive some support, if not overwhelming approval! Still, this begs the question about evidence as "belief" or "an argument" or even a position. Most of the time, it is simply taken for granted, unless someone who matters to a person in an interaction sequence raises some question about a statement or practice. So this is where analytic realism can be helpful in understanding the process and social construction of evidence: Analytic realism assumes that the meanings and definitions brought to actual situations are produced through a communication process. Researchers and observers need to be aware that the categories and ideas used to describe the empirical (socially constructed) world are also symbols from specific contexts. We must attend to the specific context and situation if we wish to understand how people perceive inconsistency and, in effect, understand the "logic in use."

The interaction process and identity hold the key to understanding consistency. People interpret things from a range of perspectives, but what standards do people use—if any—in assessing their frameworks? My position is that frameworks are seldom assessed, except, perhaps, in an academic setting, as an explicit task for another audience, e.g., a committee assignment. Seldom does it come up as a distinct moment in interaction, but mainly in a broader view, from the standpoint of an observer. Evidence is almost never a problem for a participant, but is more likely to arise for an observer. Moreover, unless an everyday task entails the charge of "be consistent," there is little practical consequence for striving to achieve consonance. My view differs substantially from a very popular psychological explanation, cognitive dissonance, developed by Leon Festinger (1968) and his colleagues over a period of several decades. It is not my intention to offer a thorough critique of this very popular concept, but to use it as a conceptual foil for an alternative approach to evidence.

■ Cognitive Dissonance as a Foreign Concept

Cognitive dissonance (CD) refers to the perception that one's experience may not be consistent with one's beliefs, or that some evidence does not support an idea or hope. The theory of CD produces a kind of psychological tension, which is abetted by an individual accepting a new thought or theory to bridge the gap, so to speak. While much of the research on this concept has been done in laboratories, several projects examined the capacity of people to

achieve consonance, or consistency, in the face of apparent conflicts or contradictions. One of the best known was Festinger's study of a "doomsday cult" that believed the world would end and that their group of faithful would ascend in a flying saucer (Festinger et al. 1956). When the world did not end, the group did not disband, but claimed that a new message indicated that their beliefs and commitment had given the world a reprieve. The researchers suggested that disconfirmation can be abetted by the individuals' (group) public espousal of their belief, strong commitment, continued support, and further proselytizing. A key part of the process was individual recognition, based on some kind of evidence (e.g., the great flood did not occur at the predicted time), that the avowed event did not occur.

I think there is a better way of explaining such adjustments, or at least providing a way of making sense of the process that may be involved in such adjustments. Without dwelling on the study of Festinger et al., a key aspect is the context and meaning of disconfirmation; simply stated, I suggest that most beliefs are not discursively or experientially tied to some kind of "specific test"; rather, all (or most) experience is viewed as confirming an "incorrigible proposition"—one that cannot be challenged—namely, that one's view of things is confirmed in so many ways. However, my focus is on the social dimension of meaning and evidence.

Cognitive dissonance is more of a "spatial metaphor," or the notion that two different freight trains cannot occupy the same track (space) very easily, and thus an adjustment is called for. However, if expectations and perceptions are accorded a temporal rather than (or in addition to) a spatial dimension, then things are much different. One train ("yes, smoking causes cancer") can leave the "station" (so to speak) before another one comes in ("sure, I smoke and see nothing wrong with it.") It is only when analysis holds the two up together—as in the same space—that the logical problem arises. (The metaphor of "trains on multiple tracks" can be operating could partially save cognitive dissonance, but that is not our concern here.) The upshot, then, is that the logic of everyday life is much different than formal logic. This does not mean, of course, that many people do not conduct their everyday affairs with some sense of trying to be consistent or having perceptions, expectations, and behavior aligned. It does mean that people are capable of locating their perspectives and claims according to relevance and situational demands. Thus, every professor knows that students may do well on an examination about the nature and role of critical thinking of, say, binge drinking, but then, in interaction with peers, completely negate the tenets of critical thinking. And quickly get intoxicated. The obvious differences must be emphasized: One situation involves an "academic" context and meaning, involving actors in the roles of student and professor, a grade in a course, a career track, and

perhaps a future letter of recommendation, while the latter reflects notions of fun, peer group identity, group norms, and important emotions of acceptance. Both scenarios can be explained with basic sociological concepts about frames of reference and social control through language and discourse, but the outcomes can be much different. Indeed, this is why words and deeds often differ (Deutscher 1973).

A theoretically informed symbolic interactionist view of evidence notes the limitation of "framing" alone and calls into question the theoretical adequacy of cognitive dissonance. The evidentiary narrative suggests that experience and communication are reflexive, or artfully constructed, interpreted, and presented with context, situation, and audience in mind. I further suggest that "cognitive dissonance" is relatively uncommon for two reasons. First, consistency is a social construction and is also a value held by very few people; rather, most activity is highly situational and contextual, while the accounts that people give or their actions (excuse or justification) are reflexive of the nature of the questioning context (and questioner) (Mills 1940). This is why many people can be charged with hypocrisy, or espousing one thing (e.g., denouncing drugs) while doing another (e.g., supporting one of their children's drug addictions). Second, people see evidence in various ways, according to time, place, and manner, and thereby avoid a confrontation of a contradiction. Indeed, insightful research by symbolic interactionists reveals that actors anticipate when statements might not be fully supported by audiences, so they hedge their bets in conversation and readily employ a range of "repair devices" such as disclaimers (Hewitt and Stokes 1975), neutralization techniques (Matza 1969), and accounts (Scott and Lyman 1968).

Evidence is not objectively given, "out there," to be picked up. Evidence is constituted by social definitions and meanings, which in turn are contextualized by culture, history, ideology, and specific expertise. There is a discourse of evidence, which, above all, requires some shared meanings, perspectives, and criteria. The "reason" that science and religion have trouble "talking to one another" is that they operate from what Kuhn (1970) called different "paradigms," but there is much more to it. Their cosmologies are different, and the bounds of authority differ. It is apparent when one looks at history that what is evidence for one person—or, more correctly, an epistemic community—does not qualify as evidence for another. There is also identity involved. The slogan "If you don't stand for something, you'll fall for anything" transforms what we would call an epistemic stance to an ideological, if not a moral, position. Standing your ground matters, and evidence is contextualized accordingly. This becomes more apparent when evidence is marshaled against personal and everyday truths, some of which are so basic that they

are referred to as "common sense." Evidentiary narratives are distinguished by what is "common sense to an epistemic community."

Researchers who share "scholarship evidentiary narrative" (e.g., critical thinking, use of data, rules about logic and consistency, etc.) can discuss religion, even if they may disagree. But lay religious people and scientists can barely discuss religion because they are likely anchored in different epistemic communities.

Evidence is a feature of the interaction between an audience, a claim, and practical epistemologies of everyday life. For most people in most situations, evidence is either evocative or banal; it is so enmeshed in a definition of the situation that it cannot be unwrapped from any assumption or claim. That is also what makes it ordinary, mundane, and banal. Evidence refers to data, which means information with a purpose, so to speak, information that an investigator, perhaps with the aid of a method—but most typically, a sharp conceptual eye—deemed relevant for a question. The key question is what is relevant for the topic or question under investigation. A reader's (listener's) perspective about what is "evidence" is informed by biography, culture, etc. Whether evidence is convincing follows along the same lines: is the evidence "good enough," or is there enough evidence relevant to the topic?

Evidence is subtle and largely taken for granted in everyday life because most people use information and examples as evidence of reality or "just the way things are" as a resource—rather than a topic in its own right—to make a point or sustain a definition (Zimmerman and Pollner 1970). Everyday-life use of evidence is quite situational and contextual, meaning that is has a spatial or "here and now" component, at least in terms of a point of reference when a matter of evidence is considered. Most people are not even aware that evidence is being artfully constructed and marshaled in basic conversations and assertions about something.

Evidence suggests a hierarchy of information in which certain claims and views about phenomena are accorded a higher status, as "evidence," as opposed to "hearsay," to use a legal example. Perhaps more directly, evidence suggests a hierarchy of reality claims, which in turn are unevenly distributed among social actors. It is in this sense that evidence involves a discourse of truth, but for all practical purposes, evidence implies a discourse of power. As I stress below, leaders with unlimited access to the mass media can promote propaganda that resonates with deeply held emotional beliefs, values, and—especially—fear that cuts across many distinctive epistemic communities.

Hierarchy is important for evidence, especially when it comes to respect. When, say, a president of the United States makes a statement, there is institutional credulity for most audience members, who do not have experience confronting authorities, challenging assertions, or arguing—as impolite!—with

exulted leaders. Moreover, if the audience members do not have independent knowledge and familiarity with the topic being discussed, there is little reasonable ground for raising an objection. This is more compelling if the meaning of the statement is a part of a convincing performance, particularly if the president is truly a professional actor, as was Ronald Reagan (Weiler and Pearce 1992). (That actors can be elected to high public office speaks volumes about the malleability of evidence by voters.) In the following pages, I address the nature, effect, and impact of the discourse of power in a mass-mediated age. Dominant discourses evolve, emerge, and, in our media age, are artfully constructed through propaganda efforts, including the uses of slogans and phrases.

Journalists, attorneys, and social scientists are unique because they work with "social" and "psychological" evidence occupationally, as part of their job. They conjure up evidence as observers. Notwithstanding some very clear differences in these occupations and perspectives, there are important similarities about referential checks on evidence and how it is collected, analyzed, and interpreted.

The late David Halberstam, an exceptional journalist who won a Pulitzer Prize for reporting about numerous deceptions and lies in Vietnam, had a clear view of evidence that was shared by many in the journalistic epistemic community. *New York Times* writer Tim Rutten expressed his view of Halberstam's "epistemology":

> Perhaps more important, Halberstam was the exemplar of a courageous intellectual approach to journalism that found its first clear public expression in a young combat correspondent's refusal to buy the government line on Vietnam. They were there; they trusted the evidence of their eyes and refused to look away, no matter how much pressure successive American administrations and the local military commanders brought to bear.

> As he said in a widely discussed *Commentary* piece in 1965, "No one becomes a reporter to make friends, but neither is it pleasant in a situation like the war in Vietnam to find yourself completely at odds with the views of the highest officials of your country.... But it was impossible for us to believe those things without denying the evidence of our own senses.... And so we had no alternative but to report the truth...." (Rutten 2007)

Journalists approach evidence referentially. Halberstam and other journalists trusted their senses and their basic comparative journalistic perspective, which basically amounts to comparing what officials say with what you see, with what people (e.g., soldiers) are telling you. We will turn to more complex examples of this a bit later in the chapter, after more examination of how the appeal to a larger standard or even a "truth" can filter what is seen as evidence.

Scientists and analysts are not immune from the use of taken-for-granted assumptions, but their disciplines usually entail some analytical framework for treating some portion of the evidence as a process, which enables them to reflect on its production. In this sense, they are treating evidence more as a topic than a resource. While many other occupations use and interpret evidence, there are very few jobs that are charged with collecting, interpreting, and working with social evidence. Moreover, these occupations as professions have established rather involved methods, criteria, and discourses for assessing skill and competence and, in short, "correctness," when it comes to working with evidence-as-data, which may be defined as information with a specific purpose. Not surprisingly, there are also important issues about evidence and "methods" associated with each of these disciplines, especially social science. I will focus mainly on social science.

Efforts to investigate the complex role of symbolic meanings in social life have fundamentally altered research methodology in the social sciences over the last 50 years (Cicourel 1964; Denzin 1994; Douglas 1970; Douglas and Johnson 1977; Lyman and Scott 1970). The perspective I am using to analyze the social construction of evidence is grounded in fundamental changes within the social sciences. As with all analysis, my approach is reflexive of a theory of knowledge and communication. Social science evidence of any kind is less compelling to people than physical science evidence. As Schutz and others have noted (Berger and Luckmann 1967; Schutz 1967), social science is dealing with "second order" constructs, meaning that our concepts and the data that we examine have already been interpreted and enacted by people. Social phenomena are already meaningful, whether highly significant or mundane. Indeed, most disagreements that people have over "social science findings" are due to the interpretive frameworks and discourses that are already established, rather than the evidence or analysis *per se*.

An established discursive position, with its relevant narratives, is more difficult to move or counter with evidence than a non-discursive one. This is particularly apparent with cultural scripts that touch one's person, or identity, as with religious and moral codes, e.g., sin and salvation (Lyman 1989). People have views about the "social" and are adrift in the morality of living; this is less so with matters of physics. People's views are reflexive of their identities. People have views and interests in whether there is a difference between blacks and whites, straights or gays; they have less tied up with Heisenberg's Principle of Indeterminacy, gamma rays, or whether there is (was) water on Mars. With exceptions (e.g., "Flat Earth Society"), we tend to leave that "science stuff" to the experts. But social science is another matter, because it deals with matters for which people have experience, interpretations, and even theories. For example, Blumer argued that race prejudice is less "psychologi-

cal" than it is social, and particularly reflexive of one's group position in a hierarchical (racially stratified) social order (Blumer 1958). The compelling evidence of "us" over "them" was informed by an evidentiary narrative about a long-held belief in the rightful and natural superiority of one's group and position over others, who are trying to achieve the status and rights of the dominant group. Thus, who "I am" is very much involved with who "they are" and by implication "who I am not." For Blumer and other astute students of race relations, prejudice would not be dispelled by facts or "evidence," but by experience and cultural meanings and more inclusive narratives. As with the earlier example of the dialogue with the Christian Business Men, the issue was not the logic, facts, and other evidence brought to bear on the argument about God's existence, but rather, that there was an argument at all! God's existence, and the forms that this took, were simply unquestionable, beyond the bounds of philosophical, logical, or scientific discourses; it was a matter of faith, with its own evidentiary narrative. I will return to the importance of membership and group perspectives a bit later in this essay. While the religious narrative remains dominant in much of the world, it is being challenged and supplemented by the mass media.

■ The Mass Media and the Evidentiary Narrative

Emotions, cultural criteria, and ideology are all involved. These are all implicated in "entertainment evidence," which is generated primarily by the mass media, but also reflected in consumption, style, and leisure (Ewen 1999; Ferrell and Sanders 1995). Mass-media information and entertainment are governed by the principles of an ecology of communication, which refers to the structure, organization, and accessibility of information technology, various forums, media, and channels of information. It provides a conceptualization and perspective that joins information technology and communication (media) formats with the time and place of activities. From this perspective, any evidence derived from the mass media is reflexive of the technology, formats, and production process. The pervasive character of mass-mediated information in contemporary society suggests that our culture is becoming a media culture.

In a broad sense, media culture refers to the character of such institutions as religion, politics, or sports that develops through the use of media. Specifically, when media logic is employed to present and interpret institutional phenomena, the form and content of those institutions are altered. As I will note below, this has important implications for the social construction

and presentation of propaganda-as-evidence that pervades news and entertainment.

As suggested by Snow's (1983) analysis of "media culture," the entertainment format emphasizes (1) an absence of the ordinary; (2) the openness of an adventure, outside the boundaries of routine behavior; and (3) that the audience member is willing to suspend disbelief. In addition, while the exact outcome may be in doubt, there is a clear and unambiguous point at which it will be resolved. Packaging such emphases within formats that are visual, brief, action-oriented, and dramatic produces an exciting and familiar tempo to audiences. Moreover, as audiences spend more time with these formats, the logic of advertising, entertainment, and popular culture becomes taken for granted as a "normal form" of communication.

Communication patterns, uses, and formats constitute evidence. Epistemic communities are emerging from historical and social contexts and events, including technology, mass media, and mass-communication formats. Partly due to the massive marketing and commodification industries, each new medium (e.g., radio, television, Internet, videotape, CD, DVD, cell phones, iPods, etc.) becomes associated with a generation (or two), and this forges epistemic preferences and communication logics that distinguish one generation from another.

Just as language and words are symbolic windows into the social construction process, mass media and popular culture increasingly provide the frames on which these windows rest. There is ample support that the mass media informs what people "know" and believe about social problems, issues, and even political decisions (Couch 1995; Gronbeck et al. 1991; Grossberg et al. 1998; McLuhan et al. 1997). While scientific versions of evidence assume a discourse grounded in critical and comparative thinking, participation in everyday life requires no such critical stance (Couch 1995). It is also apparent that what people regard as "evidence" is informed by the mass media, at least regarding criminal justice procedures. The very popular TV show *CSI* (*Crime Scene Investigation*) appeals to audience members because the cast resembles a family (Cavender 2004), but also because crimes are solved with detailed and very creative use of forensic evidence. A subtext of many of these scripts is that things are not always apparent, evidence is not clear-cut, and informed questions should always be asked about suspects and evidence. From a social science standpoint, we lack solid evidence that TV influences criminal justice outcomes (Tyler 2006), but one study suggests that this has informed "real" jurors:

> "It does seem clear that these programs are influencing people's perceptions of the legal system, which is in turn influencing the professionals who work within the legal system and the way in which they interact with the public. So we're

seeing this kind of a CSI effect," Dr. Marc Patry, one of the authors of the study, told CTV's *Canada AM*.

Patry said that the study indicated that public interaction with police has altered because of their different expectations. Consequently, the police are changing the way in which they interact with the public.

"When (police) go to a crime scene…the victims of the crime will follow them around and ask them, 'Gee did you dust over here for fingerprints and did you check the carpet over here for fibre samples?,'" Patry told *Canada AM*.

In one instance, a woman placed a brick that was thrown through her window in a freezer bag as evidence, he recounted.

"People's expectations of what's possible at a crime scene have really changed," he said. (CTV.ca and Staff 2007)

It is apparent that evidentiary narratives are reflexive of cultural narratives, although they are not synonymous. Gunnar Myrdal and colleagues (Myrdal et al. 1944) pointed out that there may be inconsistencies—as explored in *An American Dilemma*—about how we *should* treat all citizens, compared to how we *actually* treat them. Myrdal argued that this creates a deep cultural tension, which would work itself out in unpredictable ways. Recalling the discussion above about how social science data and evidence may not be honored by most people, it comes as no surprise that the American Dilemma persisted for several more decades until TV coverage brought some representations of the civil rights movement into American living rooms. As television contributed to the emergence of our more visual society, so too did it add to "visual evidence." This coverage challenged the cultural narrative about discrimination and altered the audience's visual experience and ultimately changed the evidentiary narrative about equality for many American citizens. This was particularly revealing when cameras showed police brutality against church-going black citizens, especially children.

> Most memorable, perhaps, of all these dramatic video images is the 1963 attack on young civil rights protesters by the Birmingham, Alabama, police and their dogs, and the fire department's decision to turn on fire hydrants to disperse the young black demonstrators, most of whom were children. Television cameras captured the water's force pushing young, black protesters down flooding streets like rubbish during a street cleaning. Unquestionably, this was compelling and revolutionary television. (http://www.museum.tv/archives/etv/C/htmlC/civilrights/civilrights.htm)

It was difficult to deny what had been seen by so many, especially when images were replayed and new ones occupied more space in the rapidly emerging technological order that was transforming social experiences into

visual images. An evidentiary narrative is not easily sustained by repeated viewing of contrary and "believable" experiences. It is for this reason that those who control such narratives strive to control and regulate information, particularly visual renderings. Despite the potential power of the image, what we call things still matters a great deal.

■ The Evidentiary Narrative and the Iraq War

The Iraq War offers numerous examples of the importance of what we see and call things, of the synthesis of context, situation, and stance, but we could use others. The following pages provide examples of how evidence is constructed and interpreted by epistemic communities that share basic assumptions about the moral superiority and righteousness of the United States. Scientific rationality or critical thinking is subordinate to absolutist thinking (Douglas 1971). The role of the news in defining, selecting, and framing reports is critical.

Fear tends to dominate the mass media. Evidentiary narratives susceptible to doom and gloom from the news media could find ample support for hostile views about the "Arabs," along with reassurance that steps would be taken to protect citizens from the objects of fear. Visuals of the "falling towers" on September 11, 2001, sustained an evidentiary narrative about the heartless enemies of the United States, and the necessity to make war against Iraq and do whatever was necessary to prevent such attacks in the future (Altheide 2006). Evidence was set forth to support the false claims about Iraq (Denzin 2007). Opinion poll data showed that for at least six years after this event, one-third or more of the American people believed that Saddam Hussein and Iraq were responsible for these attacks. It is what they "saw"—the destruction—that mattered. The repeated showing of the visuals, an unprecedented propaganda campaign, and the emotional appeals of the Bush Administration about the ongoing threats to the United States added to the pervasive discourse of fear that permeated our national culture (Altheide 2002).

One example involves the extensive use of more than 180,000 "contract" workers to cook and build, plus an estimated 50,000 former military people who work for rapidly growing security-for-hire companies that have received billions of dollars in government contract work. One of these, Blackwater (Silverstein 2006), came under scrutiny after its employees—who are largely autonomous from U.S. military control—killed 17 Iraqi citizens in what came to be understood as an unprovoked attack (Johnston and Broder 2007). Despite operating in the shadows for several years and engaging in numerous ques-

tionable shootings and attacks, the mass shooting attracted a lot of attention. What would the evidence be? Who would hear it? What would it look like? The director of Blackwater (Erik Prince) quickly grasped the importance of rhetoric and the evidentiary narrative via the mass media. He knew that what we call things matters for what will be taken as evidence, what will be scrutinized, so he had to take a stance. When challenged, he countered:

> He forcefully rejected the characterization of Blackwater from some members of the committee as a mercenary army. He said that contractors had served with the United States military since Revolutionary times and that mercenaries were soldiers who fought with foreign armies for money.

> *"They call us mercenaries," he said. "But we're Americans working for America protecting Americans."* (Broder 2007)

Upon further questioning by congressional committee members, Mr. Prince did acknowledge that his company employed "third country nationals" (TCNs) from Latin America and Eastern Europe, while also providing security in other countries, presumably by non-native workers. But these were only facts, and not relevant *vis-à-vis* an evidentiary narrative that would be connected to broader themes. Whatever evidence might be uncovered would be polished through the dominant cultural narrative of patriotism. Mr. Prince acknowledged that "crazy things" had happened, that they had fired some zealous and violent individuals, but the organization and service was sound. And they had "compensated" families of the numerous civilians they killed with $2,500–$5,000. (This was consistent with what the U.S. military paid for collateral damage.) To help drive home this message that they were a sound, useful, and patriotic operation, Mr. Prince quickly hired a stable of attorneys and public-relations people to help "manage" and define the situation, including, of course, exclusive interviews to "set the record straight." The strategy involved redirecting the charges away from the single shooting— and avoiding discussion of dozens of other provocations—to the broader purpose of being patriotic and defending the United States and its troops, boasting that their main charge, to protect diplomats, had been 100% successful; not one had been injured by the enemy! The aim was to move discussion away from prosecuting any Blackwater employee—and certainly not Mr. Prince—because they, after all, had been granted immunity by the former head of the Coalition Provisional Authority (CPA), Paul Bremer. Thus, Blackwater employees and the tens of thousands of other hired guns were not officially accountable to anyone: not the U.S. government, not the military, not Iraq. The discussions focused on changing some rules to make the mercenaries accountable to military authority in the future. Thus, frames were

skillfully manipulated to resonate with audiences attuned to the patriot games.

It is helpful at this point to review the process of evidence and how it is constituted by an actor, audience, a point of view, and context. Dominant evidentiary narratives are not displaced easily because their standpoint is all-encompassing and does not accommodate detractors. Thus, Blackwater was not a rogue organization; it was headed by a former U.S. soldier—a S.E.A.L.— who was quite wealthy and had supported Republican candidates. Moreover, they had a contract with the United States to help fight terrorists in a war zone. This was part of the cultural narrative that guided the evidentiary narrative. The problem was that the evidence about inappropriate and shocking killing of civilians was not likely to be considered as long as the cultural narrative remained unchallenged. After all, our cultural narrative is that troops and soldiers are fighting for us and in a fundamental sense represent us, and "are us." There is always a subtext of sacrifice, including loss of life. But highly paid mercenaries, who are not under our military's command, are another thing altogether. Both narratives are intertwined and difficult to offset in the context of numerous images and claims about "troops" and the "insurgents," who will stoop to anything. I will return to this scenario below.

Let me reiterate a few points about evidence and how I think that we can approach the subject anew. Evidence is a process, a communicative act that is part of a story. Evidence is a social accomplishment that requires a context, perspective, and framework, as well as an audience supportive of certain claims. Part of the challenge is to study how these stories get put together, what language and meanings emerge, disappear, and over time become normalized as part of the context, perspective, and narrative. Applying a perspective developed to articulate ethnography can be helpful in focusing on documents, which I believe contain the gems of the evidentiary narrative.

Analytic realism is a useful framework for obtaining data from documents, or any information contained in a medium that can be recorded and retrieved for inspection. The key is to ask questions about documents in such a way that information can be transformed into data, which in turn can be analyzed and presented in an "evidentiary narrative" appropriate for the task, the prevailing logic among the participants, and for the audience at hand.

■ Documentary Evidence and the Evidentiary Narrative

The retrievability of documents renders them an ideal source for investigating the evidentiary narrative as it is revealed over time, first in one epistemic

community, then spreading to others, and eventually penetrating more public discourse (Altheide and DeVriese 2007). I want to make documents discursive by showing how documentary evidence can be interpretively understood, emergent, and relevant for a topic of investigation (Altheide 1996). There are many illustrations of qualitative document analysis (Altheide 2006; Altheide 2002). The key is the process of understanding and linking that with concepts, themes, and symbols germane to cultural meanings. Consider the question of how we deny humanity to the "other," outsiders, the enemy (Schwalbe 2000). One way to approach this is to examine empathic statements made or withheld from insiders and outsiders. There are ample documents available for this. A key, however, is to juxtapose empathic with non-empathic comments about loss of life. This is evidence for many people—and certainly not just social scientists—about the symbolic boundaries that guide conduct.

Consider two incidents involving people being killed. The first occurred in Pakistan in January 2006 when a U.S. drone was programmed to fire 10 missiles at several houses where an Al Qaeda leader was believed to be. Eighteen people were killed, including women and children. The target escaped. Please note the way that cultural narratives are embedded about "them" and "us" in reviewing the following materials.

One foreign journalist challenged the evidentiary narrative and questioned why the civilian deaths in Pakistan were treated much differently:

> What makes the latest gory incident more abhorrent is that at least 18 Pakistani citizens, including eight women and five innocent children, were torn into pieces by the deadly missiles. This is nothing but sheer terrorism. As per US version, some foreign elements, especially Ayman al-Zawahiri, were the real target of the aggression. However, even if there were some foreign figures, the saner approach would have been to pass on the information to Pakistani authorities to carry out necessary operation against them. (Staff 2006)

At least one U.S. newspaper, the *Christian Science Monitor*, suggested that some remorse might be shown for the Pakistani civilians, further stating that this would help U.S. interests:

> The attack was meant to kill Al Qaeda's deputy leader, Ayman al-Zawahiri. It appears to have missed its target, though it killed some of his aides. It certainly killed a dozen Pakistani villagers, including women and children. This is the second such attack on Pakistan in a fortnight, and the previous one also caused eight civilian deaths.... The Bush administration, however, has yet to express regret to the Pakistani government and people over the deaths of women and children. It would also be a good thing if the US media recognized just how much damage this kind of silence does to the US image and US interests...not only has the administration failed to make a gesture that would have cost it nothing, members of Congress have rubbed salt in Pakistani wounds by affirming that

the strike was justified but failing to express equally clearly about their sorrow about the "collateral" deaths of innocent civilians." (Lieven and Menon 2006)

About a week later, President Bush traveled to Pakistan and did not refer to the civilian killings.

With Pakistan's prime minister, Shaukat Aziz, at his side, Mr. Bush spoke about areas of agreement, like trade and fighting terrorism, in four minutes of public remarks in the Oval Office. The president called the countries' relationship "vital," while Mr. Aziz called it "multifaceted" (Bumiller 2006).

Grief is tied to legitimacy: grief is for "us" but not "them." But our empathy seems to be essential to raise, if not listen to or even "see" evidence; it is the evidentiary narrative that helps frame information, give it the essential meaningful dimension that can make it significant. President Bush's lack of concern is telling, but it tells it a lot louder when it is compared with the shooting of faculty and students at Virginia Tech University in April 2007. These deaths were not justified, and certainly not ignored. This is what the president stated about the Virginia Tech shootings that took the lives of 31 students:

"It's impossible to make sense of such violence and suffering," Bush said.... "Those whose lives were taken did nothing to deserve their fate," the president said. "They were simply in the wrong place at the wrong time. Now they're gone, and they leave behind grieving families and grieving classmates and a grieving nation." (April 17, 2007)

It should be added, of course, that no one implied that the students did anything to "deserve their fate."

There is a striking contrast with death as collateral damage in fighting terrorism. The "vital" concern with terrorism informs what is relevant and what is not relevant. For all practical purposes, evidence that does not fit with the evidentiary narrative is not relevant because it is not symbolically enclosed in context of meaning. When all that matters is support for "our fight against terrorism," then loss of civilian lives, or even the Pakistani leader, General Musharraf, suspending the constitution and imprisoning his opposition as well as international human rights workers—as he did in November 2007— does not matter a great deal, as long as "our fight against terrorism" can continue. So how did the United States officially respond to this crude smashing of dissent and democracy in a country very dependent on U.S. aid? Note the reference to being "cognizant" and, presumably, examining "evidence":

Secretary of State Condoleezza Rice said that while the United States would "have to review the situation with aid," she said three times that President Bush's first concern was *"to protect America and protect American citizens by continuing to fight against terrorists."*

"That means we have to be very *cognizant of the counterterrorism operations* that we are involved in," she said. "We have to be very cognizant of the fact that some of the assistance that has been going to Pakistan is directly related to the counterterrorism mission."

In Islamabad, aides to General Musharraf—who had dismissed pleas on Friday from Ms. Rice and Adm. William J. Fallon, the senior military commander in the Middle East, to avoid the state-of-emergency declaration—said they had anticipated that *there would be few real consequences.*

...In unusually candid terms, they said *American officials supported stability over democracy. (Sanger and Rohde 2007;* my emphasis)

Evidence has a symbolic and cultural trajectory. Evidence, like a major-league power pitcher, reaches back before hurling meaningful symbols. Documents can help us appreciate how language reifies symbolic boundaries and affirms assumptions about identity and membership. The words that we use reflect the contexts of meaning that lead us to call some actions one thing rather than another. Any claim "that we did that rather than this" is easily brushed aside by disagreeing about what "that" and "this" are. This is important since any attempt to get "evidence of brutality" in policing or military action is offset by calling brutal acts something else. We saw this in the Rodney King trial and other cases involving police use of force, but we also see it in war. This suggests that membership plays a key role in what is regarded as evidence.

■ Evidence as Perspective and Membership

I have suggested to this point that evidence is not a matter of fact, but involves interaction between a claims-maker, an audience, and a body of information. My emphasis has been on evidence as a process. Now I wish to explore how one's perspective and identity are features of membership in a group, broadly defined.

The evidentiary narrative flows from the emotional and even moral grounds of communication in everyday life. The nature of the information we receive, what importance to give it, and any thought of its truthfulness turns on the situation, and particularly our knowledge, affection and commitment to a particular person. Research suggests that people are more forgiving and are willing to more positively frame indiscretions by those whom we feel closer to, and regard as more honest, e.g., "reframe the ethical violation as a competence violation" (Carey 2007). Below I will discuss how

important membership is for our assessment and honoring of certain accounts.

The evidence process is, in a sense, quite personal, because it involves a willingness and openness to consider claims about reality. Our sense and largely taken-for-granted understanding of who we are spills over into not only what we know, but also what we can know, and, most fundamentally, what "knowing" or "knowledge" even looks like. How we see things is often a feature of what we regard as relevant, irrelevant, appropriate, and inappropriate. It is very important to stress that a key step in the evidence process is tacit knowledge, or an unarticulated and often unfocused "feeling" of what is right or appropriate (Altheide and Johnson 1993b). This ineluctable glow of "being in the right ballpark," so to speak, means that we are in familiar and proper territory.

We are socialized into recognizing and accepting evidence as we acquire symbolic categories as "gates" and "chutes" of information. As I have tried to stress, the problem of evidence is *not* lacking the intelligence to follow reasoning of an argument, but rather the inability to overcome symbolic constraints limiting eligibility of information. An important feature of evidence is what is excluded. This is why I focus on membership, especially one's biography, which—no matter how personal it seems—is encompassed in most cases by concentric fields of family values, religious sanctions and directives, neighborhood and regional guidelines, social class, and ethnic and religious symbols. We learn what is acceptable to even be considered as relevant. That is to say, we learn what we won't even listen to or take seriously. A leading example is what we learn from parents about basic directives concerning right and wrong, what we should and should not do, and, more generally, what people like us believe. As our previous examples about race prejudice and group position suggest, such beliefs are often foundational for people regardless of their level of education, etc.

One's sense of peoplehood/personhood contains a regimen of what is acceptable and what is unacceptable. This is where identity is so important: Our awareness of how we are viewed by others greatly matters to us. For example, religious orders instruct their novitiates (often children) to ritually and rhetorically practice and "play" at denouncing and excluding counterclaims to their religious persuasion, but also the "messengers." Evangelical Christians, for example, learn early in life that the devil is always tempting us to listen to other voices, other appeals, and even if certain arguments seem plausible, they should beware that this is devilish trickery. Indeed, even the most fundamental questions of consistency are easily dealt with in this way. As a child, I recall asking my parents why God would permit horrible things (e.g., rape, murder) to happen to Christians. The answer was always the same:

Things happen that we cannot understand but that make sense to God. We were further cautioned that to push the argument further meant that we were trying to second-guess God, which was tantamount to blasphemy. I asked essentially the same question about why God would not "heal" my mentally retarded sister, but would heal others. Same answer. Years later one of my brilliant philosophy teachers would ask, rhetorically, why we should worship any God who was not intellectually respectable and morally consistent! (For an evangelical, this person was bound for hell!) The point is that contrary evidence was part of another discourse, and this was out of bounds, not for consideration.

Evidence as process can be illustrated with many contemporary examples. Take politics. When leaders are consumed by ideology and take actions that are consistent with beliefs, then we have ideologically informed decisions that may or may not work out. They usually do not, but then again, that is the same problem: How do we know that things aren't working out? What evidence would we accept? That question quickly becomes "whose evidence," which implies, of course, that all evidence is linked to perspective, not truly objective and "bias free." And there is considerable truth to that. This point can be illustrated by the ways in which staff were appointed for the Coalition Provisional Authority in Iraq. This is a good case study because it is fairly recent (2008) and also because it is one of the most ideologically driven crusades in modern history.

The concern of the Bush Administration was to have key workers in Iraq who were loyalists to a narrow party line. On the one hand, it is quite common for politicos to appoint "fellow travelers" to positions, but on the other hand, they usually prefer that such appointees have a modicum of competence in the appointed area. This was not the case in Iraq. Several journalists and government officials familiar with the process in Iraq have commented on how people were selected for positions in Iraq based more on their conservative politics and loyalty rather than experience and competence in the subject area. A former officer, Anthony Cordesman, explained how people were appointed:

> All of these factors seemed to combine, but to try to figure out exactly how they weighed on Vice President Cheney is very difficult. What you can say is he was the first vice president to create a large foreign policy staff, and it was the most ideologically rigid and biased staff possible. *You can't find one name there that was not part of this neoconservative structure.*" (My emphasis)

The *Washington Post* Baghdad bureau chief discussed how far ideology reached substantive areas of expertise.

What happened was that the hiring was done by the White House liaison to the Pentagon, an office of the Pentagon political appointee. This office served as the gatekeeper. Instead of casting out widely for people with knowledge of Arabic, knowledge of the Middle East, knowledge of post-conflict reconstruction, they went after the political loyalists and canvassed the offices of Republican congressmen, conservative think tanks and other places where they knew they would find people who would be unfailingly loyal to the president and to the president's mission in Iraq....

The hiring process involved questions that would have landed a private-sector employer in jail. They asked people what their views on *Roe v. Wade* were, whether they believed in capital punishment. A man of Middle Eastern descent was asked whether he was Muslim or Christian. People were asked who they voted for for president. (*FRONTLINE* Interview)

Membership informs what is taken for granted about reality, as well as what is not likely to be questioned and challenged. This is true of executing a war as well.

The way in which civilian killings in Iraq were presented illustrates the context of meaning that produces and reflects evidentiary discourse and language of "we do no wrong." It is a language of membership. While the U.S. military has prosecuted some 200 cases of violent crimes in Iraq, the contexts of war, combat, ideology, and beliefs about the "enemy" make this a very rare—and difficult—task. Much of the problem involves the language and discourse that we use to refer to acts (van Dijk 1985). However, we can learn from these cases, particularly about the nature, process, and context of definitions and uses of "evidence."

The evidentiary narrative of wrongdoing and brutality encompasses certain symbols within its discursive frame. One example is "gunmen," usually associated and framed with crime and criminals. There are several pieces to this: the context, the purpose, the use of a gun (weapon), who uses it, and on whom is it used, e.g., an innocent party. Use of the word "gunmen" is illustrative of the relationship between evidence, symbolism, and context. Research indicates that "gunmen" is seldom used by journalists (narrators) on your side to refer to actions by soldiers or other violent agents committed by your side. For example, a police officer who accidentally or intentionally shoots a civilian or a suspect is not referred to as a "gunman." Gunman is almost always the "other," on the "other" side. We can look at this in terms of a couple of examples. After former Secretary of State Colin Powell stated in September 2006 that the Iraq War was not helpful to the United States's moral reputation, President Bush stated:

"It's unacceptable to think there's any kind of comparison between the behavior of the United States of America and the action of *Islamic extremists who kill innocent*

women and children to achieve an objective," said Bush, growing *animated as he spoke.* (http://www.msnbc.msn.com/id/14848798/; my emphasis)

The enemy was presented routinely as "insurgents," and more typically as "gunmen" in press reports. This is consistent with crime coverage as well as the enemy. Here's an excerpt from a news report in 2001 about Palestinians and Israelis. When the former kills, it is by "gunmen," but not so the latter:

> The Israeli Army said it *attacked in reprisal* for the killing on Saturday of an Israeli motorist by *Palestinian gunmen* in Jerusalem. (Bennett 2001; my emphasis)

One account illustrates the "barbarism" attributed to Iraqi "gunmen," while the killing by U.S. soldiers is described as simply "killed."

> Baghdad, Iraq—U.S. forces...recovered the bodies of two American soldiers reported captured by insurgents last week. An Iraqi defense ministry official said the men were *tortured and "killed in a barbaric way...."* Maj. Gen. Abdul-Aziz Mohammed said the bodies showed signs of having been tortured. "With great regret, they were killed in a barbaric way," he said.... Also, just hours before the two soldiers went missing Friday, a *U.S. airstrike killed a key al-Qaida in Iraq leader described as the group's "religious emir,"* he said.
>
> Mansour Suleiman Mansour Khalifi al-Mashhadani, or *Sheik Mansour, was killed* with two foreign fighters in the same area where the soldiers' bodies were found, the U.S. spokesman said. The three were trying to flee in a vehicle.
>
> ...seven masked *gunmen,* one carrying a heavy machine gun, killed the driver and took the two other U.S. soldiers captive. (Gamel 2006; my emphasis)

The Haditha slaughter, in which 24 Iraqis were executed, is the single example located (thus far) of U.S. journalists referring to U.S. soldiers as "gunmen." Following a roadside bombing that killed a U.S. soldier on November 19, 2005, U.S. troops entered several houses nearby and shot 24 Iraqi citizens ranging in age from 4 to 89 (the latter an old man in a wheelchair). And this was the reference to "gunmen":

> "Everybody was at home when the *gunmen* arrived. Except for one 12-year-old daughter, the family was wiped out. Four girls and one boy, ranging in age from 4 to 15, were shot dead by the Marines, neighbors and the surviving child said." According to 12 year old Safa, the Marines yelled in the faces of her family members before they shot them.... After they were shot, they kicked them and hit the bodies with their guns. "I feel sorry. I was wishing to be alive," Safa said. "Now I wish I had died with them." Survivors say Marines went house to house in a rage. (Stack and Salman 2006; my emphasis)

Other writers and publications did not refer to the U.S. soldiers as "gunmen," despite the large amount of corroborating information about the cal-

culated shootings in Haditha. Indeed, in dozens of follow-up reports on the incident, "gunmen" was only used to refer to others—insurgents—who allegedly fired at the U.S. troops, thus leading them to attack the Iraqi civilians. Even subsequent legal investigations of the soldiers involved would not use the term. Instead, other terms and phrases were used to contextualize the discourse of war, e.g., men under stress, grieving, loss of judgment, etc.

The term "gunmen" did not suit the cultural narrative for the journalists, and quite likely most of the U.S. news audience. Gunmen, usually reserved for enemies, was not used in this massacre because the evidentiary narrative was not appropriate for it: after all, the dead were associated with the enemy, and the alleged killers were our troops. Evidence involves process in a context, for the purpose at hand. Ironically, people who supported one of the accused cited the lack of solid evidence for conviction (within an adjudication framework).

In interviews, organizers and contributors said they believed that many prosecutions were based on *feeble evidence* and gauzy recollections of Iraqis sympathetic to the insurgency and hostile to the U.S. military mission in Iraq. They note the case against Lance Cpl. Justin L. Sharratt, charged with killing three unarmed Iraqi men at point-blank range in Haditha in 2005. A Marine lawyer investigating the charges recommended dismissing them this month, for *lack of evidence*, and warned that pressing flimsy cases against *combat troops* "sets a dangerous precedent" that *eroded public support for the war* and could cause troops to hesitate when fighting a *determined enemy*. (Von Zielbauer 2007; my emphasis)

It is important to stress that the evidentiary narrative being set forth in the above appeal to "lack of evidence" and "flimsy evidence" joined the implicit connections between witnesses—who were sympathetic to insurgents (although no evidence is presented about this!)—to the public support for the war, as well as causing "combat troops" to "hesitate" and perhaps be endangered by a "determined enemy." In short, to use the word "gunmen" would weaken and invalidate the evidentiary narrative that sustains the definition of "combat troops" and even "public support for the war." But there is more.

The importance of membership and orientation toward outsiders is common in war contexts. The situational and very opportunistic perspective about evidence can be illustrated by news reports of the murder of a disabled Iraqi man by several U.S. Marines in the village of Hamdania in April 2006. The news report explicates what was implicit: *The evidentiary narrative is apparent. "They" are all bad.* The Marines' real target was a suspected "insurgent" Saleh Gowad, but they could not find him, so they grabbed another man because

they were intent on killing someone in the area, since they believed that most residents were insurgents or were friendly to them.

> According to the testimony, an eight-man squad decided to kill a known insurgent named Saleh Gowad. Unable to find Gowad, the Marines snatched Hashim Ibrahim Awad, a disabled police officer, from a nearby house, bound him and marched him about a half mile to a bomb crater, where they placed a shovel and a rifle and then killed him in a way that made it look like they'd been in a firefight with a man planting a bomb. (Perry 2007)

Notwithstanding that some 200 military personnel have been prosecuted for illegal assault and murders in Iraq, most of the military attacks on Iraqi civilians apparently go unreported (Badkhen 2005; Stack and Salman 2006). But this one got some attention, and charges were filed against the eight-man squad.

The role of membership for evidence is particularly apparent when it comes to justice. Justice in a war context is quite problematic, especially when different audiences have widely disparate contexts and frameworks for recognizing an injustice, on the one hand, and then holding someone or something accountable. My focus is not on different opinions, but on what people use and refer to as evidence. I am particularly interested in how different criteria are brought to bear on the general situation as well as the specific matter. By the general situation I mean perceptions of right and wrong, killing the enemy or "any of them," and how prosecutors of such deeds as well as the news media might be viewed. For example, numerous groups emerged to provide defense funds and other support for any soldiers who were charged with crimes. The implicit meanings of many supporters' statements is that combat operations bring specific pressures and problems that cannot be understood by "outsiders," those who are not actually in the combat situations. Notes posted on Web sites illustrate how some conservative Christians and military veterans oppose prosecution of soldiers:

> "I wonder if you are supposed to check out each enemy to see if they have a gun or wait for them to shoot first," wrote a 98-year-old woman from Grand Junction, Colo., who recently sent $25 to the Military Combat Defense Fund, a Boston-area group that has provided more than $85,000 to smaller funds set up for individual Marines accused of murder and other crimes in Haditha and Hamdania, Iraq. "Bible says that the country will always be fighting. We have been praying for all you boys and girls...." A Marine lawyer investigating the charges recommended dismissing them this month, for *lack of evidence*, and warned that pressing flimsy cases against combat troops "sets a dangerous precedent" that eroded public support for the war and could cause troops to hesitate when fighting a determined enemy. (Von Zielbauer 2007; my emphasis)

Basically, the supporters take the position that the military cannot be held accountable for any misdeeds since they are in a war. While some sites do not support cases that appear to be premeditated, other Websites include messages by parents and friends of soldiers charged with such crimes:

> Terry Pennington, a former Air Force technician whose son, Lance Cpl. Robert Pennington, was among the Hamdania Marines who pleaded guilty, said: "Many of these people see this country as not having the guts anymore to fight a war. They're outraged really all the way up to the White House." (Von Zielbauer 2007)

The evidence to support one's contribution to a Website is more conceptual and abstract, except perhaps for family members who have a loved one who is being charged with a crime. However, a more specific scenario arises when individuals are charged, tried, and judged by their peers who, presumably, would share the evidentiary narrative, which essentially would disavow acts of brutality as evidence. Thus, attorneys for individuals charged in military courts with heinous crimes are eager to demand that juries of "peers" include many individuals with combat experience in Iraq. Cpl. Trent Thomas, who was convicted of kidnapping and conspiracy to commit murder, in conjunction with the murder in Hamdania discussed above, was sentenced to the 14 months that he had already served, along with a bad conduct discharge.

> All nine jurors were combat veterans of Iraq, seven of them from infantry battalions. Of the three officers on the jury, two had experience as enlisted Marines. Five of nine jurors were black, like Thomas.

> After the verdict, Thomas' civilian and military lawyers told reporters that they wanted to thank Lt. Gen. James Mattis for making sure Thomas had "a true jury of his peers." (Von Zielbauer 2007)

The importance of "membership" and being evaluated by criteria and perspectives shared by one's judges was apparent when it could not be guaranteed. Col. Robert Pennington accepted an eight-year sentence as part of a plea bargain when his attorney could not guarantee a more friendly jury:

> Deanna Pennington, the mother of Cpl. Robert Pennington, who pleaded guilty in the same incident and accepted an eight-year prison sentence, said later that her son took a plea bargain because his jury pool contained few combat veterans. Her son, a former resident of Snohomish County, feared that Marines who had not been to Iraq would never understand what happened in Hamdania that night in April 2006. (Von Zielbauer 2007)

Clearly, there was a sense that the support and tacit knowledge/experience of combat veterans in Iraq would help one's case, even when certain

facts about premeditated killing were uncontested. It was the meaning and justification of such acts, e.g., stress and anger, that apparently mitigated the other evidence, by providing a context of membership, brotherhood, and a moral order. As noted in one account:

> Looking at his fellow Iraq veterans on the jury, Thomas, in an unsworn statement before the sentencing deliberations, talked of the kind of experience they have in common: the grief of seeing buddies killed in combat. After losing friends in Fallujah, he said he decided, "I'm getting cheated on life. This ain't right." (Von Zielbauer 2007)

■ Conclusion

This analysis of the *evidentiary narrative, which symbolically joins an actor, an audience, a point of view, assumptions, and a claim about a relationship between two or more phenomena,* focuses on evidence as process, in order to provide another way to understand how everyday life perspectives inform what we see as relevant, confirming or disconfirming of various beliefs, assumptions, and theories. Other chapters in this book make it apparent that terrorism, especially the terrorism narrative, carries its own theory and perspective about evidence. I suggested in this chapter that applying our understanding of how researchers approach ethnographic data and methods could illuminate a fresh look at the conundrums implicit in formulating and justifying courses of action ranging from domestic violence to state warfare. I do not think that this is a complete statement about evidence, nor do I contend that all the major issues have been identified. Taking into account how people in epistemic communities locate their lives, identities, and projects in interaction with others, and how these are understood and communicated can contribute to more understanding and hopefully more tolerance. I am convinced that unless we can understand how contexts of meaning are constructed and enacted—and taken for granted—we cannot promote more communication so that we are at least talking about the same things. This, then, is the problem of evidence: It is less important to convince or change someone's mind than it is to apprehend what they mean, what is the source of it, and how was this communicated.

The mass media play a critical role in contemporary evidentiary narratives about terrorism and issues, which are reflected in numerous documents that can be retrieved and analyzed. What we know, see, and believe is interactively shaped, affirmed, and perhaps even revised as audience members interpret, discuss, and reframe messages, representations, and images of reality, including images and issues. Language, and especially discourses and scripts, reflect

the media processes, including the technology, formats, and style and action that is presented. While the information is transformed into meanings through numerous filters, there is more evidence that certain themes, e.g., fear, are cumulative and become more embedded and taken for granted, which in turn shapes future interpretive frameworks. Fortunately, more journalists are reflecting on the role that they play in this new media where spin and frames are studied, promoted, and skillfully used to misinform and deceive. One editor has called for a "rhetoric beat" to signal public attention to this process in specific events:

> Still, the consequences of the decision to describe 9/11 as the beginning of a war rather than a criminal investigation drive home the importance of political language in a way that a similar semantic debate over "death tax" versus "estate tax" cannot. In the years since that decision, language—its uses and abuses—has emerged as a central issue in our political culture.... It's too late to adjust the war frame that was constructed after the attacks on 9/11. But there is another monumental framing debate looming. For the first time since Vietnam, the U.S. is stuck in an increasingly unpopular foreign conflict with no clear way out. It is undeniable that bad information, ushered into the realm of "fact" in some cases by rhetorical malfeasance, played a central role in getting us there. Now the nation's focus is shifting to how and when to get out and, more important for our purposes, there is a corollary need to *describe* the getting out.... (Cunningham 2007 p. 39)

Developing our skills and sensitivity to analysis of documents can illuminate methodological stances and approaches for mining the incredibly rich record of evidence gained, lost, and, more typically, completely overlooked.

Reflecting on the news coverage of terrorism after 9/11 can illuminate what we failed to see in the intial coverage. Pondering how certain aspects of the coverage were missed can, in turn, help sharpen our vision of future events. We shall see in Chapter 8 that the terrorism narrative taints rules of evidence.

■ Terrorism as Moral Panic

■ Introduction

The previous chapter, which dealt with evidence, noted that social definitions and meanings are often contested and that opposing positions reflect different assumptions and perspectives about social reality and the methods and rules for understanding events. This chapter will show the relevance of that reasoning in the failure to frame news-media reports about terrorism in more familiar ways. The role of ideology in routine news reports is also illustrated by comparing how the media in the United States and United Kingdom treated terrorism and other sensational mass-media reports.

Journalists and mass-media critics initially did not view the jaded reports about terrorism in a manner that was consistent with analytical concepts that were developed to keep extreme media accounts in proper perspective. Propaganda and moral panic are two concepts that social scientists developed to identify mass-media distortions of events, problems, and issues. The treatment of terrorism in the mainstream media—especially in the United States— was quite different from the more critical and analytical statements on Internet blogs.

This chapter examines how "moral panic" (MP) has been used by the mass media in a way that is consistent with entertainment formats. MP refers to the way in which "a condition, episode, person or group emerges to become defined as a threat to societal values and interests; its nature is presented in a stylized and stereotypical fashion by the mass media; the moral barricades

are manned by editors, bishops, politicians and other right thinking people; socially accredited experts pronounce their diagnosis and solutions; ways of coping are evolved or (more often) resorted to; the condition then disappears, submerges or deteriorates and becomes visible" (Cohen 1980). Unlike most sociological concepts, MP has been widely used by the mass media, particularly in the United Kingdom (Hunt 1997; McRobbie 1994), and the term is part of daily discourse. Anthony Giddens referred to moral panic in an essay about the relevance of sociology for public discourse: "Many people, for instance, now ask whether a leader has charisma, discuss moral panics or talk of someone's social status—all notions that originated in sociological discourse" (Giddens 1995). And McRobbie argued that MP became so embedded in social policy discussions that journalists in the United Kingdom routinely question politicians if they are stirring up an "MP" (McRobbie 1994). Despite its common usage, a review of materials suggests that there is a paradox of MP. On the one hand, mass media are credited with promoting MPs and contributing to exaggerated public fears that support social-control efforts and public-policy changes designed to reign in anti-social behavior associated with deviance, crime, and social disorder (e.g., drugs, sex, gangs, graffiti) (Millie 2008). On the other hand, MP is widely used in news reports, especially op-eds and editorials, that challenge such social-control efforts. I suggest that the logic of news formats accounts for the linkage of MP to news coverage of select topics, problems, and issues about social control.

My focus is on the process and logic by which MP has become newsworthy and ensconced in news reports, especially the "other side" of efforts to condemn and regulate certain behavior. Yet terrorism was typically not treated as a moral panic. I suggest that this can be explained in terms of entertainment-media formats. A qualitative media analysis of hundreds of news reports illuminates how MP was presented in media reports and was "socially constructed" by various actors for several purposes (Cohen 1980; Cohen and Young 1973; Hunt 1997). The qualitative materials help track how MP transitioned from sociological concept to public discourse over approximately three decades, and illuminate how popular culture can appropriate, redefine, and even misuse social science to denigrate, resist, and promote certain problems, issues, and policies (Goode and Ben-Yehuda 1994), while also clarifying how science as culture relates to the rest of culture (Knorr-Cetina 1999; Miller and Fox 2001). An analysis of the inclusion of MP within the news framework entails an overview of news formats and the discourse of fear.

■ News and the Discourse of Fear

Entertainment-oriented news formats, including the use of op-ed and editorial pages for audiences to express other points of view, help account for the expanded use of MP in news reports. The concept of MP is critical of claims about disorder that are carried routinely in news reports (Ericson et al. 1989). Gans (1979) found that U.S. commercial-news organizations tend to select items and events for news reporting that can be told in narratives that express ethnocentrism, altruistic democracy, responsible capitalism, small-town pastoralism, individualism, moderatism, social order, and national leadership. News coverage of social disorder and deviance are features of this narrative, and the negative coverage of such topics is often cast in moral terms that reinforce social order (Ericson et al. 1991; Ericson et al. 1987). Analytical terms and perspectives that question this narrative are seldom accepted in mainstream media (Kellner 1995). Hunt (1997) noted that some journalists referred to the use of MP by U.K. news organizations in the 1980s and early 1990s as "sociologese" of a left-wing polemic (Hunt 1997 p. 638).

Since the mid-1990s, MP has emerged from a counter-narrative to a news narrative that includes opposition or "other side" views and is incorporated within news formats (e.g., editorials and op-eds) that are dedicated to offering different views on certain topics. I argue that MP is used frequently in news reports because it fits well with news formats, which refer to the ways of selecting, organizing, and presenting information, and shape audience assumptions and preferences for certain kinds of information. By the same token, news formats cannot easily accommodate critical concepts that amount to debunking ideologically tinged concepts like terrorism. The following materials illustrate how MP fits better with newspaper than television formats, although both media rely on frames and familiar narratives that resonate with audiences (Schwartz 1973). Newspaper formats are more open for diverse views, and the major newspapers examined in this study had sections for "opinions," "features," and "reviews" that accommodate a wider range of views and interpretations about events, issues, and problems. While U.K. and U.S. television journalism differ in many ways, TV news formats are much tighter and limiting, especially regular news reports (Altheide 1987; Schlesinger et al. 1983). And, as already noted, national U.S. news relies heavily on official or governmental news sources that seldom critique governmental policy or social-control efforts (FAIR 2003) and are not likely to frame an issue as a moral panic.

Certain news forms have been developed as packages or "frames" for transforming some experience into reports that will be recognized and accepted

by the audience as "news." MP has been associated with research on social issues, and especially social problems and deviance, that questions or challenges the fear narrative, particularly about certain individuals and topics. Fear of deviants and "others" was the foundation for longstanding efforts to regulate and control deviance. Social constructionist approaches to the study of social problems and emergent social movements stress how mass-media accounts of crime, violence, and victimization are simplistic and often decontextualize rather complex events in order to reflect narratives that demonize and offer simplistic explanations (Best 1999; Best 1995; Ericson et al. 1991; Ferrell and Sanders 1995; Fishman and Cavender 1998; Johnson 1995; Taylor et al. 1974) that often involve state intervention, while adding to the growing list of victims. Labeling theorists (Becker 1973; Lemert 1962; Spector and Kitsuse 1977), for example, argued that audiences and officials were implicated in social definitions of crime and deviance, on the one hand, while their branding of individuals had important social consequences on the other. These consequences included promoting self-fulfilling prophecies whereby social stigmas (e.g., "criminal") could not only limit social interaction, but even promote self-identification with deviant groups, lifestyle, and even future deviant behavior. A qualitative analysis of news reports about fear and MP helps illustrate this process and shows how MP emerged as a feature of news discourse, albeit still limited to certain topics.

■ Moral Panic in Public Discourse

MP is one of the most successful sociological concepts to find its way to public media. There are hundreds of web pages on which it appears, and hundreds of news reports throughout its 35-year history. However, the use of MP by journalists and others (e.g., in letters to the editor) has varied widely in the years following Cohen and Young's initial publications.

MP was tracked across Lexis/Nexis from the mid-1980s to 2007, and trends were checked against another major information base, Westlaw. MP is used extensively in news reports—but even more so in letters to the editor and op-ed pieces—throughout the United Kingdom, Europe, the United States , and Australia; MP is also used as a resource—a kind of sociological "truism"—to critique government policies and social control of deviance, especially sex and drugs. Further, the use of MP in the news reflects a kind of "journalistic career" in moving, over time, from more concept-specific usage to much broader and "looser" usage that assumes audience familiarity with the term,

and more recently to become its own trope and thematic for making critical points as it has become embedded more firmly in journalistic discourse.

While most of our analysis emphasizes themes, the frequencies of reports in the United States (mainly in the *New York Times*) and the United Kingdom (mainly in the *Guardian*) are helpful. Other news media used MP, but the *New York Times* (NYT) and the *Guardian* were the most likely to present reports pertaining to MP, mainly on topics and policies about youth, sex, drugs, fear, violence, pedophiles, priests, crime, violence, police, politics, and media. Indeed, I will suggest below that mainstream news discourse connects moral panic to selected terms, but not others, for instance, terrorism. The use of MP in news reports increased steadily after 1985 in the U.K. (Hunt 1997) and U.S. news media. Since 1985, the *Guardian* has published more than 500 reports featuring MP, but two-thirds were opinions, comments, movie or book reviews, and media listings, while 75% of 150 articles published by the *Times* (London) were of a similar nature. U.S. newspapers published nine reports pertaining to MP, or about 2–4 times a year from 1985 to 1994, but this more than doubled between 1990 and 1994 (about 4 per year). The next 10 years would see the most rapid growth, to nearly 73 articles between 1995 and 1999—about 15 per year. Through 2007, the U.S. newspapers we examined published 206 articles, about 30 reports a year. Forty-four percent of these reports appeared in the *New York Times*. It should also be noted that the U.S. media, like their U.K. counterparts, used MP in numerous book reviews and opinion and op-ed comments, including many by social scientists.

MP was more likely to appear in print media than in television news. The distinctive formats for various media clarify why MP is used with print media, such as newspapers, but appears less often in electronic media, especially television news reports. Analysis of several information bases shows that that there were nearly 1,000 reports that referred to "moral panic," but newspapers claimed 934 of these. BBC commentators referred to MP in about 70 reports, but, with the exception of two CNBC broadcasts, major U.S. TV networks did not mention moral panic. (National Public Radio [NPR] featured 10 reports pertaining to moral panic.) This is quite remarkable and points to the closed and less reflective nature of U.S. network-news formats (Bennett 2005; Kellner 2004).

■ From Critique to Public Discourse

MP was used in various ways during the observational period. The metaphor of "career" captures the changing meanings and use of MP. As Hunt (1997) observed, in the mid 1980s MP was used as a cautionary rhetoric for avoiding,

negating, and resisting claims about certain social problems and issues. MP became a negative term associated with numerous reactive statements and social policy proposals about sex, drugs, and crime, the very topics upon which Cohen's work was focused. Consider an example about art and MP in 1989, involving threats from the Helms Amendment to withdraw arts funding if museums displays were inappropriate.

> The Whitney ad, in the form of an open letter, was headlined "Are you going to let politics kill Art?" Above the headline appeared a photograph by Robert Mapplethorpe, whose sexually explicit works helped spark the Helms amendment. The text declared that art "should be supported by government and protected from politics," and urged readers not to "let moral panic and political pressure kill the Arts." It asked them to get in touch with an appended list of Congressional leaders. (Glueck 1989)

A few years later, MP was affixed to Margaret Thatcher's plan to ban surrogate motherhood:

> An opponent of the move said the government is in a moral panic and that Prime Minister Margaret Thatcher is backing the move to win votes. But Professor Michael Freeman of London's University College, a leading family law expert, observed: "It's difficult to know why the government is getting into a moral panic." (Staff 1985)

In 1989, there was this report about an increased use of heroin in Israel:

> Ms. Hassin [a criminologist Yael Hassin of Hebrew University in Jerusalem] said the publicity recently afforded the Israeli drug problem was an attempt to create moral panic by politicians looking for attention and police officials looking for bigger budgets. (Ron 1989)

Moral Panic and Fear

MP served to codify or encapsulate the fear narrative for news purposes. Indeed, by the mid-1990s MP was becoming an acceptable way of explaining reactions to social change, especially events and problems that challenged the prevailing narratives of order in news reports, but also government hearings. For example, MP was referred to in congressional testimony by social scientists in 1995 and 2000. In the first case, Stuart Wright (1995) discussed how to avoid another "Waco" mass killing when U.S. agents invaded the "Branch Davidian" compound. Nearly five years later, in June 2000, Philip Jenkins, well-known authority on MP, cautioned legislators not to overreact to the drug Ecstacy:

> Sometimes, the reaction to issues is massively out of proportion to the phenomenon at hand, and in those cases, social scientists use the term moral panic.... Legislators are naturally and commendably concerned about the need to protect young people.... But the danger is that in trying to offer better safeguards for youth, they will enact new prohibitions and criminal justice-oriented policies which will result in causing more harm, more injury and death. (Jenkins 2000)

MP is part of the social control and fear narrative. Previous chapters stressed that the common thread for most scholarly and popular analysis of fear, especially in American society, is crime and victimization. News reports about crime and fear have contributed to the approach taken by many social scientists in studying how crime is linked with fear. Numerous researchers link crime, the mass media, and fear (Chiricos et al. 1997; Ericson 1995; Ferraro 1995; Garland 1997; Innes 2004; Pearson 1983; Shirlow and Pain 2003). There is also an impressive literature on crime, victimization, and fear (Baer and Chambliss 1997; Chiricos et al. 1997; Ferraro 1995; Warr 1987; Warr 1990; Warr 1992). One of the many contributions of MP was to delineate further the process by which individuals were "constructed" and given social labels commensurate with "folk devils," with the additional emphasis that the nature and cause of the particular problem (e.g., drug use) had major implications, including the destruction of the moral and social order (Goode and Ben-Yehuda 1994). The mass media played an important role in constructing and demonizing the behavior and individuals. Indeed, sociologists, who pointed this out, were themselves demonized and were accused of proselytization for homosexuals (Hunt 1997 p. 639). Thus, MP offered a focus and direction for mobilizing fear in order to stop social destruction and promote more social control. As Stuart Hall (1978) suggested, MP is a way to garner the support of the "silent majority" for the legitimacy of coercive measures. It is also important to stress that entertaining news formats, which favor having "two sides"—especially "conflicting" views—provided a potential slot for claims-makers like social scientists to caution against the creation of an MP, which in most cases was not regarded as legitimate.

Moral Panic and Crime

Notwithstanding the expanding use of MP, the focus on misdirected policies toward crime and crime control continued to get the most play. Consider these two reports in 1994 about cautionary advice toward crime and the popular "three strikes" and mandatory prison policies that swept the United States in the 1990s. A highly regarded criminologist, William Chambliss, cautioned against how fear of crime was launching an "MP":

A siege mentality so pervasive it extends even to those who, statistically speaking, are among the least likely to be victimized. Sociologists call it moral panic, a term for generalized fear that, as Chambliss put it, "is not appropriate to the situation." (de Boer 1994)

Fear is the underlying emotion for most crime-control and strong-government intervention, particularly the widely supported "three strikes" legislation that mandated life imprisonment for conviction of a third felony. Recent research has shown the fallacy of such reasoning for effective crime control (Grimes 2007), particularly for aging prisoners. It is important to note that the social scientists hedge their statements lest anyone think that his opposition to tougher sentencing means that he is looney, or perhaps too liberal or far out. Here's a statement by a sociologist about the cost of incarcerating aging inmates:

"We're in the middle of a moral panic," says Barry Krisberg, president of the National Council on Crime and Delinquency. "I'm not saying violent crime isn't a serious problem. But these treatments are worse than the disease." (Phillips 1994)

In this case, as in others we encountered, the use of MP can help position the speaker as concerned about the problem (or not...), by just decrying the overly aggressive solution(s). So it is not that prison is ludicrous or likely to structurally target the poor; it is just that MP may result in more imprisonment than is warranted.

Entertainment-media formats promote the use of terms and metaphors that audiences will recognize. U.S. audiences are less familiar with MP than those in the United Kingdom, so it is not surprising that writers and commentators use MP more often. It is not uncommon for metaphors to be used when referring to MPs, particularly by social scientists. A favorite metaphor is the "witch hunt," presumably selected because of its widespread acceptance in our culture as a reaction that was irrational, emotion-driven, and caused great harm. We found 45 examples of witch hunt being associated with MP. Consider the following example:

But only the players and scenarios have changed, according to McConchie and some sociologists. The moral panic, the secular version of the witch hunt, is alive and well and thriving on an ages-old tendency to, as folklorist Bill Ellis of Pennsylvania State University put it, "find a neat and tidy, us-versus-them explanation for what's wrong with life." (Arnold 1992)

MP in public discourse was not limited to prisons and overt crime-control efforts but was closely associated with other social-control efforts to arrest both problems and conditions. Our research uncovered several examples of control efforts directed at youth, a perennial source of MP through the ages

(Giroux 2003; Grossberg et al. 1998). The artful use of MP by this "news source" (that is, the person being interviewed and quoted) also suggests that people with social science backgrounds found MP to be a useful subtext for imparting some basic sociological dimensions about social life (e.g., socialization, symbolic interaction, self-fulfilling prophecy, unintended consequences, etc.). Clearly, MP was something to be avoided. Here's an example by a violence researcher ("Beware of MP") reacting to the Toronto police chief's pessimism about violence after a fatal shooting.

> To be sure, violence in Toronto has changed in the past few years. But when city, provincial and federal officials generate moral panic, we only worsen the problem. These types of fears have led to "three-strikes" laws, mandatory minimum sentences, criminalizing youth and sentencing them as adults—initiatives that many experts would argue have only exacerbated the situation. A more rational approach would be to look for solutions based on the extensive research that exists on this topic. (Falk 2005)

MP as cautionary narrative was common in our materials. A newspaper report—a sort of mini-case study of crime control—in the *St. Petersburg Times*, written by a reporter in England, discussed how England became aroused about the death of a two-year-old (James Bulger) at the hands of two ten-year-old boys (Hunt 1997), and several articles stressed that violent youth abounded, that moral behavior was disappearing, and that there was, in short, a crisis. (Others, like the *Times* of London, acknowledged that Britain was suffering a fit of "MP," but, the paper added, so are the French, the Germans, and the rest of Europe (Schmidt 1993). The *St. Petersburg* [Florida] *Times* article added that various authorities were summoned by the BBC to discuss the situation, and they concluded:

> *Columnists began to reminisce about the Mods and Rockers, and came to the conclusion that the 1950s were much worse....* The *Times* announced that we had all been "brainwashed by hysteria" and introduced a diagnosis borrowed from sociologists. Britain was in the throes of a moral panic which had for the most part been generated by the media itself; there was no juvenile crime wave. By the end of the second week a media analyst on television's What the Papers Say managed to satirize the most sensational of the recent crime epidemic reports by comparing them with similar—often identically headlined—stories run in the same paper some 20 to 40 years ago. (Boren 1993; my emphasis)

About two weeks later, the following "case" was reported in the *Chicago Sun Times*, also about MP in Britain. This piece contrasts with the news reports that urge strong action; it is in opposition, or the "other side." Consider the following statement from a British youth worker about a proposed plan to hold youths (aged 12–15 years) who have committed three offenses in "secured training centers":

Given recent statistics showing a decline in juvenile crime, many say the steps are unwarranted. "It is basically a highly expensive media reaction rushed in on a wave of moral panic," said Angus Stickler of the Children's Society. The best way to deal with juvenile delinquency, he said, is not by "yanking young boys out of the community, grouping them together where they will learn much more sophisticated ways of committing crime." (O'Mara 1993)

I have suggested that the allure of crime in entertaining news pushed the use of the concept of MP to its higher levels in the 1990s as critics—mainly social scientists—would often employ the phrase in stating their case and in providing the other side that is characteristic of conventional news formats. This effort to talk about "moral problems" in a different way was captured by Hunt's analysis (1997). And there were a lot of opportunities for this "interaction" with politicians and others during local and national political campaigns. For example, several politicians took strong stances against crime during the 1994 Florida political campaign. Despite a declining crime rate—the lowest since 1985—politicians proved to be ideal news sources for news media wedded to fear-as-entertainment. The following comments were contained in the same news report:

"Crime is the No. 1 problem in Florida," Republican gubernatorial challenger Jeb Bush writes in his campaign literature. "This has been the case for years, and the situation is getting worse with each passing day.... My own home has been robbed," Bush wrote in his campaign handouts. "I thank God no one was at home…" [and, according to his opponent] "The system is now beginning to work," said state Sen. Robert Wexler, D-Boca Raton, former chairman of the Senate judiciary committee. "Now try to convince the average guy in the street of that and you can't. Because all he does is watch the TV news at night and see that random violence is going up. And it is." (Leen 1994)

Of course, random violence was not going up, but it was widely covered—and viewed. As part of the standard news format, another opinion was sought, one likely to be different, and that was conveniently provided by criminologist Ted Chiricos.

"I don't think I've ever seen an election where virtually every candidate, from the school board on up to the governor, is pontificating on the issue of crime," said professor Ted Chiricos, a criminologist at Florida State University. "I find it, as a criminologist, very cynical, if not disingenuous. There's nothing happening that would justify the extreme outcry of what I would call a moral panic." (Leen 1994)

The journalist noted that there had been a few well-publicized murders, which led another source, along with the Department of Corrections, to discount the "panic" aspect of public perceptions and reactions:

"I understand that the overall numbers are down, but that doesn't lead to the conclusion that people are in a panic about nothing…. There is some basis in numbers for papers to be reporting more incidents involving juveniles committing crimes with guns and people being concerned about it." (Leen 1994)

The above example illustrates how panic is separated from MP and is used in this instance as a disclaimer, an account (Scott and Lyman 1968) that qualifies a comment such that the speaker can have it both ways (e.g., "Well, something is going on, but it can't just be an exaggeration"). The comment reflects two things: first, people are not well versed in the meaning of "MP"; second, MP is but another rhetorical strategy—or opposition—to take into account when promoting a preferred policy. An implication is that MP was becoming more normalized and familiar as a feature of news discourse, perhaps with an ideological flavor: those persons and positions promoting stronger state control were implicated in MPs.

■ Social Science and Media Use

MP gradually moved from being a counter-narrative to a central part of the news format for providing other views. MP was widely used by social scientists to defend or defuse conventional targeted groups, e.g., the poor, youth, and minorities. This defense would extend to non-academics in the years that followed. For example, about the same time as the statement from the criminologist in the example above, an American sociology professor warned in a review of his book *Gangs, Supergangs, and Kids on the Corner*, about mistakenly identifying the origins and characteristics of Milwaukee's emerging gangs:

> The book turns out to be a repudiation of the idea that the People and the Folks have spread from Chicago to his city. In fact, a large part of the book chastises politicians, police and the news media for starting a moral panic about the spread of super gangs from metropolitan areas to smaller cities. (Campbell 1989)

If MP was to be avoided in dealing with street crime, white-collar crime was another story. One researcher implied that an MP about street crime was more appealing to audiences than white-collar crime. After noting that Michael Deaver, an aide to President Reagan, was awaiting a prison sentence, he added:

> There appears to be little anxiety about having behind bars a country within a country, a burgeoning prison population of over half a million overwhelmingly poor, overwhelmingly black people. Yet no moral panic has greeted a simultaneous crime wave of virtually unparalleled scope and effect: the wave of white collar crime. (Lewis 1988)

In this case, the author suggests that we should be having an "MP" if we're truly interested in a real "crime wave."

MP was used more in the 1990s and beyond. Its use began to change as not just something to be avoided, but as synonymous with panic or overreaction. As noted, MP became a useful and interesting term/concept for referring to the "other side" that challenged the legitimacy of processes that, in effect, stirred people up and led them to scapegoat. I wish to stress that the press and various audiences gradually adopted the use of MP because it served their purposes and fit into their discursive practices and guidelines, including finding new ways to say old things. So, for example, MP shows up in book and movie reviews as a rather cute alternative to more mundane prose. It was noted above that the use of MP over the last three decades had increased, particularly in reviews, features, and opinion pieces. For example, in selected U.S. media, MP appeared in 23 reviews, and 33 op-ed and opinion pieces, while the *Guardian* featured MP in 59 reviews and 35 "Weekend" discussions (Hunter 1993).

Social scientists and other critics employ and refine MP in commentary as "sources" in various news reports but make even stronger statements in editorials as well as book reviews. Mike Males, who has written extensively on erroneous claims about the decadence of youth, including crime, violence, and drug use, often parodies sociological research against demonizing youth. In a comment about an article in the *Atlantic Monthly*, he stated: "Today's ephebiphobia is the latest installment of a history of bogus moral panics targeting unpopular subgroups to obscure an unsettling reality: Our worst social crisis is middle-Americans' own misdirected fear" (Males 2002).

We encountered many examples where editorial comments cautioned against MP, noting that the mass media played a large role, even to the point of quoting from Cohen's definitive essay. An article in Thailand in 2006 about the Video Recording Act decried sensationalistic reporting of children's deviant acts, noting that the coverage was causing a backlash against juveniles. After the concept was explained, the author blamed the mass media for the "sensationalistic reporting" that contributed to the problem (Gecker 2006).

■ New Meanings of Moral Panic

The range of topics associated with MP seems limitless, although it is also clear that most topics do not become "successful MPs" (Jenkins 1992), but, as we have suggested throughout, the use of the phrase is quite common. We have also suggested that MP is often used defensively, or as a way to prevent or discourage overreaction. Not surprisingly, as MP entered its third

decade, other uses appeared at the turn of the last century. One example was a report about gated communities, with specific focus on the symbolic meanings of "gates." A criminal justice professor noted:

> Another syndrome associated with the gates "is what social scientists call moral panic, an overreaction to crime," said Mercer Sullivan, a professor of criminal justice at Rutgers-Newark. "People react to rapid changes in society by building walls around themselves." (Quinn 2000)

News reports suggest that MP has struck a chord as a general way to attack outrageous claims about social problems and issues that might result in strong policy actions and sanctions. MP adds to news discourse by providing a contrary view that is predictable, even scripted. The foundation for articulating what may be termed the "implied agency of MP" or, more theoretically, a vocabulary of motives for MP (Mills 1940), suggests the oppositional role of this concept, and the script is appropriate for some topics in the fear narrative, but not others. Indeed, we found only one instance in which a progressive movement/orientation was challenged as promoting an MP. This involved assertions by some feminist scholars that not only is rape quite common, but that 25% of women will be raped during their college years. My intent here is not to address the veracity of the claim, but rather to use the exchange, especially the mass media reports concerning it, to illustrate the exceptional use of "MP."

> Labeling rape "the phantom epidemic," a professor at the University of California at Berkeley has started a national debate by challenging recent studies by "feminist researchers" who, he said, insult women, trivialize the crime and incite "a moral panic." (Kahn 1991)

MP is also employed as a combative tool to avoid strong criticism or scrutiny. Essentially used as a verb in these instances, MP is something to avoid, but mainly because it is unfair. Thus, our data include several articles that feature comments against an MP about Catholic priests' behavior as pedophiles:

> As a result, public perceptions of the pedophile priest and a complicit Catholic Church have promoted a moral panic. Indeed, the "sins of a few" have now been exaggerated and extended to what the media continue to call the "sins of the Fathers." (Hendershott 2002)

These comments suggest that organizational members are legitimating the concept of MP by arguing that their "issue" does not warrant such extreme results. Thus, they are operating from "inside" the organizational/institutional arena under scrutiny.

■ Positive Moral Panic

We have seen from news-media depictions of MP that it is often juxtaposed with actual or anticipated programmatic and policy efforts to react politically to reports about certain problems and issues, e.g., drugs, sexual behavior, or child abuse. Such topics have become commonplace in news reports. So basic has MP become as part of discourse of opposition to social control that proponents of certain actions (e.g., proposing sanctions against uncivil teens) anticipate what might be termed the "MP defense" and actually state, in effect, that "this might be a worthwhile MP." This becomes more relevant given the very uneven way in which MP is employed. Consider an example in which MP is denied as an appropriate term to describe officials' behavior that is consistent with MP—for example, Internet sting operations that border on entrapment:

> Some critics have also said that the recent surge of outrage about child pornography and pedophilia is driven by a moral panic reminiscent of 19th-century vice crusades. But there is nothing censorious about Ms. Pirro…. Fighting pedophiles on the Internet is simply an extension of her longstanding interest in fighting child abuse and domestic violence, she said. "It's really about protecting the vulnerable, whether they're senior citizens or children…." (Worth 2001)

This statement reflects a counter-news format usage of MP in that the customary role of challenging a public reaction must also be reacted to or negated because it is really about "protecting the vulnerable." Using MP as an account is similar to Matza's "neutralization techniques" (e.g., "denial of victim," etc.), which serve to qualify the competence and sensitivity of the actor while still making what may be a controversial or risky assertion (Matza 1969). MP is now widely associated in public discourse (i.e., news reports) with an oppositional view of efforts to regulate or intervene in various categories of deviance, including sexuality, drug use, as well as "styles" and subculture behavior. Even though proponents of regulation—as moral entrepreneurs—may still follow through on their censorship and sanctioning of such behaviors, MP has clearly entered this discursive space.

For example, the following comment was made in response to a ruling in Scotland that viewing child pornography was a victimless crime:

> Scots law is not only at variance with that in England and Wales, where there is now a maximum custodial sentence of ten years for such activity, but the possibility has emerged that the ambiguous legal climate north of the Border will encourage activity that we patently do not wish to see. *This is not a case of moral panic but of rectifying a questionable legal judgment. Generally, genuine victimless crimes should not be so stigmatised. But in this case, the victims are in front of our very eyes.* (Staff 2001; my emphasis)

The writer in this example is aware that MP is often involved in efforts to legislate sexual behavior but also claims that this case is different. This is child pornography. But terrorism is different.

■ Moral Panic and Terrorism

My comments have focused on the organization news reports with MP in order to illuminate the topics and problems associated with this important social-science concept. I stressed at the outset that media formats are key organizing features of discourse. Recall the point about the paucity of MP in U.S. network-news reports, compared to its more common usage in newspaper editorials and opinion pieces. The borders surrounding familiar contested issues such as sex and drugs demonstrate boundaries, but they also separate appropriate from inappropriate issues, acceptable and unacceptable topics for systemic criticism accompanying MP. One such boundary is terrorism. For example, pornography, especially child pornography, is linked in the sociological literature as well as news reports. The following appeared on a Website:

> It's hard to imagine any groups more vilified in society these days than terrorists and child pornographers.... In a fit of moral panic, some drafted feeble and messy bills to stop cybersmut, most of them reflecting a serious lack of understanding of the technical nature of the Net. (Kapica 2002)

Yet terrorism has not been joined with MP despite using similar elements of fear as sex and drugs.

The concept of MP is all but absent in extensive discussions of terrorism, including fear and terrorism, victimization and terrorism, and numerous negative consequences of propaganda and policies about terrorism. The United States alone has expended more than $1 trillion on a war allegedly against terrorism, violated the civil rights of its citizens, and—as part of its "extraordinary rendition" policy—kidnapped individuals throughout the world and transported them to other lands where they would be tortured in order to obtain information about terrorism. However, terrorism is not linked to MP in mainstream media. Very few news reports place terrorism or threats of terrorism close to MP.

I suggest that this omission can be attributed to the ways in which news is organized, including how news formats link MP to selected topics. Media logic and news formats operating within the fear narrative embrace crime and deviance as appropriate oppositions to MP. MP questions the legitimacy of social action and policy (Ericson et al. 1991 p. 328 ff). News values favor conflict and entertainment over analysis, especially if clear opposition or

contrasting views are neither familiar nor legitimate for the audience (readers/viewers/listeners) (Gans 1979). For example, it is acceptable for U.S. news practice to present "opposing" views or statements if they come from an acceptable source (i.e., a recognized organization) and if editors assume that the audience is at least familiar with the argument, even if many may not agree with it. This can be seen with MP, which has now been in circulation for three decades. Journalists and audiences are familiar with it and the topics with which it is associated (primarily versions of deviance, drugs, and sex). Thus, it is appropriate to invoke the language of "MP" in a report on such topics. What I wish to stress is that it is now essentially institutionalized, at least in the United Kingdom, for a source (claims-maker) to invoke MP in discussing—and usually opposing and delegitimizing—a course of action. This is quite significant, because claims about sexual deviance are easily placed in a discourse about irrational and emotional fervor, rather than a way of "saving us" from an objective evil. So, even if an audience member believes that the problem is really important for social survival, she or he is still more likely to accept the discourse, and indeed may even refer to "MP" in making a case. The example of terrorism is different. Terrorism and the terrorist threat is still regarded as legitimate and objectively real by many people in the United States and the United Kingdom. It is not viewed as a social construction, and the governments' actions are not treated in the mass media as arbitrary overreaction. Indeed, opposition parties in the United States insist that terrorism is a pressing issue and differ only slightly in how to combat it (Altheide 2006).

The mainstream media do not associate MP with terrorism, even though alternative media do. Newspaper editors do not appear willing to accept the MP definition of a situation that may potentially involve terrorism. Rather, it is off-limits in mainstream news media to extend the discourse to include legitimate opposition and characterization of terrorism with Cohen's classic definition of MP. However, it is a different story with alternative media: a Google search shows that terrorism is joined with MP on more than 17,000 media sites, including academic book advertisements, conference presentations, as well blogs and other alternative media. One author, a professor, wrote an essay (originally published in *The Humanist*) connecting fear to terrorism and MP:

> The terrorism scare is a moral panic, similar to many throughout recent history. Social scientists call these society-wide scares MPs because they are founded upon fear of threats to society from moral deviants of the worst kind. In general, MPs begin when events occur that cause a great many people to feel threatened by an internal enemy, hidden deep within their society. Secret groups of foreign

terrorists, believed to be fanatics who kill without guilt, fit the bill perfectly. (Victor 2006)

Such statements are exceedingly rare in the mainstream news media.

The paucity of comments linking terrorism to MP suggests that terrorism is not acceptable as part of the conventional news discourse of point/counterpoint (or two sides/opposition) about certain topics, especially those associated with MP, which I have argued appears to be legitimate. In the mainstream news media, MP and an informal list of topics are tacitly approved for news discourse and entertainment news formats, but terrorism is not. Just as the accompaniment of MP with discussions of sex and deviance appears to challenge the dominant discourse of propaganda that would place these topics "beyond discussion," it appears that terrorism is sacrosanct in many media, and that it is not legitimate to feature it in public discourse as an example of MP. In this sense, the propaganda of fear that continues to promote governmental claims about terrorism and terrorists is likely to persist for some time, thus reinforcing the definition as "the purposeful act or threat of violence to create fear and or compliant behavior in a victim and or audience of the act or threat" (Lopez and Stohl 1984).

■ Conclusion

Fear and terrorism share a common news space, but they are part of different narratives. Moral panic illustrates a kind of debunking of "fearful issues," but as this study suggests, terrorism—and the public reaction to it—is not typically associated with illogical fear. This study of news usage of MP demonstrates that it is widely used in newspapers, particularly editorials and op-eds. The data suggest that MP has been used more frequently in news reports during the last decade. I argue that the logic of news formats promotes fear and entertainment also encourages oppositional positions on certain topics. MP fills this bill. Electronic media, most notably U.S. network TV, avoid the use of MP altogether. I suggest that this is because newspaper formats (e.g., editorials) are more compatible with frames like MP that offer dissenting views on certain topics. However, unlike U.K. news sources, very few U.S. news sources routinely discuss MP in regular news reports. MP is also quite visible in literary and art reviews. Qualitative analysis of the materials suggests that MP has become part of critical public discourse and is widely used in editorials and op-eds that tend to oppose or offer the "other point of view" about proposed social policies and changes in social-control efforts directed toward social deviance, including sexual activity and drug use. Indeed, soci-

ologists are frequently the authors—or are mentioned—in many of these reports.

The fear narrative has played an important part in the success of MP. The major impact of the discourse of fear is to promote a sense of disorder and a belief that "things are out of control." Fear, crime, and victimization—and, more recently, terrorism—are experienced and known vicariously through the mass media by audience members. The discourse of fear has been constructed through news and popular-culture accounts. Other researchers have examined the nature and consequences of fear in connection with crime, but also in relationship to political symbols and theories of social control (Altheide 2002; Furedi 1997; Garland 1997; Glassner 1999; Massumi 1993; Moehle 1991; Naphy and Roberts 1997; Russell 1998). Ferraro (1995) suggests that fear reproduces itself, or becomes a self-fulfilling prophecy. Social life can become more hostile when social actors define their situations as "fearful" and engage in speech communities through the discourse of fear. Elliott (1972) noted how the cultivated audience essentially becomes the source of the information as well. MP captured this process, but it also became a way to defuse it, to identify the alleged problem or crisis as a "mere process," which in most cases was not regarded as legitimate.

Analysis shows that the use of MP fits entertaining news formats quite well. Clearly, there are many sociological concepts that are not widely distributed through the mass media (e.g., state-sponsored terrorism, cultural contradictions of capitalism, status degradation, etc.). As it became more familiar to audiences through scholarly writings, student exposure, and popular culture, MP emerged as a useful way of summarizing or providing the "opposition," and therefore became more acceptable. However, MP is not used to reflect opposition on all fronts but is more closely aligned with certain topics—sex and drugs—but not terrorism. Terrorism practices and beliefs are not treated as MP, despite many similarities in the process of societal action and reaction that was identified by Cohen (1980; Cohen and Young 1973) and others. Paradoxically, it may be that even this powerful and potentially liberating (from social control) concept can become a resource to use in limiting discourse and communication. The next chapter examines how terrorism became integrated with social-control efforts to define, explain, and prevent school shootings.

■ The Columbine Shootings and Terrorism

Eric Harris wanted to bomb his high school out of a desire "to terrorize the entire nation by attacking a symbol of American life." In this pseudo-political grandiosity, he is of a piece with Mohamed Atta. We see him far differently now than we did when he was widely (and inaccurately) characterized as a crazed loner striking out at jocks in 1999.

—Cullen, quoted in Rich 2004

The above statement joining Columbine with terrorism and the 9/11 attacks is an artful construction with important consequences for social control. The previous chapter described the media logic that essentially eliminated terrorism from being treated as a moral panic. This chapter addresses the relevance of the mass media for the shootings at Columbine High School in Colorado on April 20, 1999, and a national preoccupation with fear. I wish to address how these disparate events became joined. This chapter examines how they fit into the expanding discourse of fear in the United States.

School shootings are very rare, but fear is very common. And parents' fear for their children's safety shoots up whenever school violence receives mass-media attention. Consider these opinion poll results of October 2006:

A recent *USA Today*/Gallup poll finds an uptick in parents' fear for their children's safety at school. This follows the recent wave of school shootings across the country, the most prominent of which was an attack at an Amish schoolhouse earlier this month. Parental fear is now the highest it has been since early 2001.

Meanwhile, parents report their children are no more likely to express fear about their safety at school now than before the recent shootings.... The Oct. 6–8 poll finds 35% of U.S. parents with a child in kindergarten through 12th grade say they fear for their oldest child's safety at school, an increase from 25% in August this year. (Jones 2006)

Parental fear was highest (55%), according to this same poll, the day after the shootings at Columbine High School. This tragic event took on expansive symbolic and policy importance in the years to follow. Just as the "falling trade towers" in New York City came to symbolize the 9/11 attacks, Columbine enshrined fear for children at school. No other shooting of students by students would receive this extent of news coverage (Muschert 2007b). Most importantly, however, Columbine came to be associated with virtually every act of gun violence that would occur on school grounds throughout the United States and, in many cases, throughout the world. One author referred to the "Columbine Syndrome" after a vicious shooting at Virginia Tech in 2007, in which the assailant utilized mass-media and popular-culture imagery in his screed, while also sending media materials to several outlets.

■ Social Definitions, Fear, and the Mass Media

An approach to understanding how Columbine fit into a broader perspective and discourse about fear is to see how it pertains to the definition of the situation, or how social actors make sense of their lived experience. Building on the work of decades of symbolic interactionism, Peter Berger and Thomas Luckmann (1967) stressed that the most important thing you can know about someone is what they take for granted about their social world. The capacity to shape our view of the world and the words that we use to describe it are significant for future actions. Thus, one definition of power is that it is the ability to define a situation. Indeed, fear may be most important when it is taken for granted but becomes a general framework through which events are cast. When fear is used in this way, it becomes a matter of discourse (van Dijk 1988). As an institutional construction of knowledge that is reflexive of "territories, material objects, people, rules, formats, and technologies," the discourse stands for its own foundation and interpretive framework (Ericson and Haggerty 1997 p. 84). I argue that the extensive coverage and framing of the Columbine shootings contributed to the broad discourse of fear as well as a more specific context for worrying about and protecting children, legitimating the war on terror, and expanding social control.

The symbolic meanings of events and their consequences are socially constructed. Mass-media organizations and information technologies provide templates for routinizing their work, productions, and presentations that shape the images and meanings of events. In a broad sense, media culture refers to the character of such institutions as religion, politics, or sports that develops through the use of media. Recalling Snow's (1983) analysis of media culture and the entertainment format (Chapter 4, p. 82), it is apparent that as audiences spend more time with these formats, the logic of advertising, entertainment, and popular culture becomes taken for granted as a "normal form" of communication.

I noted in Chapter 4 that new communication formats such as remote controls and cell phones have fundamentally altered the distinction between "entertainment" and "news"; both belong to media culture and operate with very similar logic that cuts through selection, production, and presentation. Audiences recognize "citizens," "patriots," "victims," "beneficiaries," etc. along media lines, and how such definitions pertain to them. Corporate media promote fear as entertainment throughout popular culture and news in order to gain audiences (Altheide 2002; Furedi 1997; Glassner 1999). School shootings lend themselves to entertaining reports.

The central role of the mass media can be restated for this discussion of school shootings after 9/11. News is the most powerful resource for public definitions in our age. News reports and social-control work have become joined through mass communication organizations (Best 1995; Ericson et al. 1989; Ericson et al. 1987; Fishman and Cavender 1998). Print and electronic news media use entertaining news formats that make their work more predictable and manageable while also delivering entertaining information that news consumers have come to expect. The narrative structure of news reports reflects information technology, commercialism, and entertainment values, as well as official news sources that provide the majority of information (Altheide and Snow 1991). News sources provide content that journalists slip into entertaining story sequences and formats. Key components are formal agents of social control (FASC), such as police departments, that provide the security measures that have emerged during a particular event and soon become institutionalized and taken for granted as part of the social fabric of life (Altheide 1995; Ericson et al. 1989). The combining of entertaining news formats with these news sources has forged a fear-generating machine that trades on fostering a common public definition of fear, danger, and dread.

■ Fear and Children

A key element in the contemporary discourse of fear is children. There is a substantial literature about fear and children (Best 1990; Best 1994; Hill and

Tisdall 1997; Jamrozik and Sweeney 1996; Platt 1969; Beisel 1997; Gilbert 1986; Nelson 1984). Children are a powerful symbol for "protection" as well as "punishment" of not only those who would hurt children, but also the children who are blamed for other social ills. As powerful symbols, children have been joined with fear in entertainment as both victims and victimizers. The former may be recognized as "child abuse," while the latter appears as "juvenile crime," "gangs," and the threat of students shooting students.

Previous work (Altheide 2002) examined how fear was linked to other topics (e.g., crime, immigration, drugs, etc.) in news reports. Examining hundreds of news reports in major newspapers showed that fear has "traveled" across all the topics we examined since 1987, although children, crime, and schools have remained in the top three categories.

Topics for public interest are creatively manipulated by various claims-makers with self-serving interests. The symbolic value of children has risen dramatically in public life. The news media's emphasis of fear with children is consistent with work by Warr (1992) and others on the significance of "third-person" or "altruistic fear"—the concern for those whom you love or are responsible for. Now virtually everyone wants to "protect children," and many politicians include children in their rhetoric to justify more formal social control. This extends to the international realm as well. Just prior to the U.S. bombardment of Iraq in 1997, President Clinton argued that this was being done to force Saddam Hussein to comply with international rules. As one writer noted,

> He even absurdly brought kids into the equation in the confrontation with Iraq late last year over Saddam Hussein's expulsion of U.N. weapons inspectors. Clinton insisted the inspectors must be allowed to do their jobs because "the safety of the children of the world depends on it." (*Los Angeles Times*, June 23, 1998)

While bringing "kids into the equation" may have seemed absurd in 1998, kids and schools became integral to discussions of terrorism following Columbine and the 9/11 attacks.

The Columbine shootings have been transformed within the iconography of violence and fear (Altheide 2002). As noted, Columbine is the most-cited school shooting in the United States, is widely referred to throughout the world, and has for some become a synonym for several crises, including gangs, youthful rebellion, and the institutional failure of schools as well as families and government (Stein 2000). Such transformations are symbolic in nature and are shaped by the culture industry that massages and shapes images and meanings as features of mass-mediated formats and templates (Grossberg et al. 1998; Hall 1977; Kellner 1995). The role of claims-makers, especially government officials, who serve as important news sources and spokespersons

for this work, must also be considered (Ericson et al. 1991). All played a part in transforming Columbine from another tragic shooting to an act of terrorism with great repercussions.

The mass-media coverage of the Columbine shootings has been widely studied by Muschert (2006; 2007a; 2007b) and others. My focus here is on the way in which the mass-media coverage helped to frame and define Columbine as something other than a school shooting and as consistent with a terrorist act. Journalists, working with entertainment formats, tend to accept the rhetoric and definitions of news sources, regardless of how illogical, distorting, and deceptive. I argue that the terrorism frame was a powerful "mega frame" that captured angst, fear, and governmental legitimacy within "frame changing," becoming a national and international dimension (Muschert 2006) that transcended initial community and local frames. The aim, then, is to clarify how other school shootings were connected with Columbine, how Columbine was discursively situated with terrorism and expanding social control, and how the discourse and politics of fear were implicated in the framing.

■ Data and Method

I approached these questions through a qualitative examination of news documents. Data collection and analysis were conducted using an approach described elsewhere as "tracking discourse," or following certain issues, words, themes, and frames over a period of time, across different issues, and across different news media. News coverage of school shootings was analyzed with the qualitative method, tracking discourse (Altheide 1996). A constant comparison approach of hundreds of articles about school shootings produced an emergent set of articles that contained relevant terms, themes, and frames. A protocol was constructed to obtain data from 15 news reports about date, location, author, format, topic, sources, theme, emphasis, and grammatical use of fear (as noun, verb, and adverb), as well as items about connections to other school shootings, and surveillance, as well as accounts and neutralization techniques. Findings from these data informed additional comparative searches. Where appropriate, materials were also enumerated and charted. Once collected, the materials were placed in an information base and analyzed qualitatively using Word 2003 and NUDIST 6, a qualitative data-analysis program.

■ Defining Columbine

A review of several hundred TV and newspaper reports indicates that the meaning of "Columbine" was emergent, partly joined to previous shootings, future school violence, and international terrorism. The mass media were key for each phase or moment in the ongoing career of "Columbine." As Columbine entered news parlance and was soon institutionalized—and shortened—from the "Columbine school shooting" to "Columbine," it came to refer not only to school shootings, but also to youth problems, discipline concerns at schools, and even lax school and governmental oversight and policies concerned with protecting children. The meaning of Columbine was expanded to warrant melding school disciplinary problems and students' pranks and hoaxes with criminal justice agencies as well as the Department of Homeland Security. Offending students would no longer be charged with disorderly conduct, trespassing, or even involuntary manslaughter, but were increasingly charged with terrorism. Most important, Columbine became entrenched within the discourse of fear, especially as it was linked to terrorism and stepped-up efforts at social control of schools, including expanding surveillance.

My qualitative analysis of news coverage of Columbine included an enumerative overview of comparative emphases in major media. A summary of items from the *New York Times* (NYT) is presented here, followed by a discussion of the subsequent theoretical sample. Some materials from the *New York Times* are illustrative of the changing thematic emphasis over time of school shootings and especially Columbine. Tracking discourse revealed that school shootings were rarely linked with terrorism prior to April 1999, when the Columbine shootings occurred. Rather, urban gang concerns were more likely to be associated with terrorism up to that time, i.e., as terrorizing neighborhoods. Examining the suggestion of a connection of Columbine to terrorism after the shootings, but before the terrorist attacks of September 11, 2001, shows that Columbine and other school shootings were linked to terrorism in 14 articles. (Students were not closely linked to terrorists, notwithstanding a school administrator's statement in August 1999: "That's the worst kind of terrorism you can have: an intelligent teen-ager." The power of the discursive frame of terrorism became most apparent after September 11, 2001. School shootings were linked with terrorism in 25 articles, while Columbine increased by nearly as much (N=21).

One of the first links of Columbine and school shootings to terrorism occurred in a reflective piece just five days after the 9/11 attacks. The author noted the irony of how a handful of men with primitive tools (i.e., box cutters) had seemingly outdueled nuclear weapons, but went on to note how

difficult it was to make sense out of this, suggesting that our initial urge to compare it to "another school shooting" was not adequate, and that the TV clichés and entertainment formats that accompanied such reports seemed a bit trivial:

> ...television, with its crisp logos, only diminished the event—"America Under Attack," "Attack on America," as though this was another school shooting or forest fire, something that could be packaged with room to melodramatize. (Johnson 2001)

The meaning and significance of Columbine changed as popular culture and politicians constructed it for their own purposes. Columbine is at times linked with other school shootings, but it frequently appears without mention of other spectacular shootings, while the converse occurs rarely. Popular culture pursued profits disguised as punditry in reflecting on Columbine and other school shootings. Examining movie reviews, plays (e.g., *Columbinus*; Rich 2004), book titles, and so forth, affirms the market discourse for tragedy and reflections of dominant cultural narratives about lost youth, inept organizations (e.g., schools and police), and even pop culture opportunism. Here's one example of a spectacular title that links Columbine to youth and popular culture, including computer technology. The focus is on a Finnish "shooter," Auvinen, but reference is also made to Cho, the Virginia Tech murderer, both of whom sent materials to the mass media and the Internet:

> "Misfits on a mission to delete us all": The Young Finn who last month slaughtered eight people, having first boast of his plans on YouTube, is the latest of a new breed of killer. Armed with a gun, a camera and a computer, they use dehumanizing technology to turn bedroom cyber fantasies into blood reality. (Conrad 2007)

The diabolical character attributed to those engaged in school shootings is consistent with a dystopic narrative: technological progress and computer wonders are mere tools for misfits, who play with media in terrorism as a way of creating a mediated legacy, a ghost that will outlive them (Giroux 2003).

Other titles in this theoretical sample of articles about the use of Columbine shootings focused on violence (e.g., "In Tense Time, Prank Can Look Like a Bomb Scare"), social control responses (e.g., lockdowns, metal detectors, etc.), fear of parents, and terrorism. These charges were less likely immediately after the shootings in 1999 than they were after the 9/11 attacks 17 months later, when terrorism pervaded media messages, and were shaped to fit an expanding discourse of control, which cast many criminal events as terrorism.

■ Columbine as Terrorism

Officials played a prominent role in making statements about Columbine, especially following 9/11, when various policymakers sought to find similarities in the two events, including charging actual or would-be school shooters with terrorism. Fear is the common link or symbolic glue. Terrorism was associated with school shootings in several ways:. The first was through a connection between guns and violence. One author states, "Al Qaeda, Hizbullah, and IRA terrorists have exploited this loophole in US gun laws to purchase military-style weapons from 'private sellers' at gun shows." The implication is that there is a common factor among school shootings and terrorism. Second, they are linked by promoting fear, including taking hostages:

> Macomb County prosecutor Eric Smith acknowledges that some people would view terrorism charges as extreme, but he says people would think differently if they saw "the sheer fear of the parents" and others in his community. And, "TERRIFIED children were today said to be in fear of returning to their classrooms after a gunman opened fire outside their Birmingham junior school." (Topo 2006)

Terrorism was used as a symbolic wedge to gain more support for policies and strategies to combat school violence, but, paradoxically, some proponents of stronger measures also derided the seriousness of terrorism. Again, we see the common thread of fear. A New Jersey freeholder (education governing board) commented on the need to focus more on school safety: "Since Sept. 11, more people have been killed in school buildings than in terrorist attacks in this country. We need to improve the security level" (Kelley 2008). Indeed, police departments throughout the United States are chagrined that more emphasis is being placed on terrorism and homeland security than crime. Providence, Rhode Island, police chief Col. Dean Esserman commented:

> The support we had from the federal government for crime fighting seems like it is being diverted to homeland defense.... It may be time to reassess, not how to dampen one for the other, but how not to lose support for one as we address the other.

The president of the International Association of Chiefs of Police added: "Unfortunately, funding federal homeland security efforts at the expense of state, tribal and local law enforcement agencies weakens rather than enhances our nation's security" (Johnston 2008).

Several articles connected school shootings or the threat of a shooting with terrorism. The context of fear played an important role in shaping perceptions and discourse. The extensive government propaganda campaign

transformed the 9/11 attacks into a world condition, "terrorism world," in which ubiquitous threat and danger from terrorists defined our collective futures (Altheide 2006). Audiences' and journalists' immersion in terrorism warnings and "culture of terrorism" that emerged after 9/11 seems to have generated a common meaning for apparent individual acts/threats of violence against a collectivity: terrorism. In a few instances, the common link was the availability of guns that could be exploited by terrorists and disturbed children alike. One article about a shooting in Montreal (2006) made an explicit case for shootings as terrorist events: "Plante said that for about 45 minutes after Gill began his rampage, there was fear that the shooting was part of a coordinated terrorist attack on the city" (Wilton and Cherry 2007). (We shall see below how this usage of "rampage" with "terrorist" attack is strange in view of Muschert's (Muschert 2007b) systematic typology of school shootings.)

Defining school shootings as a terrorist act implies that there is a political context. Most school shootings are not treated as political acts although, as noted, they may still be regarded as terrorism. This separation, particularly in the United States, suggests that the terrorism discourse trumps political elements. A unique event in our sample was a school shooting in Israel. Here the political and terrorist frames can be seen as complimentary:

> While the motivation for the attack wasn't immediately clear, the school may have been targeted because of its historic status as a cornerstone for the religious settlement movement that opposes giving up land in the West Bank as part of a peace deal with the Palestinians....
>
> Frustrated and emotional Israelis gathered outside the school, chanting "Death to Arabs" and "Olmert's to blame." (MCCLATCHYNEWSPAPERS 2008)

Terrorism, gangs, and school shootings, particularly Columbine, became linked through the discourse of fear, as writers reflected on the chilling effects of uncertainty when our taken-for-granted world becomes challenged. One columnist opined how a range of attackers challenge the trust of an assumed order that we all share. He argued that the attacks disrupt our everyday world and that we all suffer from this. The grouping of incidents illustrates the commonality of diverse sources of fear:

> Marc Lépine brought this terror to Montreal 17 years ago; others brought it to Columbine and Taber, Alta., and Oklahoma City, and on and on. Gang members violated the civic trust in downtown Toronto, last Boxing Day. Nineteen men vented their rage on New York and Washington almost five years ago to the day. Suicide bombers bring hell to the innocent too often to count. (Ibbitson 2006)

The discourse of terrorism encompasses other attackers and knocks off any disparaging edges in favor of a smoother cultural narrative about blame, responsibility, and moral order. The target is unabashedly youth (Giroux

2003), but youth removed from a school and peer group context and placed into a more expansive and frightening discourse of fear encompassed by the evil psychopathology attributed to those who engage in acts of terrorism, in a crazy world. One pundit (the same one who authored the opening quotation of this chapter), writing some three years after the 9/11 attacks, sought to redefine Columbine as not just a "school shooting" but as something much more. His comment is a classic example of the "superpredator" (Muschert 2007a) as well as a retrospective interpretation, in which past events are redefined in view of present meanings and interpretations (Garfinkel 1967; Goffman 1963b; Rosenhan 1973):

> Harris and Klebold would have been dismayed that Columbine was dubbed the "worst *school* shooting in American history." They set their sights on eclipsing the world's greatest mass murderers, but the media never saw past the choice of venue. The school setting drove analysis in precisely the wrong direction. (Cullen 2004)

The redefinition of Columbine and associated school shootings would continue through several years of press reports about incidents in which students threatened, planned, and engaged in school-related threats.

Many students who threaten school violence and other disruptions are increasingly being charged with terrorism. This has happened in New Jersey, Kansas, Michigan, and Arizona (Topo 2006). Several Arizona students have been arrested and charged with terrorism because they threatened to harm students and hold others hostage, including one student who actually put a knife to the throat of another student. Fifteen-year-old Brent Clark was charged with kidnapping, aggravated assault, and terrorism. Having already served eight months in jail, he faced a 25-year prison sentence on the terrorism charge.

A county attorney explained the problem with this kind of case. After noting that police and prosecutors have become more focused (and trained) in assessing charges for alleged threats, she added:

> You can't just label every teen who makes a dark or Goth drawing a threat.... Police and prosecutors first try to determine how credible and serious a threat is and whether a youth has the resources, intent and motivation to pull it off. Authorities will look at the family, school and social dynamics as well.... It's not by any means an exact science or check list. (Grado 2008)

A Michigan prosecutor agreed, citing not just a threatening note, but the possession of weapons at a student's home:

> "You would see that this was clearly an act of terrorism," he says. "It wasn't a fight between two kids. It was, essentially, one kid holding a school hostage." (Topo 2006)

There are many who argue that while some offenses are quite serious, extending the charge of terrorism to those who threaten schools and students is excessive and not really consistent with the intent of the terrorism statutes. A law professor, who directs the University of Maryland Center for Health and Homeland Security, noted that treating all domestic attacks as terrorism and charging troubled teenagers as terrorists "cheapens the war on terror." He speculated on another organizational reason that such charges might be filed:

> "I don't know what they achieve except (that) it looks like a prosecutor is doing a wonderful job," Greenberger says. "In the end of the year, when they tote up what they've done for terrorism, they include these kinds of cases in it." (Topo 2006)

Defining school shootings as terrorism is an incredible act of power by officials who are adding their discursive slant to a complex problem. It is arbitrary and capricious in its neglect of other efforts that have been made to carefully distinguish among acts of violence. Muschert's (2007a p. 62) typology of school shootings is informed by an exceptional analysis of their characteristics since 1968. His analysis suggests that Columbine was a "rampage shooting"—defined as one in which a member or former member such as a student, employee, or former employee engages in the shooting. Other types include mass murders, targeted shootings, government shootings, and terrorist attacks—defined as individuals or groups engaging in violent acts to advance political or ideological goals. There is little in the Columbine shootings that would justify defining it as "terrorist," according to these criteria, but such definitions are less data-driven than politically charged. As suggested throughout this chapter, there are good organizational reasons to pursue the terrorism label. It is more entertaining for the mass media, and potentially more politically expedient for politicians.

Funding is a contributing reason for defining Columbine as a terrorist act, but that did not emerge until after 9/11. Columbine was grotesque enough to attract police and security funding. A few comments from an article published four years after the shootings illustrate this emphasis:

> The federal government expanded its COPS in Schools program after Columbine. The program gave $125,000 grants to local agencies to cover the cost of putting a police officer in a school for three years. About 6,500 officers have been trained to work in schools through the program.

> But funding for the program has been cut from $180 million a year in 2000–02 to $5 million this year. The change is part of an effort to shift law enforcement resources to fight terrorism…. (Cauchon 2005)

Much of this funding was for security in schools. An assistant super-intendent in Liberty, Missouri, noted that his school had applied for a $3.4 million federal grant for metal detectors, surveillance systems, and counseling programs. He added: "It hit home. We're going to continue to do things the experts say we need to be doing. But we hope and pray we don't have to use them" (Jones 1999).

Security remained a concern after 9/11, but there was a shift toward preparing for terrorism. These policy actions helped shift the discourse and definition of Columbine and school shootings. The Department of Homeland Security provided cities, police departments, and schools with tens of millions of dollars to pursue terrorism security issues, although some officials questioned whether there was adequate funding for other school monitoring (Kelley 2008).

Security and safety are part of the subtext of fear that is displayed in news reports and political action. Politicians have helped construct the aftermath of Columbine and terrorism as a mandate not only to protect children, but to attack others (opponents) for not doing enough to tighten security. New Jersey's acting governor stressed how important the safety of students in some 2,400 schools was to him, and suggested in his "State of the State" address that others weren't doing enough:

> "I will leave no stone unturned in my effort to keep our children safe from the horrors of terrorism…." For their part, New Jersey school officials seem pleased by Mr. Codey's initiative, though they say they have already been taking steps to make schools safer, especially since the 9/11 terrorist attacks….

His Republican opponent called it a "political ploy" and a "disgraceful use of fear tactics," adding:

> To single out schools, is in essence to make them a target…. What about shopping centers? What about sporting events? What about synagogues on Saturday, churches on Sunday? There is no reason to believe that schools are subject to terrorist attacks more than these other places. And our local police can do the job. (James 2005)

While it was not always clear that schools and police departments were doing a lot of things much differently, the rhetoric and emphasis was on terrorism and the important subtext of fear, including surveillance, discipline, and close monitoring of students. However, many suburban schools resisted visible signs of control such as metal detectors, which first appeared in urban schools in the 1980s in response to gang violence. A parent in a Washington, DC, suburb explained: "'I don't want my son to come to school through metal detectors. That's prison,' said Alex Colina, speaking to several hundred other parents at a community meeting Monday night" (deVise 2008).

Columbine as terrorism has been institutionalized in schools throughout the country, as many require evacuation and lockdown drills. The significance of lockdowns changed after the 9/11 attacks when government warnings were issued routinely about likely terrorist threats. Tom Ridge, head of Homeland Security, issued one early in February 2003 and suggested that homes could be protected from a bio terror attack with duct tape and plastic sheeting. Connecticut residents took the warning seriously. Paul West of Winchester, Connecticut, completely wrapped his 1800s farmhouse in plastic sheeting, and many residents of New Canaan stocked up on food and water. The school system's adjustment to reports about Columbine, and then 9/11, organizationally joined these events through bureaucratic requirements, particularly communication equipment and protocols, including drills:

> "We're in much better shape than we were a year or so ago," Thomas Murphy, a spokesman, said. "*Columbine opened our eyes,* and crisis-management plans then focused on if there was an intruder. Since 9/11, we had to take another look." (Gordon 2003)

The lockdown drills changed and became more sophisticated over time. One format was that when the drill commenced, an "intruder"—often a school official—played the role of a terrorist or shooter, stalking the hall, checking classroom doors, and listening for any noise that might indicate the presence of students. Of course, the drills did not always work out as planned. An official in New Jersey explained:

> "There were a couple police officers with kids who would text them, and we had officers responding before we had a chance to call the Police Department," said Superintendent Frank D. Borelli of the Delsea Regional High School District. "You have to figure out how to adjust and accommodate your plans." (Kelley 2008)

> The use of cameras and surveillance in schools increased after Columbine and was further reinforced following 9/11. The sense of discipline and precaution pervades many of the news accounts, especially when Columbine "copycats" occurred on its various anniversaries. But this surveillance also led to more control of students (Marx and Muschert 2007).

> "Those cameras are a good mechanism to let the students know they're being recorded and if there's misbehavior that's not noticed by the driver, there's a good chance it will be noticed on tape," Wright says. (Jones 1999)

The language of school shootings and terrorism are joined in news reports about New Jersey teacher training and orientation:

> The check list is being compiled from previous recommendations of the state Office of Emergency Management and a "best practices list" that former Gov.

James E. McGreevey directed all state departments to draft and the education department adopted in the fall, said Dennis Quinn, executive assistant to the attorney general.... Federal homeland security officers will conduct three courses for school personnel on how to recognize and react to terrorist activities.... (James 2005)

The emphasis on the language of terrorism rather than, say, "mixed up kids" is part of the discourse of fear. The concern with safety in a context of fear orients—indeed, essentially commands—school administrators and teachers to ascribe motives to all would-be student shooters as terrorists, on the one hand, while guiding interaction and discourse that constitutes the teaching environment as a place of discipline and surveillance to prevent violent acts, including those that are "prankish" and harmless pseudo-copycat ploys for attention. Such an environment and fear-prevention discourse fundamentally changes the school environment and the relationship between teachers and students. One reflective teacher noted:

"The number of fatalities has been quite low since Columbine," says Marsha Levick, legal director of the Juvenile Law Center in Philadelphia. "Fear shouldn't cause us to lose our way in handling discipline problems at school." (Cauchon 2005)

■ Conclusion

The Columbine shootings in 1999 were neither the first nor the last violent incidents on school grounds, but they were the most important in shaping a cultural narrative about school, youth, and popular culture. These shootings and terrorism were reflexively connected through the discourse of fear and expanded social control and policies that helped legitimate the war on terror. Despite their rare occurrence, such events were cast within the discourse of fear as a threat to the safety of all children, who were under the protection of school organizations and administrators. It fell to the latter to help make sense of such events and to "do something," to take steps to find the causes and prevent their recurrence. This was a similar logic that guided discourse and official actions following the 9/11 attacks, which contributed not only to the terrorism dimension of the discourse of fear, but also expanded the news space to encompass school violence.

News reports and analyses about the Columbine shootings offered fresh frames, transforming it from local to national and even international relevance. The quest to make sense out of this and other shootings, including even more brutal shootings in later years at Virginia Tech and Northern Illinois Universities,

led claims-makers, moral entrepreneurs, and journalists to retrospectively connect the most recent event with previous ones, but particularly the rhetoric and organizational responses that followed from Columbine. It was after Columbine that official national attention (e.g., the F.B.I. analyzed data) was brought to bear on the search for causative factors in the events that unfolded at Littleton, Colorado, as well as other schools (Cullen 2004). Those efforts received a lot of media attention, and, most important, discourse used in Columbine was recirculated, reinforced, and amplified.

Officials at all levels of government, including school boards, opted for more surveillance, lockdown drills, and efforts to prevent more of the same, including programs to offset the ubiquitous exclusiveness and cruelty (e.g., bullying) of school subcultures. One example was " jocks against bullies," initiated in 2008. Its aim was to sensitize school leaders to the concerns of "outsider" students (Roberts 2008). However, such programs may have been complementary of the push toward terrorism prevention, but they were not entirely consistent. "Jocks against bullies" as well as many of the counseling programs that schools established were not fully on the same page with anti-terrorist funding and emphases; they had different definitions and views about school shootings; they stressed intervention and prevention within the culture of the schools (e.g., peer groups), while the terrorism emphasis imposed an external order and logic on schools. The school culture emphasis on estranged, lonely, and misdirected youth reached out to community, familial, and the school social structure. Indeed, even when police officers were included on campuses to deal initially with "gangs" and violence, they were incorporated into the school culture, often assuming the role of mentors. But this changed after Columbine and 9/11:

> Ever since the shootings at Columbine, armed police have become a fixture in schools around the country. They are to protect the students and to enforce the law. And it's not just in big cities. Suburbs are calling police in to deal with problems that used to be handled by teachers and parents. (CBSNewsTranscripts 2004).

The 9/11 attacks were defined as part of a terrorism world, a condition and state of affairs rather than a strategy by our enemies (Altheide 2004). School shootings were only occasionally linked to the terrorism of gangs prior to 9/11. Columbine and other school shootings were referred to as terrorist activities after the 2001 attacks. This connection was manifested in plays and literature, but especially journalistic accounts. The perpetrators of Columbine and 9/11 were even linked in some analyses, as motives were easily ascribed to attacks on susceptible innocents. Governmental action to prevent terror-ism—and to arouse national concerns for impending wars—cautioned citizens about imminent danger, including targeting of schools. These programs, plus

funding opportunities to increase surveillance and profiling, were based on the notion that school violence is also terrorism. Youth suspected of planning, talking about, or engaging in such activities were more likely to be charged with terrorism. There was more talk about safe schools, avoiding fear, and cooperating with school officials and others to heighten surveillance, discipline, and to have "zero tolerance" for all forms of terrorism.

The Bush Administration's manipulation of language and use of illogic in constructing terrorism as a rationale for war is apparent in the transformation of Columbine from a school shooting to an act of terrorism. Analysis of the rhetoric and reasoning in justifying the Iraq War illustrates the power of logic and framing:

> And instead of adhering to linguistic conventions to invoke empirical facts to legitimate claims, the Bush administration used creative syntactical forms to convolute the phenomena and the discourse enacting it. All these practices— ranging from ignoring contradictory data and dismissing alternative perspectives to oversimplifying issues and applying circular reasoning—tamper with the fragility of political conventions aimed at a stable order. (Chang and Mehan 2008)

Aspects of media coverage of "the Iraq War and terrorism" and "Columbine and school shootings" emphasized evil and pathological character traits, as well as the necessity to take strong action. With Iraq and terrorism, this meant attacking without provocation, while students implicated in the planning, talking, or conduct of school shootings would be charged with terrorism.

There is scant evidence that the redefinition of school shootings as terrorism has made any impact on reducing shootings, or has had any effect other than to expand the purview of social-control agencies that are involved in the effervescent war on terror, and prior to that, the war on drugs. The focus on terrorism does promote taking direct action "before it is too late," even when the "it" is not clear. Actions taken to curtail drug use and weapons on campus have restricted students' rights while legitimating untoward use of force. For example, the principal of Stratford High School in Goose Creek, South Carolina, suspected that drugs were being sold on campus. He had previously installed 76 security cameras where he could watch the students' every move, including what he thought were drug transactions. He ordered an armed police raid that did not turn up any drugs, but did frighten students and their parents, who were not accustomed to being held at gunpoint. On the morning of November 5, 2003, 17 armed officers with dogs descended on the students when they arrived in the morning, ordering them to get down, and putting several in handcuffs. That it was early in the morning (6:35 A.M.) when only 107 students out of more than 2,000 had arrived at school—two-thirds of them black—suggested that it was racially informed. One student

said he felt like he was in a crack house that had been busted, while another observed: "I assumed that they were trying to protect us, that it was like Columbine, that somebody got in the school that was crazy or dangerous…. But then a police officer pointed a gun at me. It was really scary" (Lewin 2003). Another added, "I thought it was, like, a terrorist attack or something like—or somebody had a gun in the school." Reverend Jessie Jackson opined, "They thought it was a terrorist attack. It was" (CBSNewsTranscripts 2004). A federal court ruled three years later that the students involved in the raid were entitled to a $1.2-million settlement (http://www.feedsfarm.com/article/71851f30afa 8baff3a74622ca8d5239caf9e7d1b.html).

Notwithstanding the horror stories like Stratford High School, we do not know the consequences on schools of such protective efforts, although it is likely that the recalcitrant school cultures will find ways to resist many intrusions and bureaucratic directives (Altheide 1998; Hall 1997; Spencer 1996). Nevertheless, the discourse of fear is strengthened as more public discussion invokes terrorism threats and implores citizens to cooperate with the new world order so as to keep us all safe. Even though school shootings do not meet conventional definitions of terrorism, there are practical reasons for treating them this way:

> …the Bush administration exerted US dominance in determining what counts as legitimate knowledge…. Indeed, applying double-standards, arbitrary judgments, and oracular reasoning is a way to practice domination. (Chang and Mehan 2008 p. 474)

Clearly, the mass media played a significant role in merging Columbine and other school shootings with terrorism. The next chapter focuses on the logic of terrorism programming.

7

■ Terrorism Programming

And he [John McCain] will keep us on offense against terrorism at home and abroad. For 4 days in Denver and for the past 18 months Democrats have been afraid to use the words "Islamic Terrorism." During their convention, the Democrats rarely mentioned the attacks of September 11.

Rudy Giuliani's speech at the Republican National Convention, September 3, 2008; my emphasis

A major success of the propaganda campaign that followed the 9/11 attacks was to link those acts not only to Iraq but also to an ongoing global foe, "Islamic Terrorism." This theme cut through news reports in two ways. First, as previous chapters have noted, the attacks themselves were not only linked to Iraq and terrorists, but also the enemies of the United States and civilization itself. Second, when journalists—and later, some politicians—acknowledged that Iraq was not directly involved, there was still the tacit acceptance that the wars had to be waged, and that the armed forces personnel were engaged in a legitimate and noble cause, "fighting for our freedom" to protect us all from "Islamic terrorism," and others who "hate America." With few exceptions, the most consistent and comprehensive denunciation of all the war efforts came from Internet blogs that were directed to rather narrow (and small) audiences. Except for an occasional editorial comment, the established news media in the United States and most of Europe—especially "coalition forces"—supported the war efforts. They were following narratives that had

been scripted by previous coverage of wars, including, in some cases, a particular nation's own experience with terrorism (e.g., the United Kingdom, Israel, India). India, for example, produces more films than any country in the world, and many of these films are about terrorism, although very few deal explicitly with the U.S.-Iraq War and related matters. Still, it draws on its own context and experience with terrorist acts, and blends these with political pressure to entertain, while still promoting the government's narrative (Mehta 2004). Suketu Mehta's profound book about Mumbai (Bombay) culture and struggles in everyday life delineates the importance of movies in Indian life and politics, as well as the political problem of terrorism:

> The proportion of popular movies that deal with political issues, with terrorists, has been steadily growing.... India now deals with threats to its integrity through the movies. Many of the Hindi films of recent years are about a vast international conspiracy against the country, headed by a villain of vague ethnic outlines. There are scenes of bombings, terrorists, usually in league with Gandhi cap-wearing politicians. It is a simple explanation for the million mutinies: It's all coming from outside, what governments since independence have called the Foreign Hand. If we could only get to the one man who wants to destroy our country, everything would be all right. (Mehta 2004 p. 364)

> Mehta describes the problem of trying to move away from the dominant narrative. He is also writing the script for one movie, *Mission Kashmir*, and wants to take the script in a slightly different direction:

> Politically, I am at left angles to the film. I argue that we need to insert something about the social and economic conditions that go into the making of a terrorist, especially in Kashmir.... But I don't push the point. I do not have the necessary weight on the script-writing team. Vinod [the Director] wants the film to reinforce in the popular imagination the syncretic idea of Kashmiryat, the age-old ideology that allows Muslims...and Hindus...to worship in the same country. (Mehta 2004 p. 364)

The consistent narratives provide continuity to audiences and journalists alike, but they also create a problem for news organizations covering detractors to the narrative. This is where War Programming comes into play.

The U.S.-Iraq War and the ongoing reportage about Islamic terrorism is part of an ongoing, established news narrative about the Middle East (Adams 1981; Altheide 1981; Said 1979; Said 1981). U.S. news coverage of terrorism and the thirty-year "war" with Middle Eastern leaders—dating back to the Iranian hostage crisis in 1978—who rebelled against Western domination has morphed one crisis and event into the next one (e.g., the Iranian hostage crisis, then the "first" Gulf War with Saddam Hussein). Terms like the "Arab World," "Muslims," and "extremists" now flow together like packages of Middle

Eastern street scenes, celebrating religious holidays, chanting anti-American slogans, and, of course, denouncing Israel and supporting Palestinians. This narrative, as suggested in previous chapters, prevails after 9/11. It is now essentially institutionalized among news organizations, and with some exceptions—particularly Internet blogs—provides the framework for reporting about terrorism, as well as the opposing views of political and military action against the terrorist enemies. An additional narrative has emerged to take into account opposing views while still sustaining the dominant narrative: War Programming, and a more recent derivative, Terrorism Programming.

The news coverage of the Iraq War was presented as part of a "War Programming" narrative, which includes occasional views of detractors to give the appearance of debate and considering "all sides." The narrative survives because it is simple, entertaining, and resonates fear and fairness. The narrative resonates fear because the dominant message is that national security and public safety is at risk—and being defended. It resonates fairness because the "other side" is represented. I suggest that it is not the government that directly controls War Programming, but rather, it is the news media. Journalists' efforts to cultivate good relations with government news sources tend to compromise the craft of journalism and essentially sanction government claims-making. Decades of such relationships have institutionalized a communication pattern for covering wars. The war on terrorism reflects many commonalities with previous war coverage. An overview of the run-up to the Iraq War and the propaganda campaign—Terrorism Programming—that prepared the American people for war, will be followed by an analysis of the War Programming narrative that is characteristic of recent wars (Altheide 2006).

The 9/11 attacks stunned the leaders and citizens of the United States. Politicians used a compliant press to promote narrow claims about the meaning of the attacks and to rally the country for war. The Bush Administration immediately saw an opportunity to attack Iraq even though there was scant evidence that Iraq was involved in the attacks. Indeed, many of the hijackers were from Saudi Arabia, a close friend and ally! A propaganda campaign directed harsh messages against Iraq (Kellner 2004; Kull et al. 2002).

Journalism failed to tell the story about the early planning for the Iraq War and future wars as well. The plan and the people associated with it were called the Project for the New American Century (PNAC), but U.S. audiences learned very little about this from their news media (Altheide and Grimes 2005) because journalists, with the exception of some fine *FRONTLINE* (Public Broadcasting) reports, did not address it prior to the start of the Iraq War. Many members of the PNAC joined the Bush Administration and became

credible claims-makers, who constructed the frames for shaping subsequent news reports. Many former and current governmental officials, including Elliot Abrams, William Bennet, Jeb Bush, Dick Cheney, Steve Forbes, Donald Kagan, Norman Podhoretz, Dan Quayle, Donald Rumsfeld, and Paul Wolfowitz were members who signed many of the proclamations laying the foundation for a new American empire (Bacevich 2002; Kagan 2003; Kagan and Kristol 2000) (http://www.newamericancentury.org/).

The Iraq War narrative was framed by these efforts and the resulting propaganda campaign to convince the American people that attacking Iraq was tantamount to attacking "terrorists" and others who threatened the United States (Armstrong 2002). David Armstrong's essay in *Harper's* in October 2002 chronicled the history of the PNAC and its role in shaping U.S. foreign policy.

> The plan is for the United States to rule the world. The overt theme is unilateralism, but it is ultimately a story of domination. It calls for the United States to maintain its overwhelming military superiority and prevent new rivals from rising up to challenge it on the world stage. It calls for dominion over friends and enemies alike. It says not that the United States must be more powerful, or most powerful, but that it must be absolutely powerful (Armstrong 2002, p. 76)

The plan was clear, but the press barely covered it. The press was nearly silent when Colin Powell told the House Armed Services Committee in 1992, when military budgets were being threatened, that the United States must do what is necessary to deter any challenger. Said Powell, *"I want to be the bully on the block,"* and to let potential opponents know that "there is no future in trying to challenge the armed forces of the United States" (Armstrong 2002, p. 78; my emphasis). The Bush Administration responded to the 9/11 attacks by bombing Afghanistan and then invading Iraq as havens of terrorism. The established news media, with few exceptions, not only supported these efforts, but gave very little historical information and opposing arguments.

The terrorism narrative grew after 9/11. Terrorism became a perspective, orientation, and a discourse for "our time," the "way things are today," and "how the world has changed." The subsequent campaign to integrate fear into everyday life routines was consequential for public life, domestic policy, and foreign affairs (Kellner 2003). Alissa Rubin of the *Los Angeles Times*, who reflected on nearly four years of news coverage, suggested that news organizations did not do their jobs:

> Well, I always personally found [U.S. government briefings] valuable. I know many other people didn't because if you looked at them in terms of objective truth, they weren't very useful. But in terms of how the *U.S. government wanted us to see things,* they were quite useful. *And it's important to know what the government's narrative is.* Because in any conflict there are *competing narratives,* and our

job, from my point of view, is to sort through them and provide a reality check
on all of them. (Editors 2006 p. 28) my emphasis)

Terrorism (and terrorist) disclaimers were reflected in everyday parlance
(e.g., "since 9/11…," "…how the world has changed," "…in our time," etc.).
Terrorism, as a matter of discourse, became an institutionalized disclaimer
(e.g., "We all know how the world has changed…"), a term or phrase that
documents a general (rather than a specific) situation and conveys a widely
shared meaning (Hewitt and Stokes 1975). Indeed, the seventh anniversary
of the 9/11 attacks was heralded in numerous news reports in the United
States with such phrases: "9/11 Changed Our World Forever." The "change"
went well beyond the attacks and those who were responsible, to a redefini-
tion of domestic and international order. Domestic life became oriented to
celebrating/commemorating past terrorist acts, waiting for and anticipating
the next terrorist act, and taking steps to prevent it.

The popular refrain was that all Americans were victimized by the attacks,
and like the "potential victims" of crime featured in a decade of news reports
about the crime problem, all citizens should support efforts to attack the
source of fear (Garland 2001). The mass media emphasized that the cause
was simply because the enemy disliked the United States of America, its
freedom, and life style. Indeed, anyone who suggested that the "cause" of
the attacks was more complex and that the United States had angered many
political groups by previous actions (e.g., support for Israel) was denounced.
Talk-show host Bill Maher, who argued that the terrorists were not really
cowards, was among those pilloried and lost his job. Clear Channel, a radio
consortium, blacklisted 150 songs with critical themes (e.g., Simon and
Garfunkel's "Bridge Over Troubled Waters") (Kellner 2003 p. 68).

Reports about terrorism promoted the discourse of fear, which may be
defined as the pervasive communication, symbolic awareness, and expecta-
tion that danger and risk are a central feature of the effective environment,
or the physical and symbolic environment as people define and experience
it in everyday life. Any stranger could be a threat; we could be attacked by
many weapons, including unspecified "bioterrorism," which might include
"dirty bombs" of radiation. Officials at one point elevated the newly created
"terrorism threat" level to orange—high—and urged citizens to defend their
families by wrapping their homes in plastic and duct tape. Such messages
promoted the politics of fear, which refers to decision-makers' promotion
and use of audience beliefs and assumptions about danger, risk, and fear in
order to achieve certain goals (Altheide 2003c; Furedi 1997; Massumi 1993).
While many messages emphasized the importance of "being united," the
thrust of numerous news reports and political rhetoric was that the future
was uncertain, strong leaders were essential, and security would require

restrictions on civil rights. The politics of fear promotes attacking a target (e.g., crime, terrorism), anticipates further victimization, curtails civil liberties, and stifles dissent as being unresponsive to citizen needs or even "unpatriotic."

The symbolic construction of terrorism transformed the 9/11 attacks into a world view that was apparent in numerous news and public affairs messages. Virtually all explicit and implicit political statements, holiday messages, commercials and advertisements, economic projections, domestic issues, fiscal discussions, and even sporting events reflected terrorism and thereby added to it.

News media reports after 9/11 enabled elite decision-makers to construct terrorism as the object of fear and to cast all Americans as victims. Citizens were asked not only to give blood and money, but to grant elites and formal agents of social control (FASC) all authority to take whatever measures were deemed necessary to protect citizens, take revenge, and prevent such a deed from reoccurring. The metaphor of "investment" covered a context of meaning that joined contributing to "victims" of 9/11, buying products to "keep America rolling," and supporting military action and budget increases. These messages promoted a national identity (Shapiro 1992; Thiele 1993) based on the politics of fear that was later used by President Bush to pursue a "first-strike" policy against U.S. enemies. Indeed, some 11 months after the United States attacked Iraq in pursuit of "weapons of mass destruction" (WMD) that were not found, President Bush explained his actions:

> I'm a war president. I make decisions here in the Oval Office in foreign policy matters with war on my mind.... I believe it is essential that when we see a threat, we deal with those threats before they become imminent. It's too late if they become imminent. (NBC, *Meet the Press*, February 8, 2004)

American citizens were reminded daily of the "danger" by a color-coded fear alert created as part of the new office of "Homeland Security." The level rose to "high" or orange alert five times between March 2003 and March 2004. The atmosphere of alarm and fear was heightened as federal law enforcement officials warned that more attacks were likely. On October 12, 2001, the House of Representatives advanced "anti-terrorist" legislation to grant broad surveillance and detention powers to the federal government. The United States Patriot Act passed by a vote of 337–79 with little debate despite pleas from civil liberties advocates that the legislation could be a dangerous infringement on rights. Some members of Congress acknowledged that they had not read the legislation. This act removed restraints that had been placed on the FBI and CIA because of their numerous civil rights violations (e.g., those associated with COINTELPRO) (Churchill and Vander Wall 1990).

There was little criticism or dissent about administration incursions into civil liberties and violations of due process, especially when everyday life routines were interrupted when color-coded "terrorism alerts" were put in place. President Bush garnered 90% approval in opinion polls. Authorities called for relaxing civil rights and detention. Several thousand immigrants and some citizens were questioned and detained without due process. The social definition of impending attacks by terrorists among us was essentially unchallenged in public discourse, with the exception of some Internet traffic. Indeed, a columnist for *Newsweek* advocated the development of a "domestic C.I.A." (Zakaria 2002 p. 39), and civil libertarian Alan Dershowitz argued that judges should issue "torture warrants" when terrorist suspects were jailed (Walker 2002). During the critical eight-month period between the 9/11 attacks and the U.S. invasion of Iraq, the American news media essentially repeated administration claims about terrorism and Iraq's impending nuclear capacity (MacArthur 2003).

Attorney General John Ashcroft made it clear that anyone concerned with the civil rights of the suspicious was also suspect. Ashcroft told members of a Senate committee that critics "aid terrorists" and undermine national unity: "They give ammunition to America's enemies, and pause to America's friends" (*Minneapolis Star Tribune*, December 9, 2001, p. 30A). Apparently, many Americans accepted this view. *Sacramento Bee* president and publisher Janis Besler Heaphy was booed off the stage during a commencement address at California State University, Sacramento, after she suggested that the national response to terrorism could erode press freedoms and individual liberties. One professor in attendance stated: "For the first time in my life, I can see how something like the Japanese internment camps could happen in our country" (the *New York Times*, December 21, 2001, p. B1).

Mass-media support for the emerging national identity was commensurate with moral character and a discourse of salvation or "seeing the light" to guide our way through the new terrorism world. The "younger generation" was implored to meet the new challenge; this was, after all, their war, and the mass media carried youthful testimonies of new-found loyalty and awakening that would have made a tent-meeting evangelist proud. *Newsweek* published statements by young people, one by a woman "confessing" her naïveté about the "real world," and another by a former university student who criticized "antimilitary culture" with a call to arms:

> Before the attack, all I could think of was how to write a good rap.... *I am not eager to say this*, but we do not live in an ideal world.... I've come to accept the idea of a focused war on terrorists as the best way to ensure our country's safety. (Newman 2001 p. 9; note the disclaimer, my emphasis)

Unlike reactions to previous "external attacks" (e.g., Pearl Harbor) that stressed conservation, personal sacrifice, and commitment, a prevailing theme of consumption-as-character and financial contributions as commitment and support pervaded mass-media messages surrounding the 9/11 attacks. The American Ad Council produced messages designed to get Americans to consume, share, support, and continue living:

> Following the tragedies of September 11th, the Ad Council reached out to the federal government as well as important national non-profits with an offer to create and also distribute their crisis-related messages to media outlets nationwide. A few weeks later, the Ad Council announced a special crisis response team, now called the "Campaign for Freedom," to oversee the development of public service advertising campaigns intended to help the American people respond to the crisis.

> Since the attacks, Americans have experienced profound grief, disbelief and immobilizing fear that has shaken beliefs, threatened security and deepened the economic decline. These new messages are designed to inform, inspire and involve all Americans to participate in activities that will strengthen our nation and help win the war on terrorism. (http://www.campaignforfreedom.org/)

Many messages made giving and buying commensurate with patriotism and national unity (Espeland 2002). A nation's grief was directed to giving and spending dollars. Cultural scripts of generosity and sympathy were processed through organizational entertainment formats emphasizing market participation and consumption (Kingston 2002 p. CP1). The emphasis was embodied in regular local TV reports about "fallen heroes" that valorized young men and women who were killed by roadside bombs. The symbolic elevation of anyone who died in the war "theatre" as a "hero" continued throughout the war. The routine deaths were separated by "true hero" deaths such as National Football League player Pat Tillman, whose death at the hands of his own comrades was initially covered up and played out as a propaganda tale of a hero who was killed as he "was storming a hill to take out the enemy" (Altheide 2007; Rich 2006).

A new national identity was born of victimization, patriotism, and revenge.

Gun manufacturers targeted fearful citizens. The gun industry and the National Rifle Association (NRA) urged Americans to buy their slogans and products. Many Americans responded to the September attacks by arming themselves. As one reporter noted, "People may say: 'Let Tom Ridge watch out for our shores. I'll watch out for my doors'" (Baker 2001). Gun sales were up nationwide 9% to 22%, despite the concern of police officials (Baker 2001). Examples from advertisements illustrate the point: "Ithaca Gun Company is selling its Homeland Security model for our current time of national need...."

In every respect, these new Homeland Security Model shotguns are up to the demanding tasks which lay before us as a nation." The Beretta gun company promoted its "United We Stand," a 9-millimeter pistol bearing a laser-etched American flag. The company sold 2,000 of them to wholesalers in one day in October..." (Baker 2001).

With network and local nightly newscasts draped in flag colors, lapel flags, and patriotic slogans reporting events "primarily through the viewpoint of the United States" (e.g., "us" and "we"), news organizations presented content and form that was interpreted by the publisher of *Harper's Magazine* as sending "...signals to the viewers to some extent that the media are acting as an arm of the government, as opposed to an independent, objective purveyor of information, which is what we're supposed to be" (Rutenberg 2001). Numerous news reports promoted more fear about potential terrorists and enemies of the United States.

■ The Expanding Definition of Terrorism

Numerous "internal" conflicts and revolutionary movements were classified as "terrorism." Within a matter of days after 9/11, countries dealing with revolutionary movements within their own borders (e.g., Colombia, Peru, and Israel) vowed to join the United States in its fight against terrorism (Bennett 2001).

Audiences consumed a symbolic bombardment that was forging a national identity commensurate with fear, a right to retaliate and attack present and future enemies, and support for restriction of civil liberties to protect us from our enemies. The military expenditures were commensurate with a socially constructed morality play of the enemy and its horrendous acts. Support for military expenditures and the public's tacit approval of civil liberty restrictions—including profiling of Arab-Americans—reflected fear-induced communalism surrounding terrorism. News reports reflected the mass media's use of routine "elite" news sources to "get the story" of attacks and promote entertaining reports about "America Strikes Back." The public support quickly became a resource to use in "striking back" when the Bush Administration proposed a "first strike"—not against Afghanistan or Al Qaeda networks, but against sovereign nations that either support terrorist activities or engage in threatening acts. The propaganda messages were consistent with a fear narrative that justified military action. The social scientist's challenge is to locate this unique retaliation against avowed terrorists within a theoretical framework. Previous work on media formats and news narratives are useful for this task.

■ Mass-Media War

Administration news sources provided a compliant news media with ample material and conjecture about both of the claims that linked Iraq and Hussein with the terrorist attacks of 9/11. Prior to the invasion, as well as after the president triumphantly declared from the deck of an aircraft carrier that victory had been won, the Bush Administration insisted that Hussein had supported the terrorists and had weapons of mass destruction (WMD) that he planned to use. The propaganda campaign to "sell the Iraq War" emphasized Iraq's connections with Al Qaeda and development of "weapons of mass destruction" (WMD), including chemical, biological, and nuclear weapons.

> As The Associated Press put it: "The implication from Bush on down was that Saddam supported Osama bin Laden's network. Iraq and the Sept. 11 attacks frequently were mentioned in the same sentence, even though officials have no good evidence of such a link." Not only was there no good evidence: according to the *New York Times*, captured leaders of Al Qaeda explicitly told the C.I.A. that they had not been working with Saddam. (Krugman 2003 p. 29)

■ Terrorism Programming

Previous work suggests that the current structure of policy and critique is now institutionalized and, essentially, connects criticism and "challenge" within the action as a War Program. The scope of the action is so immense that it precludes and preempts its critique. Analyses of news-media coverage of previous wars indicates that each "current" war is greatly informed by images, symbols, language, and experience associated with "previous" wars, including the demonization of the enemy, the virtues and necessity of waging war, and the social and political benefits for doing so. The irony, of course, is that each new "war situation" is presented by producers as something unique and novel, while the informational and emotional context for relating to it is historically embedded in previous wars, often experienced mainly through the mass media. Thus, we draw on War Programming, an ordered sequence of activities.

War Programing:
1. Reportage and visual reports of the most recent war (or two);
2. Anticipation, planning, and preparing the audiences for the impending war, including "demonizing" certain individual leaders, e.g., Noriega, Hussein;

3. Coverage of the sub-segments of the current war, using the best visuals available to capture the basic scenes and themes involving the battle lines, the home front, the media coverage, the international reaction, anticipation of the war's aftermath;

4. Following the war, journalists' reaction and reflection on various governmental restriction, suggestions for the future (which are seldom implemented);

5. Journalists' and academics' diaries, biographies, exposés, critiques, and studies about the war, and increasingly the media coverage;

6. Media reports about such studies, etc., which are often cast quite negatively and often lead to the widespread conclusion that perhaps the war was unnecessary, other options were available, and that the price was too high; all of this will be useful for the coverage of the next war;

7. For the next war, return to step 1.

Each of these phases has been verified empirically with other U.S. wars (e.g., Vietnam, Panama, Grenada, Somalia, Gulf War) and will not be repeated here (Altheide 1995). The challenge of the Iraq War is that while it officially ended on May 2, 2003, with Bush's dramatic photo-op landing on an aircraft carrier—"major combat operations in Iraq have ended"—the war has continued for six more years (as of this writing), and troops are likely to remain in combat for many more months, possibly even years. Nevertheless, critiques (steps 4 and 5) are forthcoming. War Programming differs from conventional propaganda analyses (Barson and Heller 2001; Lasswell et al. 1979) because critique is included as part of the narrative and script of promotion.

Terrorism Programming poses challenges to the War Programming process because the definition of terrorism as a condition—rather than a tactic or "enemy"—is ongoing. Thus, even after the United States withdraws from Iraq and declares "victory," fighting terrorism will continue. In this sense, the war will never be won, and therefore the final steps in the War Programming conceptual scheme will be elongated. Nevertheless, there are examples of stages 4, 5, 6, with the Iraq War, and these have been noted elsewhere (Altheide and Grimes 2005). Journalists' reflections on Terrorism Programming are less consistent than might be expected, especially in view of the wide agreement among academic researchers as well as some individual news organizations, e.g., the *New York Times*. Nor has there been much attention to human rights violations that occurred routinely in the conduct of urban warfare as well as the bombing of housing compounds and the deaths of dozens of people ("collateral damage") in the pursuit of a few individuals.

■ Organizational Reasons for Propaganda

The lack of reporting about human rights violations as a result of the U.S. invasion of Iraq illustrates embedded propaganda as a feature of institutionalized news sources and media formats. Several analyses of U.S. news reports found an overwhelming emphasis on victimization at the time of the initial attacks, but that emphasis gradually turned to war preparation, the conduct of war, and then victory over Iraq (Kellner 2004; Norris et al. 2003).

While there were detractors in editorial pages, the Internet, and, of course, the foreign news media, the major TV networks were tightly aligned with the war scenario. We wish to stress the critical contribution of news formats and the emerging common definition of the situation—that the nation had to act, that audiences supported action against enemies, and that simplistic, emotionally tinged messages would carry the day. Key to the Bush Administration's success was journalists' penchant to get on the "war" bandwagon, not only for patriotic purposes, but also because that was what "people were interested in," and that's "where the story was." Network TV played to the administration.

Most of the Gulf War coverage originated from the White House and the federal government. Journalists now acknowledge that they did not cover many aspects of the impending war with Iraq.

The organizational and format limitations of War Programming misdirected journalists from major topics. Moreover, as our model suggests, news organizations began to reflect on "what went wrong" in their coverage of Iraq. A *Columbia Journalism Review* "debate" between a foreign editor, Leonard Doyle, of the British newspaper the *Independent*, and the ombudsman, Michael Getler, for the *Washington Post*, illustrates this awareness.

> *Getler:* Any analysis of how the American press performed in the run-up to the war in Iraq is a complex task. And it is also vulnerable to the easy cheap shot. So much that was forecast by the Bush Administration in the strongest possible terms and imagery has turned out, as of this writing, to be wrong. So it is easy to say the press did not do its job. That is true, in part. But it was a very hard job....

> How did this happen? One factor, in my view, was a failure by editors, a lack of alertness on their part, to present stories that challenged the administration's line in a consistent way and that would have some impact on the public. That's why, I believe, so many of those public events were played inside newspapers rather than on page one....

Doyle: Mike Getler accepts that the press fell down on the job, that it was out-flanked by the Bush administration. Surely it is now time for a fundamental reappraisal of the way the press operated. Because, like it or not, the media were co-conspirators in America's rush into this illegal war. How badly we needed—before the war—solid reporting that explained how a kitchen cabinet of neoconservatives and their bellicose friends were cooking up a war that has brought so much bloodshed to Iraq and danger to the world. Surely we need to reassess the whole concept of "embedded" reporting. Consider this conundrum: How could it be that Scott Ritter, the most famous U.S. inspector and the one person who got it right about Saddam Hussein's supposed arsenal of WMD, was treated with total suspicion? Meanwhile, dubious exiles with no inherent knowledge of WMD were treated with great respect by TV and newspapers. (ColumbiaJournalismReview Staff 2004, pp. 46–47)

The *New York Times* also acknowledged their systematic oversight and reliance on official news sources:

"In some cases, information that was controversial then, and seems questionable now, was insufficiently qualified or allowed to stand unchallenged," the newspaper said. "Looking back, we wish we had been more aggressive in re-examining the claims as new evidence emerged or failed to emerge."

The *Times* also said it had featured articles containing alarming claims about Iraq more prominently than follow-up stories that countered those claims.

Many of the stories used information from Iraqi exiles and critics of Saddam Hussein…. (AP in *The Arizona Republic*, May 27, 2004, p. A1)

Consistent with War Programming, other journalists joined in reflecting on the news coverage of the Iraq War.

…In the rush to war, how many Americans even heard about some of these possibilities? [the numerous problems that would follow the war, e.g., interim government, health and water resources, Halliburton's contract that basically gave it control over the oil] Of the 574 stories about Iraq that aired on NBC, ABC, and CBS evening news broadcasts between September 12 (when Bush addressed the UN) and March 7 (a week and a half before the war began), only twelve dealt primarily with the potential aftermath…. (Cunningham 2003 p. 24)

Notwithstanding these reflections, network TV journalists in the United States disagreed in their assessment of the quality of their news coverage (Barrett 2008). For example, network news anchors discussed President Bush's former press secretary Scott McClellan's (2008) disclosures and statements about the Bush Administration propaganda campaign in the Iraq War as well as the press complicity in getting out the propaganda and not challenging the reports. He called the media "complicit enablers" in the Iraq War. Many of

these comments support the general model of War Programming, although it is noteworthy that the most critical comments were offered by Katie Couric, a longtime talk-show host before becoming a news anchor. However, the ambiguities associated with Terrorism Programming may be contributing to less self-criticism among journalists (e.g., Charles Gibson and Tom Brokaw below). A few of the network anchors' hubris-laden comments follow.

> *CBS* Early Show*'s Harry Smith:* "(McClellan) talks about the failure of mainstream media to hold the Bush administration's feet to the fire in the run-up to the war. Is that an allegation that feels to you like it has merit?"

> *ABC News's Charles Gibson:* "When I write my book I will take exception to that. No, I think the media did a pretty good job of focusing and asking the questions. We were not given access to get into the country, to go along…with the inspectors but the questions were asked. The questions were asked. It was just a *drumbeat* from the government and I think it's convenient now to blame the media. But I don't." (my emphasis)

Note that Gibson overlooks the important role of the news media in constructing and maintaining the "drumbeat." This is apparent in other comments as well.

> *CBS News's Katie Couric:* "I think it is a very legitimate allegation. I think it's one of the most embarrassing chapters in American journalism. I think there was a sense of pressure from the corporations who own where we work and from the government itself to really squash any kind of dissent or any kind of questioning of it. I think it was extremely subtle but very effective. I think Scott McClellan has a really good point…."

> *NBC News's Brian Williams:* "I think people have to remember the post-9/11 era and how that felt and what the president felt he was empowered to do and that Colin Powell speech at the U.N."

> *Smith:* "And what the mood of the country was."

> *Couric:* "Absolutely. But our responsibility is sometimes to go against the mood of the country and ask the hard questions." (Barrett 2008)

Veteran anchorman Tom Brokaw's comments were less critical of TV's reporting. He emphasized the "context" of the time and the "mood" of the

country. We also see the "drumbeat" metaphor used by Brokaw, the former NBC news anchor.

> *Williams:* "Are you confident in taking the coverage…that the right questions were asked, the right tone was employed and should it be viewed in the context of that time?"

> *Brokaw:* "It needs to be viewed in the context of that time. When the president says we're going to war, there's the danger of the mushroom cloud, we know there had been experiments of Iraqi nuclear programs in the past, honorable people believed he had weapons of mass destruction. But there is always a *drumbeat* that happens at that time. You can raise your hand and put on people like Brent Scowcroft which we did, very credible man, who said this is the wrong decision. But there are other parts of America who also have a responsibility. How many senators voted against the war? I think 23 is all, altogether…."

And Brokaw's next comment reaffirms the War Propaganda script:

> "Look, I think all of us would like to go back and ask questions with the benefit of hindsight and what we know now, but a lot of what was going on then was unknowable…. So there was a fog of war, Brian, and there's also the fog of covering the war…."

■ Conclusion

The discourse of fear that promotes the politics of fear is increasingly joined to mass media, and especially propaganda campaigns. Entertaining news messages often resonate fear. Thus, as the first quotation in this chapter shows, the attacks of 9/11 and fear of terrorists continue to define leadership capacity. The news coverage of terrorism can be attributed to organizational and format considerations, as well as a culture of information that draws journalists to official sources of information—typically government officials—and discourages critical questioning. These factors suggest their solution as well.

1. Public information and awareness is an organizational product of news agencies and our massive popular culture industry. The mass media and information technology (IT) are part of an ecology of communication—the interaction of IT, communication formats, and social action—that influences perspectives, awareness, policy, and action throughout the world (Altheide 1995). Audiences and political

leaders know very little about the world beyond our own borders, and news organizations share the responsibility for this.

2. The major change in news coverage during the last 30 years, especially with "visually oriented TV reports," is the emergence of the entertainment format that tends to promote simplistic, familiar, dramatic, and visual presentations (e.g., combining the meanings of terms like Arab, Muslim, radical).

3. One consequence of this format has been to promote a discourse of fear, or the pervasive communication, symbolic awareness, and expectation that danger and risk are a central feature of everyday life. The "solution" that is usually offered includes formal agents of social control (police and military).

4. The news coverage of terror attacks reflects, in part, a failure of news organizations to report systematic changes and social impacts of foreign-policy decisions throughout the world. Context and consequences of political action are sorely missing in favor of the immediacy of the moment. Terrorism, as political communication, is likely to escalate when initial "messages" are disregarded.

5. Part of the solution is to create new formats for news and current affairs.

News reports were part of the discourse of fear about terrorism after 9/11. The contribution of other entertainment-oriented popular culture is examined in the next chapter.

■ The Terrorism Narrative and Mediated Evil

"He died hungry" "My son has been turned into pieces"
...the baby's mother *...the baby's father*

Fear expanded after 9/11. The media changed terrorism, and terrorism changed the mass media. Technology played a part. Terrorism was blended with media logic to color mass-media messages about events and issues. Recall that the thrust of media logic is to manage meanings of events and issues through media formats, including entertainment. Media logic is global; all sides of conflicts are joined through communication formats. Just as marketers world-wide use similar approaches and logic, as do arms manufacturers and merchants who engineer wars and killing, messages and claims are produced through a process involving technologies, entertainment, dramatic and visual impacts, as well as framing and thematic emphases. Events and problems are increasingly treated as sporting events and theatrical productions awaiting audience approval; players—be they individuals, groups, or states—are cast as characters, with pasts and futures forged in timeless narratives (at least since 9/11). And people die.

Terrorism has joined crime as a master narrative of fear that contains many accounts (that is, justifications) and disclaimers for all kinds of behavior. As stressed in previous chapters, this means that terrorism and its numerous artfully constructed meanings and nuances are an important context of experi-

ence in its own right, essentially blocking out other contexts and considerations. Thus, terrorism has become a social definition that encompasses a self-referential discourse and justification, on the one hand, while also serving as a rationale for revenge and counter-attacks, on the other. Carefully orchestrating, restricting, and controlling images can manage terrorism and news sources that get to make claims about social reality. There was war before terrorism became so closely linked with the discourse of fear—the pervasive communication, symbolic awareness, and expectation that danger and risk are a central feature of the symbolic environment. But terrorism war is grounded in an insatiable attraction to identifying and validating sources of fear with the commitment to attacking them.

These points can be illustrated with a few examples of post 9/11 discussion about another murderous war. Hamas, the government of Gaza, relentlessly sent rockets into Israeli cities near the Gaza strip, which became a pretext and justification for the Israeli siege of Gaza in late December 2008. Both sides demonized the other, proclaimed justifications for death and destruction, and, most important, attempted to manage messages and images about suffering *vis-à-vis* their protagonists' actions.

After ten days of bombing, shelling, and blowing up babies, Israel's foreign minister, Tzipi Livini, neutralized the eventual killing of more than 1,300 Palestinians—a quarter of them children—in Gaza. She promised officials from the Czech Republic, Sweden, and France, who were seeking a ceasefire, that Israel would "change the equation" in the region, adding that in other conflicts:

> "...countries send in forces in order to *battle terrorism*, but we are not asking the world to take part in the battle and send their forces in—we are only asking them to allow us to carry it out until we reach a point in which we decide our goals have been reached for this point."

President Bush, a few days prior, stated that Hamas was to blame because it "unleashed a barrage of rockets and mortars that deliberately targeted innocent Israelis—an *act of terror* that is opposed by the legitimate leader of the Palestinian people, President (Mahmoud) Abbas."

Israel insisted that it tried to make telephone calls and drop pamphlets warning residents that their homes would be blown up soon, so they should leave. That did not help 11 members of the Soumani family, including 5 four-year-olds, who fled their own home, only to die together when a missile hit their relatives' dwelling. Masoua al-Soumani explained that she was fixing her baby something to eat when he was blown up, so that's why he died hungry.

Another Israeli spokeswoman told reporters, essentially, that Hamas is responsible for any civilian casualties because they live, train, store, and fire

rockets near where people live: *"We have no intention of harming civilians...."* *Hamas "cynically uses" civilians* by operating in their midst, she said, adding, "Sometimes there can be situations where civilians get hurt"

When one's actions are killing people, it is useful to manage or "spin" accounts by appealing to noble motives and intentions. Modern warfare has seen many examples of this, including the United States's artful appeals to inevitable "collateral damage" when civilians are killed during air strikes, or, more typically, killing a dozen women and children who were accompanying a target that was stalked by unmanned predator drones. For example, in October 2008, a U.S. air strike in Afghanistan killed an estimated 30 civilians, including 11 children and a few "militants," although the U.S. military claimed that only 5–7 civilians were killed. Photos from cell phones (we'll return to cell phones a bit later in this chapter) tended to support the Afghanistan estimate.

> The *New York Times* on Sept. 8 described freshly dug graves, lists of the dead, and *cellphone videos and other images* showing bodies of women and children in the village mosque seen on a visit to Azizabad. Cellphone images a Times reporter saw showed at least 11 dead children, some apparently with blast and concussion injuries, among some 30 to 40 bodies laid out in the mosque.
>
> Afghan and United Nations officials backed this accounting of a higher civilian death toll, putting them in direct conflict with the American military's version of events. In that account, American Special Forces troops and Afghan commandos called in airstrikes after they came under attack while approaching a compound in Azizabad, a village in the Shindand district of Herat Province. Among the militants killed, the military said at the time, was a Taliban leader, Mullah Sadiq.
>
> By the next day, Afghan officials complained of significant civilian casualties and President Karzai strongly condemned the airstrikes. American military officials rejected the claim, saying that extremists who entered the village after the bombardment encouraged villagers to change their stories and inflate the number of dead (Schmitt 2008; my emphasis)

These were not really accidents, because the target—a bunker—was selected, but they can be claimed to not be intentional, meaning that the legitimate targets—the avowed enemy—permitted the "unfortunate" others to be with them.

In other instances, the enemy can even be blamed for operating under cover of a legitimate civilian enterprise, such as a hospital, school, or powdered-milk factory—as was the case during a U.S. bombing in the first Gulf War. But managing accounts and meanings is challenging when others might transmit images and claims that are in conflict with official propaganda. Thus,

when visual images were available of 40 Palestinians killed while seeking shelter in a U.N. school, an Israeli spokesperson claimed that secondary explosions indicated that weapons were being stored in the school. One U.N. official noted that in this war "There was no safe haven," while a colleague expressed grave concern about shelling a U.N. facility:

> "Anyone on either side of the confrontation lines found to have violated international humanitarian law must be brought to justice," Mr. Gunness said.
>
> The night before, the United Nations said, three Palestinian men were killed in an Israeli attack on another United Nations school for refugees in Gaza. "These attacks by Israeli military forces which endanger U.N. facilities acting as places of refuge are totally unacceptable and must not be repeated," the United Nations secretary general, Ban Ki-moon, said in a statement. "Equally unacceptable are any actions by militants which endanger the Palestinian civilian population." (El-Krodary and Kershner 2009)

In a Kafkaesque sequel to the banality of evil (Arendt 1966), Israel would idle down its death machine for a few hours so that citizens could escape, get supplies, have funerals, and send ambulances to treat the hundreds of wounded. Then the war would start up again, and then ambulances and trucks would be fair game if they were part of a targeted area. I discuss the changing character of mass-mediated evil later in this chapter.

The chance for competing definitions about this war was apparent; the Palestinians who were being slaughtered by mortars, missiles, artillery, and bombs were not consulted about their views of the attacks, although the Hamas leader, Hamoud Zahar, who had presided over several years of indiscriminate rocket attacks into neighboring Israeli cities, told the few members of a TV audience with electricity:

> The Israeli enemy in its aggression has written its next chapter in the world, which will have no place for them. They shelled everyone in Gaza. They shelled children and hospitals and mosques, and in doing so, they gave us legitimacy to strike them in the same way. (El-Khodary and Kershner 2009)

Hamas played the media card after 40 men, women, and children were killed at a U.N. school that had been attacked by Israel. The attention to mass-mediated symbolism for relevant audiences is apparent. According to one report:

> The bodies of the children who died outside the United Nations school here were laid out in a long row on the ground. *Some were wrapped in the vivid green flag of Hamas, some were in white shrouds, and some were in the yellow flag of Fatah, which is rarely seen these days in Hamas-run Gaza.* Hundreds of Gazans crowded around, staring at the little faces, some of them with dark eyes still open, but dulled. *Abdel Minaim Hasan, 37, knelt, weeping, next to the body of his eldest daughter,*

*Lina, 11, who was wrapped in a Hamas flag. "From now on I am Hamas!" he cried. "I
choose resistance!" But then he cursed Arab nations for ignoring the plight of the Gazans.
"The Arabs are doing nothing to protect us!" he shouted....* On a loudspeaker, a man
praised the dead and said: *"What Israel is doing is bringing us unity again! We are all
together!"* That idea appeared to explain the willingness of Hamas to have Fatah
flags in such evidence. (El-Krodary 2009a; my emphasis)

In the next sentence of the report there was a description of one woman who
was not inclined to follow a mass-mediated script:

Halfway along the row of bodies—uncountable in the press of the mourning
crowd—Huda Deed was weeping. *She lost nine members of her extended family, ages
3 to 25. "Look, they've lined them up like a ruler!" she said, inconsolable. But when asked
for an interview by Al Aksa television, the Hamas channel, she refused.* (my
emphasis)

Numerous Internet sites carried commentary and repeated various articles
and videos about the brutal attacks as well as current and historical events
involving Israel and Gaza. The media "traffic" was quite surprising since Israel
sought to control press and information access about the invasion of Gaza.

Israel employed media logic to manage the meanings and definitions of
its attacks. No stranger to image problems, Israel had been roundly criticized
for killing civilians during previous bombardments of Lebanon, especially
Qana in 1996 and 2006. The problem in a media age was not just that people
had died, but that there were reporters narrating images of people dying and
that these were carried worldwide. There is something enduring and real
about seeing vivid photos of people, especially children, dead and wounded.
This brought condemnation from many quarters, including Israel's strongest
supporter and weapons supplier, the United States. Bloody corpses, especially
of women and children, are difficult to "spin," even, as noted above, when
the enemy is blamed for 'hiding behind' the innocent civilians. Advanced
targeting technology seems to negate too many claims about mistakes, par-
ticularly when graphic visuals show bodies strewn about. People respond
viscerally to photos of human suffering.

An editor for one site that promotes Israeli and Palestinian dialogue com-
mented on efforts to avoid "a Qana," referring to a village in southern Lebanon
that suffered many civilian casualties from the Israeli shelling of a U.N. com-
pound in April 2006 as part of its battle against Hezbollah. The first shelling
of Qana, referred to as the "Qana Massacre," occurred in 1996. More than
100 people were killed in what Israel described as an "accidental" attack,
although a U.N. investigation found otherwise (Asser 2006):

It was clear from the start in this operation that there could be a Qana, given
how Hamas has chosen to fight, and it could seriously derail Israeli operational
plans.... A Qana is not just a function of the numbers of civilians killed, but also

a function of how the Israeli population reacts, how the Israeli leadership deals with it and how the international community responds, and it's too early to say. (Erlanger 2009)

There would be other claims about "accidents" during the three-week war. After the Islamic University was attacked, a medical student said, "They hit my future with a rocket" (Tavernise 2009). He and others wondered why civilian structures were targeted. An anonymous Israeli source said that the science labs were supporting Hamas, so that is why they were destroyed. However, Capt. Benjamin Rutland, a spokesman for the Israeli military, clarified how the civilian buildings and activities were viewed: "The civilian infrastructure provides the administrative, logistical, human resources and funding structure, which supports Hamas's entire military effort" (Tavernise 2009).

Israel took great pains to restrict press access to the battle zones by prohibiting journalists from entering Gaza for nearly three weeks after the start of the invasion (January 15, 2008) as well as confiscating its soldiers' cell phones. A *New York Times* reporter explained:

> This time, there is no illusion about winning a war only from the air. This time, the military chief of staff has kept his silence in public, all cellphones have been confiscated from Israeli soldiers, and the international press has been kept out of the battlefield. In these and many other ways, Israel is applying the lessons it learned from its failed 2006 war against Hezbollah in southern Lebanon to its current war against Hamas in Gaza. (Erlanger 2009)

An Israeli journalist explained how the information was strategic domestically and internationally:

> Further, the "home front" defense against rockets has been improved and there has been a much stronger effort to *control the message* and mask Israeli intentions.

> To that end, the cellphones of soldiers were confiscated; commanders were banned from talking to reporters, even their friends; the international press corps has been kept out of Gaza; and even the close circle of senior Israeli political and defense correspondents have been getting far less access than before to decision makers…. (Erlanger 2009; my emphasis)

The importance of media logic and information technology is further illustrated by efforts to restrict soldiers' cell phone use. This kind of technological muzzle is commonly used by authorities seeking to control space for a specific purpose, and not others, e.g., "no talking," but it also is common to reinforce control over subordinates, e.g., students in public schools. That the confiscation was about social control is suggested by Israel's providing 10,000 MP3 players to soldiers so that they could listen to recorded religious mes-

sages urging them on in battle to do God's work and fight evil (Wagner 2009). Criminals have been reported to confiscate patrons' cell phones at public restaurants while they eat (Lacey 2009). The strategic benefit of restricting soldiers' cellphones is less critical than information control and public relations. Confiscating soldiers' cell phones would limit conversations that could provide other accounts of the conflict, but most important, it would reduce the likelihood of taking and transmitting battlefield photographs, including the carnage that tends to disrupt rehearsed justifications for killing people. After all, individuals' digital photos contributed to the shocking brutalities of Abu Ghraib prison. Such efforts are bound to be only partly successful since visual and digital technologies are so vast and likely to surface at any time, from many news sources. Indeed, several U.S. press reports—with pictures of some of the carnage, especially the U.N. school bombing—were compelling and carried multiple meanings about the wages of war and questions about the relative silence of the United States about this campaign. NBC's Andrea Mitchell reported (January 6, 2009) that the invasion was planned for the final days of the Bush Administration, rather than wait for the less certain support of President-elect Obama. As noted, President Bush referred to the Hamas rocket attacks on Israel as justifying the attacks—the terrorism narrative that was cast and refined through his administration's employ of media logic. What mattered most is how it appears; controlling the images is vital, but the meanings are even more important. Not surprisingly, web and blog sites were the most critical, although *The Daily Show with Jon Stewart* discussed the humanitarian crisis.

Israel used its managed news to keep a balanced perspective, reminding interviewers that Hamas was still firing rockets into Israel, injuring citizens. President-elect Obama cautiously expressed concern about loss of life on both sides: "The loss of civilian life in Gaza and Israel is a source of deep concern for me" (El-Krodary and Kershner 2009). The U.N. Security Council sought a resolution calling for an immediate ceasefire, but the United States opposed this.

> "We must find a way to prevent arms and explosives from entering Gaza," the American secretary of state, Condoleezza Rice, told the Security Council. "When this ends, there must be new arrangements in place, not a return to the status quo ante." (El-Krodary and Kershner 2009)

Letters to the editor in many U.S. newspapers argued that Hamas's rocket attacks on Israel were responsible for the attack. And besides, Israeli Foreign Minister Tzipi Livni insisted that there was no crisis and that aid was getting through. A U.N. Relief and Works Agency (UNRWA) spokesman said the claim was "absurd":

"The organisation for which I work—Unrwa—has approximately 9,000 to 10,000 workers on the ground. They are speaking with the ordinary civilians in Gaza.... People are suffering," he said. "A quarter of all those being killed now are civilians. So when I hear people say we're doing our best to avoid civilian casualties that rings very hollow indeed." (Al Jazeera, January 7, 2009; http://english. aljazeera.net/news/middleeast/2009/01/200915143237167997.html)

The United Nations suspended its humanitarian aid work providing food and clothing on January 8, 2009, because Israeli bombs had hit its trucks and staff members had been killed and wounded. The U.N. Security Council passed a resolution calling for an "immediate, durable and fully respected cease fire, leading to the full withdrawal of Israeli forces from Gaza." The resolution was supported by 14 of the 15 members; the United States abstained (Witte and Lynch 2009). Horror stories continued. A physician rushed to the Shifa hospital in Gaza not to work, but to seek treatment for his bleeding head and his daughter's broken jaw. Hamas soldiers had fired mortars and rockets near his apartment, and Israel returned fire, killing his wife and son. "My son has been turned into pieces," he cried. "My wife was cut in half. I had to leave her body at home" (El-Krodary 2009b). Israel and Hamas refused to stop fighting. The headquarters of the U.N. Relief and Works Agency was shelled a week later, wounding three and destroying "a warehouse full of hundreds of tons of food and medicine…" (Kershner 2009 p. A8). Israel claimed that Hamas fighters were firing from the building. U.N. Secretary General Ban Kimoon expressed "strong protest and outrage" and demanded an investigation. A spokesman for Israeli Prime Minister, Mr. Ehud Olmert replied in a way that is consistent with the terrorism narrative. He said that surely the refugee agency "understands that Israel cannot give *immunity to terrorists* because they are working from within, or adjacent to, a United Nations compound" (Kershner 2009 p. A8). A spokesman for the United Nations stated that in a meeting Israeli Army representatives "privately admitted that the militants' fire was several hundred yards from the compound."

The human dimension, especially suffering, was reported in more detail in this war than in most wars on terror. One difference in this case was that that there were many news reports about the actual suffering that accompanies incendiary explosives; there were also advertisements in major newspapers (e.g., the *New York Times*) supporting one side or the other, along with news-media advertisements (e.g., Al Jazeera). Typically, routine terrorism battles, such as when the United States sends an unmanned Predator aircraft to fire a missile at an Al Qaeda operative in, say, Pakistan, we hear nothing about the suffering of either the target or "collateral" damage to family members and other civilians. For example, after a recent Predator drone attack in Pakistan that was reported to have killed two "top Al Qaida terrorists," the only

description was that "They died preparing new acts of terror," according to an anonymous source, "because the agency's actions are secret" (Warrick 2009).

The mass media help simplify things, especially given the brief entertainment formats that transform all issues into simple dichotomies of good, bad, right, wrong, familiar—and proper, or strange. As I have argued throughout this book, the mass media play an important role in helping to define and categorize not only who is and who is not a terrorist, but also what the characteristics of terrorism are.

Israel's soldiers began to admit their brutal actions several weeks after most forces had been withdrawn. Soldiers' testimonies about wanton brutality and indiscriminate killing were leaked to two Israeli newspapers (Bronner 2009).

Dan Zamir, the head of an Israeli military academy where some of the reports were published, stated:

> "Those were very harsh testimonies about unjustified shooting of civilians and destruction of property that conveyed an atmosphere in which one feels entitled to use unrestricted force against Palestinians" (Bronner 2009).

Notwithstanding the proclamations by Israeli officials that their army was the "most moral" in the world, a veteran soldier's description of the training sessions his tank unit received shortly before it entered Gaza belie the routine denials. In general, it was "shoot and don't worry about the consequences," he said, adding:

> "This is very, very different from my usual experience. I have been doing reserve duty for 12 years, and it was always an issue how to avoid causing civilian injuries. He said in this operation we are not taking any chances. Morality aside, we have to do our job. We will cry about it later."

Reflecting on the tales of atrocities in Gaza, a political scientist, who lectures at defense colleges, observed:

> "Unfortunately, I think that selective use of killing civilians has been very much on the agenda for fighting terror..."

■ Mediated Terrorism

The recent war between Israel and Gaza did not fit the conventional terrorism war narrative, at least not at the beginning. I wish to stress that terrorism as a strategy is different from the terrorist who performs these acts. Very few terrorists define themselves as such. They prefer "fighter," "liberator," "patriot," or they might identify with an aggrieved group, e.g., "Shia" or "Sunni." Terrorist

is an identity that is bestowed by the opposition, those toward whom the terrorist act is directed. Essentially, the terrorism narrative holds that terrorism (and terrorists) do not follow civilized rules of warfare and that since terrorism is not justified insofar as "innocent" civilians are targeted, then the moves against them can also be outside acceptable limits, e.g., torture, kidnapping, and widespread killing of civilians in the pursuit of terrorists (Glaberson 2009; Satterthwaite 2009). But they must be categorized in an appropriate category, e.g., Al Qaeda, and not viewed as individuals. One analysis of news coverage of the "enemy" across two wars and many ethnic groups illustrates the simplification and cavalier disregard for systematic evidence as discussed in a previous chapter:

> It's a curious thing that, over the past 10–12 days, the news from Iraq refers to the combatants there as "al-Qaida" fighters. When did that happen?
>
> Until a few days ago, the combatants in Iraq were "insurgents" or they were referred to as "Sunni" or "Shia'a" fighters in the Iraq Civil War. Suddenly, without evidence, without proof, without any semblance of fact, the US military command is referring to these combatants as "al-Qaida."
>
> Welcome to the latest in Iraq propaganda.
>
> That the Bush Administration, and specifically its military commanders, decided to begin using the term "Al Qaeda" to designate "anyone and everyone we fight against or kill in Iraq" is obvious. All of a sudden, every time one of the top military commanders describes our latest operations or quantifies how many we killed, the enemy is referred to, almost exclusively now, as "Al Qaeda." But what is even more notable is that the establishment press has followed right along, just as enthusiastically. I don't think the *New York Times* has published a story about Iraq in the last two weeks without stating that we are killing "Al Qaeda fighters," capturing "Al Qaeda leaders," and every new operation is against "Al Qaeda."
>
> The *Times*—typically in the form of the gullible and always-government-trusting "reporting" of Michael Gordon, though not only—makes this claim over and over, as prominently as possible, often without the slightest questioning, qualification, or doubt. If your only news about Iraq came from the *New York Times*, you would think that the war in Iraq is now indistinguishable from the initial stage of the war in Afghanistan—that we are there fighting against the people who hijacked those planes and flew them into our buildings: "Al Qaeda." (Greenwald 2007)

As argued in this book, there are conventions for defining and covering newsworthy events. Mass media seldom focus on "both sides" in a conflict, but prefer to emphasize the good works as well as the suffering—and injustice—of their "side." The creative way in which this is done is referred to as "propaganda"(Jackall 1994). Previous work has shown that this focus and

format for covering conflicts was disastrous for the United States because it permitted a dissembling Bush Administration to distort information about Iraq's threats to the United States as well as the 9/11 attacks (Altheide 2006). The absence of a critical journalism that would challenge official government definitions and information contributed to the rush to war, as well as the emergence and acceptance of the "Bush Doctrine," that preemptive attacks on sovereign states were warranted if you believed that they intended harm. The systematic avoidance of covering death and suffering of the enemy reinforces stereotypes of the opposition. But propaganda is difficult to sustain when contrary and especially "humanizing" information is forthcoming.

The rise of Al Jazeera and numerous Internet and blogging sites made a difference in coverage of Middle Eastern conflicts. It has been vilified and targeted by the U.S. military in two wars (Afghanistan 2001 and Iraq 2003) but continues to cover international news. Despite the essential banning of Al Jazeera broadcasts in the United States (it is carried in Burlington, Vermont; Toledo, Ohio; and Washington, D.C.), its Internet sites' reach is formidable, including the blending in with more youthful-oriented sites like YouTube.

> By contrast, Al Jazeera's English-language service can be seen in over 100 countries via cable and satellite, according to Molly Conroy, a spokeswoman for the network in Washington.

> Recognizing that its material from Gaza will have influence in the United States only if it is highly accessible online, Al Jazeera has aggressively experimented with using the Internet to distribute the information it has gathered (Cohen 2009).

Accounts and images of Arab protagonists and perspectives on international affairs are available throughout the world and also show up on thousands of other Internet sites and blogs. An estimated 40 million Arabs view Al Jazeera, also referred to as the "Arab CNN." According to its BBC-trained editor-in-chief Ahmad al-Sheikh, the charge is to: "Be accurate, factual, be there first—that's not necessarily most important—and be with the human being all the time—you don't stay at the top getting the views of politicians and diplomats" (Soliman and Feuilherade 2006).

The focus on the "human being" has changed the mass media since 9/11. This can be seen with coverage throughout the Iraq War, as well as the 2008–2009 Israel-Gaza war.

The U.S. mass-media coverage of the 2008–2009 Israel-Gaza war was different than coverage of other "terrorist" wars, at least initially. The suffering and oppression of Palestinians in Gaza was given more attention for several reasons. First, the U.S. media, especially the major TV networks, were more aggressive in presenting the visually entertaining coverage of human suffering—

especially the Gaza population—because Israel is not regarded as a terrorist state, but Hamas-governed Gaza is. The suffering by members of a terrorist state is seldom reported, but as noted previously, the availability of other information sources—especially Al Jazeera—added more audience points of view.

The U.S. media carried numerous reports about the suffering in this conflict. There are three important aspects to consider. First, Gaza, except for launching missiles that are not cleverly targeted, was inflicting relatively little human suffering, compared to the Israeli bombardment. Second, Gaza had significant audiences and allies who not only sympathize with its goals and plight, but also had the mass-media technology and organization to provide images and alternative meanings about what was occurring. Indeed, Qatar and Mauritania suspended political and economic ties with Israel less than three weeks after the invasion. This was not the case, for the most part, with the U.S. war on terrorism against Al Qaeda, or Iraq, or Afghanistan. There was little institutionalized mass-media space for the "other story," the suffering and casualties of the enemy. Al Qaeda communicates to the "outside world" mainly with occasional web materials; the United States basically controls the Iraqi mass media, although not Al Jazeera. The same is true of the Iraqi media, which tends to support the "war on terror," although it is important to note the exceptions when the government took a firm position about Abu Ghraib prison torture, as well as several well-documented instances in which the United States—or some of its Blackwater mercenaries—used excessive force and murdered civilians (Broder 2007; Johnston and Broder 2007).

A third consideration was the role of the United Nations's relief forces in this conflict. As several of the quotations above indicate, the United Nations's voice about the suffering and inhumane treatment was very strong in several major news outlets (e.g., the *New York Times*, CNN, and NBC). The U.N. Security Council's resolution calling for a cease-fire was also quite strongly presented in news reports.

Another factor in the U.S. news media's providing more coverage of the human suffering in this conflict is that the mainstream U.S. news media departed from administration "talking points" and statements about Israel's justification for the invasion. A pending change in U.S. presidents within three weeks of the invasion was surely a factor in the mass media's reluctance to follow a rather narrow and conventional line about the "good guys" and the "bad guys" (Adams 1981). I believe that a related factor was journalists' reaction to several years of the Bush Administration's efforts to push an agenda to limit criticism and civil liberties, on the one hand, while openly challenging press freedom on the other, a point that I will return to below. Nevertheless,

the coverage shifted back to a conventional terrorism narrative within a matter of days. The suffering and killing became a "human interest" feature of the first few days of the war. But this would change.

■ Terrorism and the Banality of Evil

News formats eliminated evil on 9/11. Now we had terrorism. The banality of evil has been transformed by the role of media logic and the news cycle in our information system. The mass media and journalism are changing according to the economic and risk assessment rationality that governs much of social life. Risk assessment is based on applying knowledge about how to reduce unfavorable results. It slides on failure and fear:

> ...the institutions that make up risk society share a number of common elements. Risk society operates within a negative logic that focuses on fear and the social distribution of "bads" rather than on progress and the social distribution of "goods." It is characterized by a foreboding that is reflexively connected to its reliance on probabilistic thinking. Collective fear and foreboding underpin the value system of the unsafe society, perpetuate insecurity, and feed demands for more knowledge of risk. Knowledge of risk is directed towards the control of the irrational by rational means. Life is to be made both real and liveable by risk technologies that tame chance in the landscape of fear. (Ericson and Haggerty 1997 p. 449)

Rationality and risk assessment increasingly govern perceptions and policy; nothing needs to be tolerated if we can fix it, and we can fix anything.

Media are part of the risk assessment process in two senses: first, the mass media come and go according to marketing logic and cost-benefit analysis. Journalism, long held to be the "Fourth Estate" and a key part of governing in a democratic society, exists increasingly at the whim of massive mergers and reductions. Media are a product that is bought, sold, or dispensed with; this is the fate of journalism. News decisions are more centralized, and journalism is cheapened. There are some 350 fewer daily newspapers today than there were 50 years ago, with a significant reduction in the number of journalists (Schudson and Haas 2009). Notwithstanding the growth of Internet news, which basically recirculates mainstream news material—plus commentary, journalism and the mass-media organizations within which they work has been watered down. (The HBO five-year series *The Wire*, set in Baltimore, illustrated how this pressure affects journalism work and city culture.) This has implications for what journalism does, what is covered and presented as news. This is where terrorism programming comes into play.

Journalism's governing rationale of marketing and profit-making defines what survives. As we have seen throughout this book, and with the current discussion of the Israel-Hamas war, news content is socially constructed through production formats to be "interesting" and "entertaining." Dominant news sources are sought who can spin reports to fit dominant narratives. There is a limited space for evil in this logic; there are interesting, crucial, important, and critical events. Evil, like good and felicity, is now a feature of media formats that direct public attention and discourse to information chunks that are defined, constructed, and presented according to the time, place, and manner of entertainment and marketing-powered technology. And fear is the big-ticket item.

There is more fear and less evil in the terrorism narrative. Simply killing people no longer qualifies as evil. Rather, it is how the killing is framed, packaged, and thematically encapsulated for audiences steeped in well-established narratives about what is connected and relevant, including good and evil. Any killing can be justified; the trick is to find the narrative that suits the medium with which one is working. Indeed, preliminary indications from a survey of news reports suggests that genocide—and the killing of millions—was less compelling than terrorism after 9/11, and that in some cases, terrorism became linked with genocide. Of course, the terrorism attacks were on U.S. citizens, and one's own people take precedence over the deaths of "others." But the interesting development is how a narrative linking the two became more common. An example is from a law review article discussing "The Legacy of Nuremberg" and terrorism:

> As the Cold War ended, equally powerful forces of disintegration began to tear the new world apart. States that had been held together for decades by Cold War tensions or strong-man regimes began to fail and collapse. In these failed states ethnic, political and religious conflict broke out, and the conflict was often manipulated by cynical leaders seeking to enhance their power, like Slobodan Milosevic in Yugoslavia or the Taliban in Afghanistan or Osama bin Laden in Somalia and Sudan. *Some of these leaders began to use terrorist tactics to commit massive crimes against humanity and genocide.* Huge numbers of refugees and dislocated people began to flee from failed states and the human rights wars inside them, and by the end of the 1990s there were more than 20 million—even more than after World War II. Meanwhile, the gap between the rich and the poor began to grow, as economic globalization made the rich richer and left the poor behind. And those left behind began to turn to religious fanaticism, especially political Islam, and became recruits for the terrorist designs of their leaders.... (Shattuck 2006; my emphasis)

The author added that U.S. foreign policy was influenced by the deaths of some 800,000 Rwandans in 1994, but that it took the 9/11 attacks to really shift public and policy attention to foreign affairs. After Rwanda, for example,

the rule of law—especially international law—was the vehicle for stemming genocide and bringing to justice Slobodan Milosevic, who was brought to The Hague to stand trial at the International Criminal Tribunal for the Former Yugoslavia. Terrorism and genocide became linked under yet another term, "human rights," and helped forge a stronger narrative that to fight one was to fight all three; it was just that terrorism appears to have gotten the most emphasis *vis-à-vis* 9/11. But the rule of law would be the vehicle for justice. However, the media treatment of the 9/11 attacks and the push for revenge permitted the Bush Administration to sidestep the rule of law and any codified principles that would prevent their assault on matters defined as terrorism (Shattuck 2006). Thus, international law was pushed aside as a meaningful guideline in the newly defined "terrorism world."

This is ironic and, in a narrow sense, not a correct meaning of the terms, since terrorism, on the one hand, refers to "the purposeful act or threat of violence to create fear and or compliant behavior in a victim and or audience of the act or threat" (Lopez and Stohl 1984). On the other hand, genocide refers to the intentional killing of people in order to completely eliminate the group. The former is explicitly fear based and thrives on the uncertainty that what has (or could) happen to a relatively small number of people (e.g., 9/11 attacks) could happen to others, while genocide is more focused on complete decimation. Thus, the emphasis is often on numbers of people killed.

About the only killing that is illegitimate and evil these days, *vis-à-vis* news reports, is killing by a "criminal" or a "terrorist." Within the logic and discourse of mass-media reporting, criminal and terrorist are cast as typical characters, with scripts, roles, and even appearances. A Lexis/Nexis review of the way in which "evil" was used in news reports and blogs shows that evil was more likely to be used in more personal opinion pieces. Evil was used frequently in phrases like "an evil necessity" (e.g., Israel bombing Hamas) and "axis of evil" (President Bush's statement about countries such as Iraq, Iran, Korea, etc.). Mainstream news media were more selective, especially TV news. Here is one example from an ABC newscast on December 26, 2008, of the contrasting use of evil in referring to a homicide investigation, and then discussing the Israel-Hamas war:

> *(Off-camera):* In the Los Angeles suburb of Covina tonight, authorities are still piecing together what caused a man to go to his former in-laws' home on Christmas Eve dressed as Santa and begin shooting the party-goers inside, then setting the house on fire before ultimately turning the gun on himself. Today, we learned the death toll has now risen to nine. Here's ABC's Lisa Fletcher.

Lisa Fletcher: (Voiceover) Initially, people thought Bruce Jeffrey Pardo cracked under the pressure of a painful divorce, finalized only a week ago. But as details unfold, the story reveals premeditated evil.

This was followed by a report about escalating tensions in Pakistan, and then a report about Israel-Hamas:

David Muir: (Voiceover) And in the Middle East tonight, Israel opened its border to allow food and medicine into the Gaza strip, despite a barrage of rockets fired by Palestinian militants there in recent days. The crossings into Gaza have been largely closed since Hamas militants seized control of the coastal strip there last year. Israel agreed yesterday to allow the shipments to avoid a humanitarian crisis. (ABC 2008)

Note the important contrast: An individual killing several people is evil; a state offering a temporary halt in bombing is cast as trying *"to avoid a humanitarian crisis."* But people are getting killed, so who is evil, if anyone? The frame had shifted to the war as a "necessary evil," in which Israel had to attack Hamas in order to stop it from launching rockets toward Israel's cities. And the killing of people is sad, but killing children is even more sad; the Israelis were framed as offering aid "to avoid a humanitarian crisis"—which several aid workers indicated had already occurred—but the narrative still seeks an evil one. A few days later (December 30, 2008) CNN reporter Bob Joseph explained that it was not the bombs *per se* but, rather, who was putting the children in danger:

They have created an environment where they ensure that some civilians can get hurt. And what they target themselves is, they target children and schools and hospitals. *That is what makes Hamas the most evil entity—one of the most evil entities on this planet.* (CNN 2008;; my emphasis)

In this netherworld of entertaining news formats, we can kidnap them, torture them, or kill them. If others—such as children or other "innocent" civilians—are killed, so be it. It's sad, but necessary. Thus, the Israeli military's killing of civilians is not intentional, but it is part of a strategy to have Hamas agree to stop firing rockets into Israel. If they do not stop, then it is they who are doing the killing, killing their own people by "forcing" Israel to attack them. So now the story shifts to the strategy and tactics of the war, and the deaths of hundreds becomes a tragic sidebar.

This is why the terror narrative is so important in understanding how the mass media operates: any action is permissible against terrorism or whatever is promoting fear. Of course, terror is the supreme fear. And anything goes when fighting against the sources—and nature—of fear; action can always be justified. Let's return to the killing in the Israel-Hamas war. The

killing is part of a sequence of news reports, placed in a narrative context about the interaction between the two adversaries. When "innocents" are killed, it is unfortunate, but it is not evil or murder or a heinous act that the international court of justice is likely to investigate for prosecution. It is just war. It might be different if treated outside the news narrative. (Of course, the United Nations focuses on human suffering in this war, but even they act according to organizational criteria about, say, what is genocide and what is not, what warrants U.N. action, and what does not .) So, when we receive news reports about babies being blown apart, we can have it both ways; we can feel a bit shocked—but not totally surprised—and certainly feel sad, even empathic for the child, her mother, etc. But we cannot easily go against the narrative that features one side against another, both with "good reasons" for the fighting. We wind up saying (or feeling) that this is what happens in war, and it is terrible.

This is the critical point about mediated evil: The communicated meaning is the relationship of "both" (or all) parties involved; both are "to blame," and if no one is to blame, there is not evil, but only horror, tragedy, sadness, dead children. And the terrorism narrative normalizes the killing and colors the discourse that brings meaning. Like most stories that promote fear, the Israel-Hamas war received less coverage over time. For example, after 18 days of fighting, the *Arizona Republic* offered three column inches, on page A3, and the report stressed that Israel was keeping the pressure on Hamas. A cease-fire was called after 22 days of fighting that left over 1,300 Palestinians dead and more than 5,000 wounded, while Israel suffered 13 deaths and some injuries.

■ Terrorism, Fear, and Popular Culture

The biggest impact of terrorism and fear was on the mass media and culture. 9/11 came to be associated with many "threatening" or important matters. For example, NBC's *Morning Show* added a segment, "Money 9/11," that dispensed advice about investing and saving. Many things changed and became more normalized and accepted, including pervasive threats, state intervention, and surveillance, and the protests against civil liberties violations became more common and therefore more a part of the "news and communication routine," the surrounding environment of fighting terrorism. Terrorism meanings sanction any activity that is purported to help eliminate this fear. This book has dealt with some of these that pertain to the mass media. In the United States, this has included extended propaganda campaigns, gross violations of civil liberties—including kidnapping, torture, imprisonment without due process (i.e., *habeas corpus*), massive wiretapping of U.S. citizens' telephone

calls and e-mails—drug testing, profiling (racial, religious, and ethnic), as well as "chilling" journalistic investigations and reporting. Moreover, most of these have been "normalized" and accepted as the "status quo" in terms of mass communication.

The model of an ecology of communication and its relevance for terrorism was set forth in Chapter 1. I stressed that changes in information technology contribute to adjustments in communication formats, and these in turn shape, change, and initiate new social behaviors and organizational routines. Chapter 3 examined how the discourse, style, and language of news reporting, especially TV news, was influenced by extensive reporting of terrorism.

There was more information control by government. Most important, it became more common, and eventually the public—and even mainstream journalism—became more accepting of the terrorism narrative. The Bush Administration invoked executive privilege as well as national security on numerous occasions when information was sought by congressional committees, the American Civil Liberties Union, and especially journalists. Steps were taken to essentially rewrite the freedom of information act (FOIA), as numerous requests were denied. In a report prepared by the Reporters Committee for Freedom of the Press, various aspects of FOIA were challenged:

> Since Sept. 11, 2001, the media have had to contend with a new reluctance on the part of federal and state governments to release information. There have been many and continual rollbacks in disclosure. The names of terrorism-suspect detainees stateside and in captivity on foreign soil are considered secret. The predictions of water flow from a dam burst or a worst-case scenario for a manufacturing accident are now considered somehow useful to terrorists and no longer available to a public seeking environmental safety reforms. The change in attitude can be traced straight back to the top, as seen in the policy statement released by the attorney general in October 2001 that has come to be known as "The Ashcroft Memorandum."
>
> In late March 2003, the administration also amended the Clinton Executive Order on classification, allowing more classification than the existing memorandum anticipated. The memo reverted to an allowance of reclassification of documents that already had been made public. (ReportersCommitteeforFreedomofthePress 2005)

In addition to "taking down numerous web sites" that provided information to the public and researchers, the government also attacked whistleblowers who revealed alleged illegal governmental activities and strongly discouraged federal employees from discussing employment problems that had a bearing

on national "Homeland" security. Consider the case of Sibel Edmonds, who worked for the FBI as a translator of Middle Eastern languages:

> Sibel Edmonds, a contract translator in Middle Eastern languages at the FBI, was terminated in March 2002 for, she was advised, the "convenience" of the FBI. She had complained that despite a critical need for translations by FBI investigators in the field, her supervisor had insisted that she slow down her translations so that it would appear that the office needed more translators and more funds. She found translations erased on her computer—erasures that needed to be redone were called "a lesson" by her supervisor, she said. Edmonds also reported that a colleague with ties to a "semi-legitimate" organization had misidentified documents about that organization as not relevant. (ReportersCommitteeforFreedom ofthePress 2005)

Most alarming, the courts, with few exceptions, upheld the administration's views of this and similar cases (Satterthwaite 2009).

> In October 2002, Edmonds filed a whistleblower suit in federal district court in Washington, D.C., to get her job back, but Judge Reggie Walton accepted the government's arguments that hearing the case would reveal "state secrets," and dismissed the case on July 6, 2004. In the course of the litigation and Edmonds' agreement to testify in the cases brought by the families of Sept. 11 victims, the government reclassified information that was part of her suit and that had been widely discussed in Congress and in an appearance by Edmonds and Sen. Charles Grassley (R-Iowa) on CBS's "60 Minutes" in 2002 shortly after her suit was filed. The court also held that she could not present the classified information in testimony on behalf of the families.

> In May 2005 the U.S. Court of Appeals in Washington, D.C., upheld the government's claim of "state secrets" and refused to hear Edmonds's case. The ACLU in August 2005 asked the Supreme Court to review the case. (ReportersCommittee forFreedomofthePress 2005).

The attempt to control people and information became well known and resonated throughout the government as well as the broader culture.

I mentioned various secret wars that the Bush Administration had with the press, including the attempts to hold journalists accountable for any information provided by sources or "whistleblowers" about various illegal activities, including kidnapping, torture, and domestic surveillance (Rozen 2009). One of the most egregious examples of persecuting and prosecuting a whistleblower was that of Thomas Tamm, a federal prosecutor whose father and uncle were officials in the F.B.I. under J. Edgar Hoover. Tamm is given credit for his 2004 revelations about the Bush Administration and the National Security Agency's (NSA) massive wiretapping of domestic and international e-mails, telephone calls, and financial statements as part of their war on terrorism (Isikoff 2008). He became aware of a "secret program" –codenamed

"Stellar Wind"—to eavesdrop on U.S. citizens while he was performing his duties for the Office of Intelligence Policy and Review (OIPR). He inquisitively asked colleagues what they knew about the program but was told that he should forget about it and not talk about it. But as he learned more, it became apparent to him that the program was illegal and, in good conscience, he could not condone it.

> "I thought this [secret program] was something the other branches of the government—and the public—ought to know about. So they could decide: do they want this massive spying program to be taking place?" Tamm told *Newsweek*, in one of a series of recent interviews that he granted against the advice of his lawyers. "If somebody were to say, who am I to do that? I would say, 'I had taken an oath to uphold the Constitution.' It's stunning that somebody higher up the chain of command didn't speak up." (Isikoff 2008 p. 42)

He would find out later that colleagues at the Justice Department were also balking at the NSA's surveillance program (Lichtblau 2008a). Tamm contacted the *New York Times* about the program.

> ...he insists, he divulged no "sources and methods" that might compromise national security when he spoke to the Times. He told reporters Eric Lichtblau and James Risen nothing about the operational details of the NSA program because he didn't know them, he says. He had never been "read into," or briefed, on the details of the program. All he knew was that a domestic surveillance program existed, and it "didn't smell right." (Isikoff 2008)

His basic information, which was supplemented by other sources, eventually led to the *New York Times* publication of the Pulitzer Prize-winning report, "Bush Lets U.S. Spy on Callers Without Courts" on December 16, 2005. It should also be noted that the *New York Times* (Lichtblau 2008a) did not publish the story for over a year; *Newsweek* reported that Bush had warned "there'll be blood on your hands" if another attack were to occur (Isikoff 2008).

> The story—which the Times said relied on "nearly a dozen current and former officials"—had immediate repercussions. Democrats, including the then Sen. Barack Obama, denounced the Bush administration for violating the FISA law and demanded hearings. James Robertson, one of the judges on the FISA court, resigned. And on Dec. 30, the Justice Department announced that it was launching a criminal investigation to determine who had leaked to the Times. (Isikoff 2008 p. 47)

Congress also passed a watered-down law to insure that surveillance is conducted in a way that is consistent with civil liberties. The congressional oversight that emerged from the *New York Times* article illustrates the important interaction between journalists and policymakers, how each can trade

off the other, and work—formally and informally—toward emerging defini-
tions of a situation.

Reporting—fine as much of it has been—can't replace congressional
oversight. "Journalists will do incredible work and it just drops into a great
black void," Mayer says. "I have subpoena envy."

> While some stories fall into a void, others never get done. "When Congress is
> actively engaged in oversight, there's a synergy with the press," says Steven
> Aftergood, who heads the Federation of American Scientists' Project on
> Government Secrecy. "It's a powerful mechanism for disclosure that nourishes
> press coverage. Without the Congress there's a kind of negative synergy.
> Congressional inaction serves as a signal to leave this alone. And, frankly, taking
> a pass is perfectly understandable. These are very hard stories to cover, and
> sources are very hard to come by." (Umansky 2006 p. 26)

Tamm has suffered tremendously from coming forward. He lost his job,
his home has been searched, computers removed, and his family interrogated.
He could be arrested and charged with penalties that could send him to prison
for 10 years or more. His attorney, Asa Hutchinson, a former U.S. attorney
and under secretary of the Department of Homeland Security, thinks that
Tamm did the right thing:

> "When I looked at this, I was convinced that the action he took was based on
> his view of a higher responsibility…. It reflected a lawyer's responsibility to
> protect the rule of law." Hutchinson also challenged the idea—argued forcefully
> by other Bush administration officials at the time—that The New York Times story
> undermined the war on terror by tipping off Qaeda terrorists to surveillance.
> "Anybody who looks at the overall result of what happened wouldn't conclude
> there was any harm to the United States," he says. After reviewing all the cir-
> cumstances, Hutchinson says he hopes the Justice Department would use its
> "discretion" and drop the investigation. In judging Tamm's actions—his decision
> to reveal what little he knew about a secret domestic spying program that still
> isn't completely known—it can be hard to decipher right from wrong. Sometimes
> the thinnest of lines separates the criminal from the hero. (Isikoff 2008 p. 48)

Tamm isn't the only one who has suffered after the Bush Administration
threatened and cajoled journalists and policymakers who publicized and
challenged governmental illegal activities. The Bush Administration

> …in highly coordinated campaigns, tried to turn the onus of the revelations on
> its head, accusing the newspapers that exposed the information of treachery.
> "There can be no excuse for anyone entrusted with vital intelligence to leak it,
> and no excuse for any newspaper to print it," Bush said in St. Louis on June 28,
> 2006…. Vice President Dick Cheney said: "Some in the press, in particular The
> New York Times, have made the job of defending against further terrorist attacks
> more difficult by insisting on publishing detailed information about vital national-
> security programs." (Rozen 2009 p. 34)

The interaction between journalists and policymakers took a slightly different turn after 9/11. The government became more hostile to a press that was being fed information by agency workers like Mr. Tamm. Breaking with a tradition that honored journalists' first-amendment rights, the Bush Administration threatened to prosecute the news media and any journalists who would not divulge confidential sources. There was a five-fold increase in subpoenas of journalists after 9/11. James Risen and Eric Lichtblau have been scrutinized by the government for their reporting. Risen received a federal subpoena "which demanded that he testify about the identities of his confidential sources for a chapter in his 2006 book, *State of War*" (Rozen 2009 p. 34). This chilled congressional action as well. A journalist was quoted a few paragraphs above indicating that press coverage can embolden Congress to take more direct action. But this did not happen on a significant scale after the press revelations of secret prisons, torture, and the NSA's illegal surveillance. Congress was also afraid. The Democratic majority after 2006 did not take even the most basic steps to sanction egregious behavior, such as getting the major telephone companies to let the NSA wiretap the country.

> This fear factor has been central to the Bush administration's post 9/11 strategy on any number of fronts, but arguably none more so than its efforts at secrecy…. Seymour Hersh, the veteran investigative reporter [stated] "There's been an incredible diminution of Congress. The truth of the matter is it is different now." And that sense of fear and intimidation has seeped into the DNA of media institutions as well. (Rozen 2009 p. 35)

Pulitzer Prize-winner Risen noted the absurdity: "I do think one of the great ironies is that I may be the only one who goes to jail out of all this…while Congress is trying to give immunity to the telephone companies [which they did receive]" (Rozen 2009 p. 34). Such draconian actions provide symbolic support for others who would abuse power and threaten policymakers and journalists.

Crossing the line to protect citizens helped justify the harsh action against whistleblowers and reinforced a controlling mood and practice throughout the United States. When the White House can take questionable steps to "protect us," then why not a local sheriff? Enter Sheriff Joe Arpaio of Maricopa County, Arizona. His media image of being America's toughest sheriff is aided by weak supervisors and law-and-order appeals to citizens who like his rough treatment of inmates in his "tent city" jail, feeding them green baloney, clothing them in pink underwear and striped jumpsuits, and sending them out to work on chain gangs. Notwithstanding that civil penalties, including several killings of inmates in his custody, have cost taxpayers some $50 million in recent years, he relentlessly pushes a "Homeland Security" agenda playing to fear of terrorists and immigrants. Several years ago his department purchased

a "SWAT" tank to protect citizens, and also to use in parades. But now the focus is on illegal immigrants and "keeping our borders secure." He uses racial/ethnic profiling and conducts midnight raids of other cities' government buildings in search of illegal immigrants posing as janitors. His popularity soars among residents even as city officials seek an answer to his fear mongering:

> A federal lawsuit by the Mexican American Legal Defense and Education Fund accuses the sheriff's department of racial profiling and detaining legal residents and American citizens for long periods while their status is checked.
>
> The Government Accountability Office, a watchdog arm of Congress, is re-evaluating a program under which federal officials trained the deputies here (Issenberg 2008) and elsewhere in immigration enforcement. And the mayor of Phoenix, Phil Gordon, has asked the Justice Department to investigate the tactics employed by Sheriff Arpaio, who first gained national attention years ago for forcing inmates to wear pink underwear, housing them in tents and feeding them food of a green hue.
>
> "The sheriff always did his pink underwear and other publicity stunts," Mr. Gordon said in an interview, in which he expressed regret over not speaking out sooner. "While they were funny, they weren't breaking the Constitution and they weren't endangering lives."
>
> Mr. Gordon said he acted in April after meeting privately at a church with Hispanic constituents who complained that Sheriff Arpaio, in routine patrols and crime sweeps that included the arrest of large numbers of illegal immigrants, had sown a fear of all law enforcement officials, raising concerns that crimes were going unreported. (Archibald 2008)

Arpaio's style and tone were part of the discourse of fear that promotes information control.

Several chapters in this book have pointed out how the war on terrorism contributed to a harsh propaganda campaign. Even the reporting about the war was mired in official denial. Treating the press like they were biased and the bringers of bad news also helped cement such cynical feelings among U.S. citizens. Even battlefield casualties were deemed too sensitive to be discussed early in the Afghanistan War.

> In Baghdad, official control over the news is getting tighter. Journalists used to walk freely into the city's hospitals and the morgue to keep count of the day's dead and wounded. Now the hospitals have been declared off-limits and morgue officials turn away reporters who aren't accompanied by a Coalition escort. Iraqi police refer reporters' questions to American forces; the Americans refer them back to the Iraqis.

> Reporters and government officials have always squabbled over access; but the news coverage of the messy, ongoing conflict in Iraq has worsened the already tense relationship between the press and the administration. American officials accuse reporters of indulging in a morbid obsession with death and destruction, and ignoring how Iraq has improved since Saddam Hussein was toppled. Reporters grumble that the secretive White House and Pentagon hold back just how grim and chaotic the situation really is. (Wolfe and Norland 2003)

And,

> Bush himself complained about the national media's fixation on bad news, and made a show of going around them by granting interviews with local TV reporters. *"I'm mindful of the filter through which some news travels,"* he told one interviewer, *"and sometimes you just have to go over the heads of the filter and speak directly to the people."* (Wolfe and Norland 2003; my emphasis)

The notion that the press is fundamentally biased or "too liberal" was apparent in the attacks on journalists for divulging sensitive information that could lead to more terrorist attacks and harm American citizens. Two strong supporters of this view, Karl Rove and Dick Cheney, saw things a bit differently several years later when Tom Brokaw interviewed them for his book about the 1960s. Rove disputed Brokaw's suggestion that the "right" now has a stronger media position:

> Look...the range of choices of where you can get information means the idea of an overwhelming, dominant culture, imposed on the people, is now gone... because we're now in a country so diverse in media streams. (Brokaw 2007 p. 374)

Cheney disagreed with the assertion that the right can't compete with liberal domination of popular culture and that this will gradually bring the country back to liberal pursuits:

> I don't think so.... There are so many more media outlets...the Internet, it's phenomenal. The variety of political views that get expressed...we used to be dominated by the major networks and the *New York Times* and the *Washington Post* in terms of national political dialogue. That is no longer the case. It's now a far more diverse field." (Brokaw 2007 p. 390)

Political discourse in the mass media became hateful and accusatory, well beyond mere "negative" campaigning. The right-wing media, especially "talk radio," has been given license by 9/11 and the war on terror to be incredibly hateful of their political opposition. More than just doubting an opponent's qualifications, the last several years have seen a fuselage of scurrilous name-calling and attacks, including questioning patriotism and "Americanism." Massing's (2009) investigation revealed the depth of the hate-filled permissiveness:

> Any inventory of the right's media bombast must begin with talk radio. In reach and rancor, it had no equal. Leading the way was Rush Limbaugh. An estimated fourteen to twenty million people tune in to his show every week, and he treated them to nonstop character assassination, calling the Democratic candidate the Messiah, a revolutionary socialist, a liar, "Osama Obama," a man with a "perverted mind" who wants to destroy America and the middle class, a frontman for terrorists who wants to turn the country into a version of Castro's Cuba or Mugabe's Zimbabwe…. As documented in a recent report by the group Media Matters, these hosts harped on the notion that Obama is a Muslim whose true loyalties lay outside the United States…. Cincinnati's Bill Cunningham stated that Obama wants to "gas the Jews…." (Massing 2009 p. 14)

The mass-media campaign coverage got so bad that Republican vice-presidential candidate Sarah Palin sprinkled her campaign banter with claims that Obama had "been palling around with terrorists." Audiences listening to the candidates and the hateful TV and radio broadcasts were clearly affected. At one point Republican candidate John McCain, who had been attacking Obama's character, finally objected when his audience referred to Obama as a traitor and an Arab:

> When a woman referred to Obama yesterday as "an Arab," McCain cut her off and seized the microphone from her hands. "No, ma'am," he interjected. "He is a decent family man with whom I happen to have some disagreements." In fact, the most rousing applause of the afternoon came not for McCain, but for one of several questioners who appealed to the candidate to "fight" in next Wednesday's final debate with Obama…. There was a rumble of disapproval from the crowd when McCain defended his Democratic rival. "I have to tell you he is a decent person and a person that you do not have to be scared of as president of the United States," McCain said. (Issenberg 2008)

The raw talk was part of the terrorism narrative, about "them" and a very narrow "us." As noted above, the press was often cast as "them" and the "liberal media" by talk-show hosts as well as many political candidates. This took a toll on journalists, and they reacted.

The context of press reporting about the war on terror contributed to the flux of coverage, sometimes more critical, sometimes more cheerleading. The mass media and the stories and images that they report influence policymakers as well as other journalists. All too often, journalists, and especially editors, play it "safe" by going along with what others are doing. It is not so much that they don't want to step on toes but, rather, that they do not have to "be out there all alone" trying to defend a contrary or controversial position when everyone else is saying something else. We saw that this was the case with the reluctance to refer to terrorism reactions as "moral panic," but the same kind of pressure is apparent in decisions to cover or not cover events. The *New York Times*, for example, could have published the report much earlier

about President Bush's illegal wiretapping, but they were pressured, and they were essentially alone. The front-running journalism organizations usually are "alone," and sometimes they might make mistakes without the assurance of other organizations confirming and supporting their claims. Yet, it is more difficult to do this when political pressure and rhetoric heats up. This was apparent when a journalist reported that an Afghani detainee had been killed while in U.S. custody in 2002; he was not the first. The reporter, Carlotta Gall, filed the report, but it was buried in the back of the paper. One interpretation was that there was not other coverage along these lines, along this theme; it would come later, with Abu Ghraib and other events, but it just did not mean the same thing at the time. A press critic commented:

> "Compare Judy Miller's WMD stories to Carlotta's story," says Frantz. "On a scale of one to ten, Carlotta's story was nailed down to ten. And if it had run on the front page, it would have sent a strong signal not just to the Bush administration but to other news organizations."
>
> Instead, the story ran on page fourteen under the headline "U.S. Military Investigating Death of Afghan in Custody." (It later became clear that the investigation began only as a result of Gall's digging.)
>
> Gall, who is British, chalks up the delay to reluctance to "believe bad things of Americans," and in particular to a kind of post-9/11 sentiment. "There was a sense of patriotism, and you felt it in every question from every editor and copy editor," she says. "I remember a foreign-desk editor telling me, 'Remember where we are—we can smell the debris from 9/11.'" (Umansky 2006 p. 18)

This control and playing down came from politically sensitive editors.

The widespread disdain of press control was perhaps most strongly expressed in a resolution adopted by the Association for Education in Journalism and Mass Communication at its annual convention in San Francisco on August 4, 2006. As part of the preamble, the resolution stated:

> A working democracy requires a free press that is muscular in its reporting. It requires a press that holds leaders accountable for their actions. It requires a press that contrasts leaders' words with their actions. It requires a press that uncovers errors and wrongdoing by employing named and unnamed sources. We believe the actions of the current administration compromise these press functions. (Rosen 2006)

Ten specific complaints were then listed:

1. The Bush Administration's response to press requests for information.
2. The Bush Administration's use of staged town meetings.

3. The Bush Administration's vision of the government as a private domain.
4. The Bush Administration's practice of massive reclassification of documents.
5. The Bush Administration's support of policies that weaken the multiplicity of voices on a local and national scale.
6. The Bush Administration's policy of not allowing photographs of coffins of soldiers killed in Iraq to be released.
7. The Bush Administration's use of propaganda, including video news releases.
8. The Bush Administration's use of bribes and payments to columnists and other opinion makers, both in the United States and abroad.
9. The Bush Administration's manipulation of the Corporation for Public Broadcasting.
10. The Bush Administration's using the courts to pressure journalists to give up their sources and to punish them for obtaining leaked information. (Rosen 2006)

There were other mass-mediated cultural changes as well.

The meaning of terrorism changed and became much broader. This was an artifact of managed information and extensive media cover age that promoted entertainment; it fit well with violence, fear, dread, security, military, and police intervention. After all, if the government can torture (Barry et al. 2004; Glaberson 2009; Perlez et al. 2009), kidnap (Jehl and Johnston 2005; Wilkinson 2005), and engage in blanket surveillance of its own citizens (Umansky 2006), why not Hollywood? One of the most extreme programs that presented torture of suspects and even co-workers who came under suspicion was Fox's *24*, a tale of action-adventure combating enemies of the United States over a 24-hour period. The show debuted two months after 9/11 "…when the nation seemed ready to embrace a hero who did not stop to ask questions about legal niceties in his pursuit of the bad guys" (Wyatt 2009). The hero is Jack Bauer (Kiefer Sutherland), who, in the course of five seasons, combats—and sometimes loses to—terrorists with varied ties: sometimes Middle Eastern, sometimes Russian, with a few Chinese and Africans thrown into the mix with corrupt politicians and business people.

The significance of going against the grain and doing whatever it takes to get the job done, even if it violates civil liberties, human rights, and treaties, was carried over to programs that violated human dignity as well. Three come to mind. One was NBC's *Dateline*, with its "reality show" version *To Catch a Predator*, which tried to induce "Web surfers" to contact underage juveniles. An enduring myth persists, in spite of research to the contrary, that stranger-predators abound and are a major threat to Internet users, especially children

(Stone 2009). A spin-off of several decades of manufactured fears about "missing children" (Best 1990; Best 1985; Fritz and Altheide 1987) and "sexual predators," this program fit the quick-and-dirty entertainment genre by arranging for a meeting with the underage "victim," only to have an accusatory program host— Chris Hansen —show up with cameras and police cars. The crime narrative is completed when the "predator" confesses on camera or, very rarely, is prosecuted. The audience is thereby assured that predators are everywhere, especially "on the Internet," and that law enforcement is protecting them. But it doesn't always work this way. In November 2006, Louis Conradt, a 56-year-old prosecutor in Rockwall County, Texas, had explicit sexual conversations with a person whom he thought was a 13-year-old boy. When Conradt did not show up at a house for a meeting that had been wired with cameras and recorders to meet his young friend, the *Dateline* crew and police cars came to his door with a search warrant (which was later found to be faulty). Mr. Conradt opened the door, said that he did not want to hurt anyone, and shot himself in the head. Dead. His sister won a $105-million lawsuit two years later from NBC for an undisclosed settlement. "The judge indicated that the lawsuit contained sufficient facts to make it plausible that the suicide was foreseeable, that police had a duty to protect Conradt from killing himself and that the officers and NBC acted with deliberate indifference" (AssociatedPress 2006).

There were other programs, too, that stressed individual heroics, coarse interpersonal relationships, public humiliation, lack of civility, and "dressing down" (*Newsweek* 2009) that were hallmarks of the Bush Administration "war on terror" and the general treatment of terrorists, critics, journalists, and other enemies. Reminiscent of Nixon's categorical assertions about the enemy, part of popular culture resonated the authoritarian "I'm the decider" and "bring it on" attitude. It was Nixon, after all, who told National Security Advisor Henry Kissinger in 1972: "Never forget…the press is the enemy. The establishment is the enemy. The professors are the enemy." "Professors are the enemy," he repeated. "Write that on a blackboard 100 times and never forget it" (AssociatedPress 2008).

American Idol originated in the United Kingdom as *Pop Idol*. Hollywood producers saw the emerging emphasis about heroes and nationalism and transformed it into *American Idol* (*Newsweek* 2009). It became very popular in the United States. Contestants in a singing contest, to be chosen as the next American singing idol, would be evaluated and demeaned and praised by a cast that enacted scripted roles as very harsh critics (e.g., "mean Simon"). Spin-off videos (and ringtones) were shown on YouTube and other Websites for fans to share. The audience could call in or "text" their votes, in keeping with the emerging technology readily mastered by a youthful audience.

Another reality show that emphasized raw, personal insults was *The Biggest Loser*. Selected obese contestants—individuals or entire families—would disrobe and "weigh in." Interviews show them embarrassed and humiliated by their appearances and, occasionally, broken relationships, which can all be changed through rigorous workouts and diets that are filmed and shown in several episodes. Then they compete to see who won and lost.

The relentless reminders about fear influenced other aspects of popular culture. Some movies challenged the Bush orthodoxy (e.g., *Syriana, V Is for Vendetta, The Valley of Elah*). A good deal of popular music supported patriotism and the Iraq War (e.g., Toby Keith). The sounds of the national discussion about terrorism and fear screamed through millions of iPods. Through the din of drums in the left ear, guitars in the right, cultural resistance was also apparent by outspoken critics such as the Dixie Chicks, whose music was banned by Clear Channel radio stations, and Neil Young ("Living with War"). But it was Green Day's album "American Idiot" and accompanying video that resonated the most with young people and was widely downloaded on iTunes.

> ". . .a concept album about a clueless teen—the "Jesus of Suburbia"—who feels forgotten in Bush's America: "This land of make-believe/that don't believe in me." Over the course of the album, the kid sleepwalks from 7-Eleven parking lots onto the battlefields of Iraq. The video for "Wake Me When September Ends" scored the most direct hit, picking up the antihero at a moment of crisis: seeing little future at home, he deceives his girlfriend by joining the Marines, then ships off to Iraq and never returns." (*Newsweek* 2009)

Popular culture remains a major U.S. export, but popular depictions of American life and especially justice have taken a toll. American culture has been idolized and copied in various ways throughout the world. Much of this is due to affluence and consumer goods, but there is also the element of style and fashion. There is also the idealism, including the sense of social justice, equality, and the "American dream," of equal opportunity and fairness enabling hard workers to earn wealth and civic and social respectability. American institutions, especially education, religion, and law, have been highly regarded throughout the world. However, the conduct of courts during the Iraq War, especially regarding foreign detainees, has reduced that admiration. Specifically, U.S. court rulings have influenced other countries' legal opinions since World War II, but there is some evidence that this is now changing, as fewer countries show the same admiration for the American way of doing things. According to one recent study:

> "One of our great exports used to be constitutional law," said Anne-Marie Slaughter, the dean of the Woodrow Wilson School of Public and International Affairs at Princeton. "We are losing one of the greatest bully pulpits we have ever

had...." The story is similar around the globe, legal experts say, particularly in cases involving human rights. These days, foreign courts in developed democracies often cite the rulings of the European Court of Human Rights in cases concerning equality, liberty and prohibitions against cruel treatment, said Harold Hongju Koh, the dean of the Yale Law School. In those areas, Dean Koh said, "they tend not to look to the rulings of the U.S. Supreme Court...." Another reason is the diminished reputation of the United States in some parts of the world, which experts here and abroad said is in part a consequence of the Bush Administration's unpopularity around the world. Foreign courts are less apt to justify their decisions with citations to cases from a nation unpopular with their domestic audience. "It's not surprising, given our foreign policy in the last decade or so, that American influence should be declining," said Thomas Ginsburg, who teaches comparative and international law at the University of Chicago. (Liptak 2008)

I have noted throughout this book that there were occasional critical mass-media reports about violations of civil liberties, social control, and an occasional discussion about human-rights violations. But on the whole, the war on terrorism was communicated through numerous reports, discourses, and narratives about the necessity for domestic control and usurping civil liberties since, after all, "9/11 changed everything." Even protests at political conventions, long an institutionalized staging ground for political pluralism in the United States, were curtailed. Perhaps most important, police and military control and disruption of demonstrations was sanctioned and was seldom discussed. For example, the police raided, detained, and harassed potential protesters in Minneapolis the weekend before the 2008 Republican National Convention. Working on the pretext of safety and preventing terrorists from harming and disrupting the Republican conclave, the police "were authorized" to look for "a laundry list of items, including fire bombs, Molotov cocktails, brake fluid, photographs and maps of St. Paul, paint, computers and camera equipment, and documents and other communications" (Liptak 2008). At three houses people were arrested for "conspiracy to commit a riot," described as a "preventive detention charge" by one attorney.

"They handcuffed all of us," said Sonia Silbert, 28, from Washington. "They searched everyone."

People who had been in the building said that officers entered shortly after 8:30 p.m. with a warrant and instructed them to lie on the ground, adding that they had been questioned and photographed before being released.

Jordan Kushner, a member of the National Lawyers Guild, said the two-story brick building had been rented by a nonprofit organization and was being used by several groups planning protests.

People who had been inside said teach-ins and legal training had been conducted there, and that the space was also a repository for such items as computers and bicycles.

The R.N.C. Welcoming Committee, a group that has said it wants to block roads during the convention, issued a statement Friday night that was read aloud outside the meeting place by a woman who identified herself as Sarah Coffey. Ms. Coffey said that the officers, citing fire violations as the reason for their visit, "detained over 50 people in an attempt to pre-empt planned protests." (Moynihan 2008)

These protesters, of course, were not alone. It seems that even the journalists attempting to cover demonstrations that were allowed to occur did not fare so well. Amy Goodman, a radio commentator and author on politics and the media, was arrested in St. Paul when she inquired why two of her producers, with press credentials, were arrested:

For her trouble, she got busted—arrested by the police at a demonstration and held for several hours before she was charged with obstructing an officer and released.

Goodman, whose nationally circulated show is heard 9–10 a.m. daily on WBAI (99.5 FM), told listeners yesterday she was asking the police why they had detained two of her producers, Nicole Salazar and Sharif Abdel Kouddous.

Their response, she said—supported by a short video of the incident—was to order her to put her hands behind her back for plastic handcuffs. (Hinckley 2008)

Neither of these reports was picked up by U.S. news media.

■ Further Reflections

News media and popular culture depictions of the U.S. reaction to terror attacks reveal a culture and collective identity steeped in marketing, popular culture, consumerism, and fear. The military-media complex managed press releases and cultivated news sources to produce terrorism scenarios that were reflected in national agendas and everyday life. The attacks on the United States on September 11, 2001, were defined in the news media and popular culture as an assault on American culture, if not civilization itself (Altheide 2004). These definitions were aligned with a broad context and a preexisting discourse of fear, along with symbolic images of "Arabs" as the "other," or marginalized outsiders, who are threats to personal and national security (Adams 1981; Altheide 1981; Altheide 1982).

Terrorism discourse is part of a general context involving the discourse of fear, which was mainly associated with crime, as well as nearly two decades of negative reporting and imagery about the Middle East, and Iraq in particular. The politics of fear emerged from this discourse, but so did the resistant *Daily Show* and *The Colbert Report*, serious comedies with an international audience, especially young people. There was a lot of resistant comedy, e.g., *Reno 911*, about inept police officers in Reno who are always on the lookout for serious crime and terrorists. Other examples of resistance include *Countdown with Keith Olbermann* and, very importantly, the emergence of dozens of "alternative media" cites and blogs, e.g., The Onion. These productions played with and sarcastically resisted dominant mass-media images and themes about risk and safety. These control efforts included fundamental violations of international law, custom, and the Geneva accords: "torture" programs and policies, operation of secret prisons, denial of *habeas corpus* to detainees (which can be applied to all who threaten national security; Stolberg 2006), kidnapping and illegal international transport, and domestic and international surveillance of telephone and computer communication. As noted above, U.S. journalism was very supportive of U.S. actions against Iraq and any group placed under the broad umbrella of "terrorism." Only a handful of American news media carried reports about German and Italian arrest warrants for CIA agents who kidnapped German and Italian citizens, respectively, and shipped them to other countries to be tortured and questioned because they were thought to be terrorists (Wilkinson 2005; Williamson 2006). The power of discourse can be illustrated in the above-cited reports by comparing the relative emphasis of language and details provided in several different accounts of the Italian case. Particularly noteworthy in U.S. news reports is the use of qualifying terms to defuse the significant charges (e.g., "purported" CIA agents, "allegedly" kidnapped, and "supposedly" tortured).

The seriousness of the German and Italian charges, along with widespread revulsion throughout the European Community, can be illustrated by the Bush Administration's efforts to have Congress pass legislation that would grant immunity to key officials—including President Bush—and CIA agents who carried out their superiors' orders. According to one report:

> Congress has eased the worries of CIA interrogators and senior administration officials by granting them immunity from U.S. criminal prosecutions for all but "grave" abuses of terrorism detainees....

> "The obstacles to these prosecutions are not legal, they're political," said William Schabas, director of the Irish Center for Human Rights at the National University of Ireland in Galway. (Gordon and Taylor 2006)

■ Conclusion

Terrorism and 9/11 were used by the mass media and politicians to promote fear related agendas and ideologies. Terrorism added to the fear of crime narrative that has become part of public life. Citizens became accustomed to "safety rhetoric" by police officials, which often required them to permit police searches, condone "overaggressive" police action, as well as join in a myriad of crime-prevention efforts, many of which involved more human as well as electronic surveillance of work places, neighborhoods, stores, and even our "bodies," in the form of expansive drug screening. The discourse of fear promotes the politics of fear, and numerous surveillance practices and rationales to keep us safe (Monahan 2006). By the mid-1990s, many high school students had "peed in a bottle" as a condition of participating in athletics, applying for a job, and, in some cases, applying for student loans and scholarships. Several legal challenges to this scrutiny were turned down, as the courts (with few exceptions) began to uphold the cliché that was echoed by local TV newscasters and others that "why worry if you have nothing to hide?" In short, many U.S. citizens had been socialized into the garrison state, no longer being offended by surveillance; indeed, many chose to use the rapidly expanding—and inexpensive—technology to monitor their own children, including testing them for drugs.

Rituals of control were embodied in physical screening and inspection of travelers, including demands that they publicly sacrifice personal items in line with the "terror threat." The 9/11 attacks and the coalescing of the discourse of fear with terrorism meant that more of our lives would be subject to closer scrutiny, particularly air travel. A new federal organization was invented—the Department of Homeland Security—and with its multi-million-dollar budget came a requirement to establish an army of federal airport security personnel, the Transportation Security Administration (TSA). Notwithstanding numerous "experiments" that continue to demonstrate that conscientious "smugglers" can bring an array of weapons and explosives on board (Phillips et al. 2004), the discourse of terrorism continued to promote the claim that our screening was keeping us all safe, and that it should continue because, after all, the world changed after 9/11, and fear prevailed.

On January 20, 2009, Barack Obama was inaugurated as the 44th president of the United States of America. He stated, "On this day, we gather because we have chosen hope over fear, unity of purpose over conflict and discord." A public opinion poll released two days later listed terrorism as citizens' third-most-important issue; global warming was number 20 (Revkin 2009).

■ References

ABC 2008. "Christmas murders: Deadly Christmas eve." *World News with Charles Gibson*. December 26, 2008. http://www.lexisnexis.com.ezproxy 1.lib.asu.edu/us/lnacademic/ results/docview/docview.do?docLinkInd=true&risb=21_T5543768869&format=GN BFI&sort=RELEVANCE&startDocNo=1&resultsUrlKey=29_T5543768872&cisb=22_T 5543768871&treeMax=true&treeWidth=0&selRCNodeID=64&nodeStateId=411e n_US,1,62&docsInCategory=1&csi=8277&docNo=1 (accessed January 15, 2009).

Adams, William C. 1981. *Television coverage of the Middle East*. Norwood, NJ: Ablex Pub. Corp.

———.1982. *Television coverage of international affairs*. Norwood, NJ: Ablex Pub. Corp.

Altheide, David. 1981. "Iran vs. U.S. TV news! The hostage story out of context," in *TV coverage of the Middle East*, edited by William C. Adams. Norwood, NJ: Ablex Pub. Corp.

———. 1982. "Three-in-one news: Network coverage of Iran." *Journalism Quarterly* Fall: 482–486.

———. 2006. *Terrorism and the politics of fear*. Lanham, MD: Alta Mira Press.

Altheide, David L. 1976. *Creating reality: How TV news distorts events*. Beverly Hills, CA: Sage.

———.1987. "Format and symbols in TV coverage of terrorism in the United States and Great Britain." *International Studies Quarterly* 31: 161–176.

———. 1995. *An ecology of communication: Cultural formats of control*. Hawthorne, NY: Aldine de Gruyter.

———. 1996. *Qualitative media analysis*. Newbury Park, CA: Sage.

———. 1997. "The news media, the problem frame, and the production of fear." *Sociological Quarterly* 38: 646–668.

———. 1998. "The technological seam," in *Studies in symbolic interaction*, edited by Norman K. Denzin. Stamford, CT: JAI Press.

———. 2002. *Creating fear: News and the construction of crisis*. Hawthorne, NY: Aldine de Gruyter.

———. 2003a. "Communication as power in Peter Hall's work," in *Studies in symbolic interaction*, edited by Norman K. Denzin. New York: Elsevier Science Ltd.

———. 2003b. "The mass media as a social institution," in *Handbook of symbolic interactionism*, edited by Larry T. Reynolds and Nancy J. Herman-Kinney. Walnut Creek, CA: Alta Mira Press.

———. 2003c. "Notes toward a politics of fear." *Journal for Crime, Conflict and the Media* 1: 37–54. http://www.jc2m.co.uk/Issue1/Altheide.pdf.

———. 2004. "Consuming terrorism." *Symbolic interaction* 27: 289–308.

———. 2007. "Pat Tillman's death and the military/media complex," in *Communicating war: Memory, military and media.*, edited by S. Maltby & C. Keeble. Suffolk, UK: Arima Publishing.

Altheide, David L., and Katie DeVriese. 2007. "Perps and junkies: Normalizing stigma in the mass media." *Crime, Media, Culture* 3: 382–389.

Altheide, David L., and Robert P. Gilmore. 1972. "The credibility of protest." *American Sociological Review* 37: 99–108.

Altheide, David L., Barbara Gray, Roy Janisch, Lindsey Korbin, Ray Maratea, Debra Neill, Joseph Reaves, and Felicia VanDeman. 2001. "News constructions of fear and victim: An exploration through triangulated qualitative document analysis." *Qualitative Inquiry* 7: 304–322.

Altheide, David L., and Jennifer N. Grimes. 2005. "War programming: The propaganda project and the Iraq War." *Sociological Quarterly* 46: 617–643.

Altheide, David L., and John M. Johnson. 1980. *Bureaucratic propaganda*. Boston: Allyn and Bacon.

———. 1993a. "The ethnographic ethic," in *Studies in symbolic interaction*, edited by Norman K. Denzin. Greenwich, CT: JAI Press.

———. 1993b. "Tacit knowledge: The boundaries of experience," in *Studies in symbolic interaction*, edited by Norman Denzin. Greenwich, CT: JAI Press.

———. 1994. "Criteria for assessing interpretive validity in qualitative research," in *Handbook of qualitative methodology*, edited by Norman K. Denzin and Yvonna Lincoln. Newbury Park, CA: Sage.

Altheide, David L., and R. Sam Michalowski. 1999. "Fear in the news: A discourse of control." *Sociological Quarterly* 40: 475–503.

Altheide, David L., and Robert P. Snow. 1979. *Media logic*. Beverly Hills, CA: Sage.

———. 1991. *Media worlds in the postjournalism era*. Hawthorne, NY: Aldine de Gruyter.

Anderson, Terence J., William L. Twining, and John Henry Wigmore. 1991. *Analysis of evidence: How to do things with facts, based on Wigmore's Science of judicial proof*. Boston: Little Brown.

Archibald, Randal C. 2008. "Challenges to a sheriff, both popular and reviled." *New York Times* September 27, 2008. http://www.nytimes.com/2008/09/28 /us/28sheriff.html?_r=1&scp=5&sq=arpaio&st=cse (accessed January 12, 2009).

Arendt, Hannah. 1966. *The origins of totalitarianism.* New York: Harcourt Brace & World.

Armstrong, David. 2002. "Dick Cheney's song of America: Drafting a plan for global dominance." *Harper's Magazine* October 2002: 76–83.

Asser, Martin. 2006. "Qana makes grim history again." January 13, 2009. http:// ne ws.bbc.co.uk/2/hi/middle_east/5228554.stm.

Associated Press. 2006. "Texas prosecutor kills himself after sex sting/County assistant district attorney commits suicide as police serve warrant." http://www.msnbc.msn. com/id/15592444/ (accessed January 10, 2009).

———. 2008. "Tapes show a besieged Nixon saw enemies all over." *USA Today* December 3, 2008. http://www.usatoday.com/news/washington/2008-12-03-nixon-disclosures_N. htm?csp=34.

Bacevich, A. J. 2002. *American empire: The realities and consequences of U.S. diplomacy.* Cambridge, MA; London: Harvard University Press.

Badkhen, Anna. 2005. "Colonel's toughest duty/Battalion commander pays his respects, apologizes to Iraqis whose civilian relatives have been killed by anonymous GIs in passing patrols and convoys." *San Francisco Chronicle* October 14, 2005: A1.

Baer, Justin, and William J. Chambliss. 1997. "Generating fear: The politics of crime reporting." *Crime, Law and Social Change* 27: 87–107.

Baker, Al. 2001. "A nation challenged: Personal security; steep rise in gun sales reflects post-attack fears." *New York Times*: p. 1; column 3; Metropolitan Desk.

Barrett, Liz Cox. 2008. "Pre-Iraq War coverage: 'Pretty good job' or 'embarrassing'?" *Columbia Journalism Review.* http://www.cjr.org/the_kicker/preiraq_war_coverage_pretty _go.php.

Barry, John, Michael Hirsh, and Michael Isikoff. 2004. "The roots of torture: The road to Abu Ghraib began after 9/11, when Washington wrote news rules to fight a new kind of war." *Newsweek* May 24, 2004. http://www.msnbc.msn.com/id/4989422/site/ newsweek/.

Barson, Michael, and Steven Heller. 2001. *Red scared! The commie menace in propaganda and popular culture.* San Francisco: Chronicle Books.

BBC. 2004. "Iraq death toll 'soared post-war.' " *BBC Newscast* October 29, 2004. http:// news.bbc.co.uk/2/hi/middle_east/3962969.stm.

Becker, Howard Saul. 1973. *Outsiders: Studies in the sociology of deviance.* New York: Free Press.

Beckett, Katherine. 1996. "Culture and the politics of signification: The case of child sexual abuse." *Social Problems* 43: 57–76.

Beisel, Nicola Kay. 1997. *Imperiled innocents: Anthony Comstock and family reproduction in Victorian America.* Princeton, NJ: Princeton University Press.

Bennett, James. 2001. "Israel wants cease-fire to precede truce talks." *New York Times* September 16, 2001: p. 1.

Bennett, W. Lance. 1988. *News: The politics of illusion.* New York: Longman.

———. 2005. *News: The politics of illusion.* New York: Pearson/Longman.

Berger, Peter L., and Thomas Luckmann. 1967. *The social construction of reality: A treatise in the sociology of knowledge*. New York: Doubleday.

Best, Joel. 1990. *Threatened children: Rhetoric and concern about child-victims*. Chicago: University of Chicago Press.

———. 1994. *Troubling children: Studies of children and social problems*. New York: Aldine de Gruyter.

———. (ed). 1995. *Images of issues*. Hawthorne, NY: Aldine de Gruyter.

———. 1999. *Random violence: How we talk about new crimes and new victims*. Berkeley; London: University of California Press.

Best, Joel, and J. Horiuchi. 1985. "The razor blade in the apple: The social construction of urban legends." *Social Problems* 35: 488–499.

Blumberg, Abraham S. 1967. "The practice of law as a confidence game: Organizational cooptation of a profession." *Law and Society Review* 1: 15–39.

Blumer, Herbert. 1958. "Race prejudice as a sense of group position." *Pacific Sociological Review* 1: 3–7.

———. 1962. "Society as symbolic interaction," in *Human Behavior and Social Processes*, edited by A. M. Rose. Boston, MA: Houghton Mifflin.

Broder, John M. 2007. "Chief of Blackwater defends his employees." *New York Times* October 3, 2007. http://www.nytimes.com/2007/10/03/washington/0 3blackwater.html (accessed October 4, 2007).

Brokaw, Tom. 2007. *Boom! Voices of the sixties: Personal reflections on the '60s and today*. New York: Random House.

Bronner, Ethan. 2009. "Israel deepens Gaza incursion as toll mounts." *New York Times*: A1. http://www.nytimes.com/2009/01/06/world/middleeast/06mideast.html?_r=1&th&emc=th (accessed January 6, 2009).

Bumiller, Elisabeth. 2006. "Bush meets with premier of Pakistan." *New York Times*: A13.

Carey, Benedict. 2007. "Denial makes the world go round." *New York Times* November 20, 2007: D1. http://www.nytimes.com/2007/11/20/health/research/20deni.html (accessed November 21, 2007).

Cauchon, Dennis. 2005. "Extent of Columbine's shadow hard to determine." *USA Today*, March 23, 2005. http://www.usatoday.com/news/nation/2005-03-22-redlake-columbine_x.htm.

Cavender, Gray. 2004. "In search of community on reality TV: *America's Most Wanted and Survivor*," in *Understanding reality*, edited by Su Holmes and Deborah Jermyn. London: Routledge.

CBS News Transcripts. 2004. "60 Minutes: Ambush at Goose Creek; Drug raid at Stratford High School." February 4, 2004.

Cerulo, Karen A. 2002. "Individualism Pro Tem: Reconsidering U. S. Social Relations." Pp. 135-171 in *Culture in Mind: Toward a Sociology of Culture and Cognition*, edited by Karen A. Cerulo. New York: Routledge.135-171

Chang, Gordan, C., and Hugh B. Mehan. 2008. "Why we must attack Iraq: Bush's reasoning practices and argumentation system." *Discourse & Society* Vol. 19: 453-482.http://das.sagepub.com/cgi/content/abstract/19/4/453

Chermak, Steven. 1995. *Victims in the news : crime and the American news media*. Boulder, Colo.: Westview Press.

Chiricos, Ted, Sarah Eschholz, and Marc Gertz. 1997. "Crime, News and Fear of Crime: Toward an Identification of Audience Effects." *Social Problems* 44: 342-357

Chiricos, Ted, Kathy Padgett and Marc Gertz. 2000. "Fear, TV News, and the Reality of Crime." *Criminology* 38: 755-785

Churchill, Ward, and Jim Vander Wall. 1990. *The Cointelpro papers : documents from the FBI's secret wars against domestic dissent*. Boston, MA: South End Press.

Cicourel, Aaron Victor. 1964. *Method and measurement in sociology*. [New York]: Free Press of Glencoe.

2008. "Day Four of Attacks in Gaza; Controversial Collision; Blames Hamas; Retailers at Risk." *CNN NewsRoom*.December 30, 2008.

Cohen, Noam. 2009. "Few in U.S. See Jazeera's Coverage of Gaza War." *The New York Times* January 12, 2009: B1 http://www.nytimes.com/2009/01/12/business/media/12jazeera.html?_r=1&th&emc=th accessed January 12, 2009

Cohen, Stanley. 1980. *Folk devils and moral panics : the creation of the Mods and Rockers*. Oxford Oxfordshire: M. Robertson.

Cohen, Stanley, and Jock Young. 1973. *The manufacture of news; social problems, deviance and the mass media*. London,: Constable.

ColumbiaJournalismReviewStaff. 2004. "Brits vs Yanks: Who Does Journalism Right." *Columbia Journalism Review*: 44-49

Conrad, Peter. 2007. " SOCIETY: Misfits on a mission to delete us all: The young Finn who last month slaughtered eight people, having first boasted of his plans on YouTube, is the latest of a new breed of killer. Armed with a gun, a camera and a computer, they use dehumanising technology to turn bedroom cyber fantasies into bloody reality." *The Observer* December 30, 2007: 8

Couch, Carl. 1995. "Oh, What Webs Those Phantoms Spin (SSSI Distinguished Lecture, 1994)." *Symbolic Interaction* 18: 229-245

Couch, Carl J. 1984. *Constructing civilizations*. Greenwich, Conn. ; London, England: JAI Press.

Couch, Carl J., David R. Maines, and Shing-Ling Chen. 1996. *Information technologies and social orders*. New York: Aldine de Gruyter.

Coyle, Michael J. 2007. *The language of justice: Exposing social and criminal justice discourse*. Tempe: Arizona State University.Dissertation.306

CTV.ca, and News Staff. 2007. "Study suggests 'CSI effect' impacts legal system." Study suggests 'CSI effect' impacts legal system October 31, 2007. http://www.ctv.ca/servlet/ArticleNewsstory/CTVNews/20070608/csieffect_legal_070608?s_name=&no_ads=

Cullen, Dave. 2004. "The Depressive and the Psychopath: AT LAST WE KNOW WHY THE COLUMBINE KILLERS DID IT." *The Slate* April 20, 2004 T http://www.slate.com/id/2099203/

Cunningham, Brent. 2003. "Re-Thinking Objectivity." *Columbia Journalism Review* July/August 2003: 24-32

—. 2007. "The Rhetoric Beat: Why journalism needs one." *Columbia Journalism Review*: 36-39.http://www.cjr.org/essay/the_rhetoric_beat.php accessed November 21, 2007

Davies, Frank. 2007. "Many Americans believe there was a link between Iraq, Sept. 11." *San Jose Mercury News* September 11, 2007

Davis, Charles. 2003. "Duct Tape, Plastic, and Bio-terrorism: What Reporters Don't Ask About Can Kill All of Us." in *University of Missouri Symposium: Understanding Crises: Media Coverage and Statistics on War and Terror*. University of Missouri.

Deaver, Michael. 1988. "Sound-Bite Campaigning: TV Made Us do It." *The Washington Post* Oct. 30: C7

Denzin, Norman K. 2007. "The Secret Downing Street Memo, the One Percent Doctrine, and the Politics of Truth: A Performance Text." *Symbolic Interaction* 30: 447-464

Denzin, Norman K. and Yvonna S. Lincoln, ed. 1994. *Handbook of Qualitative Research*. Newbury Park, Ca: Sage.

Denzin, Norman K., and Yvonna S. Lincoln, eds. 2003. *9/11 in American Culture*. Latham, Maryland: Rowman and Littlefield.

Deutscher, Irwin. 1973. *What we say/what we do; sentiments & acts*. Glenview, Ill.,: Scott Foresman.

deVise, Daniel. 2008. "Suburban Schools Reject Metal Detectors." *The Washington Post* April 18, 2008: A1

Douglas, Jack D. 1970. *Understanding everyday life : toward the reconstruction of sociological knowledge*. Chicago: Aldine Pub. Co.

—. 1971. *American social order; social rules in a pluralistic society*. New York,: Free Press.

—. 1976. *Investigative social research : individual and team field research*. Beverly Hills: Sage Publications.

Douglas, Jack D., Freda Cruse Atwell, and John Hillebrand. 1988. *Love, intimacy, and sex*. Newbury Park, Calif.: Sage Publications.

Douglas, Jack D., and John M. Johnson. 1977. *Existential sociology*. Cambridge [Eng.] ; New York: Cambridge University Press.

Dubber, Markus Dirk. 2002. *Victims in the war on crime : the use and abuse of victims' rights*. New York: New York University Press.

Edelman, Murray J. 1971. *Politics as symbolic action; mass arousal and quiescence*. Chicago,: Markham Pub. Co.

—. 1988. *Constructing the political spectacle*. Chicago: University of Chicago Press.

Editors, Columbia Journalism Review. 2006. "Into the Abyss: Reporting Iraq, 2003-2006: An Oral History." *Columbia Journalism Review* November/December 2006: 14-79.http://www.cjr.org/iraq/

Ekecrantz, J. 1998. "Modernity, globalisation and media." *SOCIOLOGISK FORSKNING* 35: 33-60

El-Khodary, Taghreed , and and Isabel Kershner. 2009. "Warnings Not Enough for Gaza Families." *The New York Times* January 5, 2009: A8 http://www.nytimes.com/2009/01/06/world/middleeast/06scene.html?th&emc=th accessed January 6, 2009

El-Krodary, Tagreed. 2009a. "Grief and Rage at Stricken Gaza School." *The New York Times* January 7, 2009: A12 http://www.nytimes.com/2009/01/08/world/middleeast/08scene.html?scp=1&sq=gaza+grief+rage&st=nyt accessed January 8, 2009

—. 2009b. "In a Hospital, Pain, Despair and Defiance." *The New York Times* January 9, 2009: A1

El-Krodary, Tagreed, and and Isabel Kershner. 2009. "Shells Kill 40 at Gaza U.N. School." *The New York Times* January 7, 2009 http://www.nytimes.com/2009/01/07/world/middleeast/07mideast.html?_r=1&th&emc=th accessed January 7, 2009

Ellenius, Allan, and European Science Foundation. 1998. *Iconography, propaganda, and legitimation*. New York: Oxford University Press.

Elliott, Philip Ross Courtney. 1972. *The making of a television series; a case study in the sociology of culture*. London,: Constable.

Engel, Matthew. 2002. "War on Afghanistan: American media cowed by patriotic fever, says network news veteran." *The Guardian* May 17, 2002: 4

Ericson, Richard V., ed. 1995. *Crime and the Media*. Brookfield, VT: Dartmouth University Press.

——. 2007. *Crime, Risk and Uncertainty*. London: Polity Press.

Ericson, Richard V. , and Kevin D. Haggerty. 1997. *Policing the Risk Society*. Toronto: University of Toronto Press.

Ericson, Richard V., Patricia M. Baranek, and Janet B. L. Chan. 1991. *Representing Order: Crime, Law and Justice in the News Media*. Toronto: University of Toronto Press.

Ericson, Richard V., Patricia M. Baranek, and Janet B. L. Chan. 1989. *Negotiating Control: A Study of News Sources*. Toronto: University of Toronto Press.

Ericson, Richard Victor, Patricia M. Baranek, and Janet B. L. Chan. 1987. *Visualizing deviance : a study of news organization*. Toronto: University of Toronto Press.

Erlanger, Steven. 2009. "For Israel, 2006 lessons but old pitfalls." *New York Times* January 7, 2009. http://www.nytimes.com/2009/01/07/world/middleeast/07military.html?_r=1&th&emc=th (accessed January 7, 2009).

Espeland, Wendy Nelson. 2002. "Commensuration and cognition," in *Toward a sociology of culture and cognition*, edited by Karen A. Cerulo. New York: Routledge.

Ewen, Stuart. 1999. *All consuming images: The politics of style in contemporary culture*. New York: Basic Books.

FAIR (Fairness and Accuracy in Reporting). 2003. "In Iraq crisis, networks are megaphones for official views." March 18, 2003. http://www.fair.org/reports/iraq-sources.html.

Feller, Ben. 2009. "Bush: Hamas attacks on Israel an `act of terror.' " January 6, 2009. http://news.yahoo.com/s/ap/20090102/ap_on_go_pr_wh/bush_mideast.

Ferraro, Kenneth F. 1995. *Fear of crime: Interpreting victimization risk*. Albany, NY: State University of New York Press.

Ferrarotti, Franco. 1988. *The end of conversation: The impact of mass media on modern society*. New York: Greenwood Press.

Ferrell, Jeff, and Clinton Sanders. 1995. *Cultural criminology*. Boston: Northeastern University Press.

Festinger, Leon. 1968. *A theory of cognitive dissonance*. Stanford, CA: Stanford University Press.

Festinger, Leon, Henry W. Riecken, and Stanley Schachter. 1956. *When prophecy fails: A social and psychological study of a modern group that predicted the end of the world*. Minneapolis: University of Minnesota Press.

Fishman, Mark, and Gray Cavender. 1998. *Entertaining crime: Television reality programs*. New York: Aldine de Gruyter.

Fowler, Roger. 1991. *Language in the news: Discourse and ideology in the British press*. London; New York: Routledge.

Frank, Thomas. 2008. "Feds consider searches of terrorism blogs." *USA Today* December 23, 2008. http://www.usatoday.com/news/washington/2008-12-23-terrorblogs_N. htm?csp=34 (accessed December 26, 2008).

Fritz, Noah, and David L. Altheide. 1987. "The mass media and the social construction of the missing children problem." *Sociological Quarterly* 28: 473–492.

Furedi, Frank, 1948; 1997. *Culture of fear: Risk-taking and the morality of low expectation*. London: Cassell.

Gamel, Kim. 2006. "Two captured U.S. soldiers killed 'in barbaric way.' " *Seattle Times* June 20, 2006: 1. http://seattletimes.nwsource.com/html/nationworl d/2003073487_webi-raq20.html (accessed June 29, 2006).

Gamson, William A., David Croteau, William Hoynes, and Theodore Sasson. 1992. "Media images and the social construction of reality." *Annual Review of Sociology* 18: 373–393.

Gans, Herbert J. 1979. *Deciding what's news: A study of CBS evening news, NBC nightly news, Newsweek, and Time*. New York: Pantheon Books.

Garfinkel, Harold. 1967. *Studies in ethnomethodology*. Englewood Cliffs, NJ: Prentice-Hall.

Garland, Catherine Ann. 1997. *The context of fear as an indication of healthy community investment: 80 low-income neighborhoods in Los Angeles*. University of California, Irvine.

Garland, David. 2001. *The culture of control: Crime and social order in contemporary society*. Chicago: University of Chicago Press.

Gerber, Rudolph J., and John M. Johnson. 2007. *The top ten death penalty myths*. Westport, CT: Praeger.

Gerth, Hans H. 1992. "Crisis management of social structures: Planning, propaganda and societal morale." *International Journal of Politics, Culture and Society* 5: 337–359.

Ghosh, Amitav. 2008. "India's 9/11? Not exactly." *New York Times* December 2, 2008. http://www.nytimes .com/2008/12/03/opinion/03ghosh.html?th&emc=th (accessed December 3, 2008).

Giere, Ronald N. 2002. "Discussion note: Distributed cognition in epistemic cultures." *Philosophy of Science* 69: 637–644. http://www.tc.umn.edu/~giere/DCEC.pdf.

Gilbert, James Burkhart. 1986. *A cycle of outrage: America's reaction to the juvenile delinquent in the 1950s*. New York: Oxford University Press.

Giroux, Henry A. 2003. *The abandoned generation: Democracy beyond the culture of fear*. New York; Houndmills, UK: Palgrave Macmillan.

Gitlin, Todd. 1980. *The whole world is watching*. Berkeley: University of California Press.

Glaberson, William. 2009. "Detainee was tortured, a Bush official confirms." *New York Times* January 14, 2009. http://www.nytimes.com/2009/01/14/us/14gitmo.html?_ r=1&th&emc=th (accessed January 14, 2009).

Glassner, Barry. 1999. *The culture of fear: Why Americans are afraid of the wrong things*. New York: Basic Books.

Goffman, Erving. 1959. *The presentation of self in everyday life*. Garden City, NY: Doubleday.

———. 1963a. *Behavior in public places: Notes on the social organization of gatherings*. New York: Free Press of Glencoe.

———. 1963b. *Stigma: Notes on the management of spoiled identity*. Englewood Cliffs, NJ: Prentice-Hall.

———. 1974. *Frame analysis*. New York: Harper and Row.

Goode, Erich, and Nachman Ben-Yehuda. 1994. *Moral panics: The social construction of deviance*. Cambridge, MA: Blackwell.

Gordon, Greg, and Marisa Taylor. 2006. "U.S. interrogators may not be in the clear yet; Bill on abuses won't stop prosecutions in other countries, experts warn." *Sacramento Bee* September 30, 2006: A16. http://web.lexis-nexis.com.ezproxy1.lib.asu.edu/universe/document?_m=d80652d20e771dc3cce2b25851fdad6f&_docnum=1&wchp=dGLbVzb-SkVA&_md5=29a184922fe7c2c6ef498c271153e0c3 (accessed October 9, 2006).

Gordon, Jane. 2003. "Final preparing for the unthinkable." *New York Times* February 23, 2003; 14CN. http://www.lexisnexis.com.ezproxy1.lib.asu.edu/us/lnacademic/results/docview/docview.do?docLinkInd=true&risb=21_T4207424099&format=GNBFI&sort=BOOLEAN&startDocNo=1&resultsUrlKey=29_T4207425403&cisb=22_T420742 5402&treeMax=true&treeWidth=0&csi=6742&docNo=17.

Grado, Gary. 2008. "E.V. Columbine copycats face diverse fates." *East Valley Tribune* April 19, 2008: A7. http://www.eastvalleytribune.com/story/114304 (accessed April 19, 2008).

Greenwald, Glenn. 2007. "Everyone we fight in Iraq is now 'al-Qaida.' " June 25, 2007. http://www.salon.com/opinion/greenwald/2007/06/23/al_qaeda/.

Grimes, Jennifer N. 2007. *Crime, media, and public policy: Striking out ten years later*. Ph.D. 120. Tempe: Arizona State University.

Grimm, Matthew. 2003. "Good news, bad news." *American Demographics* July/August 2003: 36–37. http://www.findarticles.com/p/articles/mi_m4021/is_6_25/ai_105777529.

Gronbeck, Bruce E., Thomas J. Farrell, and Paul A. Soukup. 1991. *Media, consciousness, and culture: Explorations of Walter Ong's thought*. Newbury Park, CA: Sage Publications.

Grossberg, Lawrence, Ellen Wartella, and D. Charles Whitney. 1998. *Media making: Mass media in a popular culture*. Thousand Oaks, CA: Sage Publications.

Hall, Peter. 1988. "Asymmetry, information control, and information technology," in *Communication and social structure*, edited by David Maines and Carl J. Couch. Springfield, IL: Charles C. Thomas Publishing.

Hall, Peter M. 1997. "Meta-power, social organization, and the shaping of social action." *Symbolic Interaction*. 20: 397–418.

Hall, Stuart. 1977. "Culture, media, and the ideological effect," in *Mass communication and society*, edited by J. Curran, M. Gurevitch and J. Wollacott. London: Edward Arnold.

———. 1978. *Policing the crisis: Mugging, the state, and law and order*. New York: Holmes & Meier

Hartsock, Nancy C. M. 1998. *The feminist standpoint revisited and other essays*. Boulder, CO: Westview Press.

Hertsgaard, Mark. 1988. *On bended knee: The press and the Reagan presidency*. New York: Farrar Straus Giroux.

Hewitt, John P., and Randall Stokes. 1975. "Disclaimers." *American Sociological Review* 40: 1–11.

Hill, Malcolm, and E. Kay M. Tisdall. 1997. *Children and society.* London; New York: Longman.

Hinckley, David. 2008. "Busted covering protest at GOP confab." *Daily News* September 3, 2008: 76. http://www.lexisnexis.com.ezproxy1.lib.asu.edu/ us/lnacademic/results/ docview/docview.do?docLinkInd=true&risb=21_T5516828859&format=GNBFI&so rt=RELEVANCE&startDocNo=1&resultsUrKey=29_T5516828862&cisb=22_T5516 828861&treeMax=true&treeWidth=0&csi=151550&docNo=11 (accessed January 12, 2009).

Hoffer, Eric. 1951. *The true believer: Thoughts on the nature of mass movements.* New York: Harper.

Hornqvist, Magnus. 2004. "The birth of public order policy." *Race and Class* 46: 30–52.

Hunt, Arnold. 1997. " 'Moral Panic' and Moral Language in the Media." *British Journal of Sociology* 48: 629–648.

Husting, Ginna, and Martin Orr. 2007. "Dangerous machinery: 'Conspiracy theorist' as a transpersonal strategy of exclusion." *Symbolic Interaction* 30: 127–150.

Ibbitson, John. 2006. "Trust: Assumed, until it's broken." *Globe and Mail* September 14, 2006: A9.

Innes, Martin. 2004. "Crime as a signal, crime as a memory." *Journal for Crime, Conflict and the Media* 1: 15–22. http://www.jc2m.co.uk/Issue2/Innes.pdf.

Isikoff, Michael. 2008. "The Fed who blew the whistle." *Newsweek* December 22, 2008: 40–48. http://www.lexisnexis.com.ezproxy1.lib.asu.edu/us/lnacademic/search/home-submitForm.do (accessed January 12, 2009).

Issenberg, Sasha. 2008. "Supporters jeer as McCain calls Obama ` a decent person' /Promises civility after days of harsh attacks on rival." *Boston Globe* October 11, 2008: A1. http:// www.lexisnexis.com.ezproxy1.lib.asu.edu/us/

lnacademic/results/docview/docview.do?docLinkInd=true&risb=21_T5545033742&form at=GNBFI&sort=RELEVANCE&startDocNo=1&resultsUrKey=29_T5545033745&cisb =22_T5545033744&treeMax=true&treeWidth=0&csi=8110&docNo=5 (accessed January 15, 2009).

Iyengar, Shanto and Donald M. Kinder. 1987. *News that matters.* Chicago: University of Chicago Press.

Jackall, Robert, ed. 1994. *Propaganda.* New York: New York University Press.

James, George. 2005. "Thinking terror, thinking schools." *New York Times* January 23, 2005. http://query.nytimes.com/gst/fullpage.html?res=9D0DE1D81038F930A15752C0A9 639C8B63.

Jamrozik, Adam, and Tania Sweeney. 1996. *Children and society: The family, the state, and social parenthood.* South Melbourne: Macmillan Education Australia.

Jehl, Douglas, and David Johnston. 2005. "Rule change lets C.I.A. freely send suspects abroad to jails." *New York Times* March 6, 2005. http://www.nytimes.com/2005/03/06/ politics/06intel.html?ex=1110776400&en=e36cc36fc5ef2f81&ei=5070.

Jenkins, Philip. 1992. *Intimate enemies: Moral panics in contemporary Great Britain.* New York: Aldine de Gruyter.

———. 2000. "Capitol Hill hearing testimony on ecstasy." Washington, DC. http://www. lexisnexis.com.ezproxy1.lib.asu.edu/us/lnacademic/results/docview/docview. do?risb=21_T3580447305&format=GNBFI&sort=BOOLEAN&startDocNo=1&resu ltsUrlKey=29_T3580447311&cisb=22_T3580447310&treeMax=true&treeWidth=0 &selRCNodeID=7&nodeStateId=411en_US,1,4&docsInCategory=3&csi=138357& docNo=1 (accessed April 22, 2008).

Johnson, George. 2001. "Before & after; order of magnitude: The toll and the technology." *New York Times* September 16, 2001: 3.

Johnson, J. M. 1995. "Horror stories and the construction of child abuse," in *Images of Issues*, edited by Joel Best. Hawthorne, New York: Aldine de Gruyter.

Johnston, David. 2008. "A city's police force now doubts terror focus." *New York Times* July 24, 2008. http://www.nytimes.com/2008/07/24/us/24terror. html?pagewanted=1&th&emc=th.

Johnston, David, and John M. Broder. 2007. "F.B.I. says guards killed 14 Iraqis without cause." *New York Times* November 14, 2007: A1. http://www.nytimes.com/2007/11/14/ world/middleeast/14blackwater.html?_r=1&th&emc=th&oref=slogin (accessed November 14, 2007).

Jones, Charisse. 1999. "Back to school, guardedly districts spending on safety." *USA Today* August 4, 1999: 1A.

Jones, Jeffrey. 2006. "Parent concern about children's safety at school on the rise." *Gallup News Services* October 16, 2006. http://www.gallup.com/poll/25021/Parent-Concern-About-Childrens-Safety-School-Rise.aspx (accessed June 10, 2008).

Kagan, Robert. 2003. *Of paradise and power: America and Europe in the new world order.* New York: Knopf.

Kagan, Robert, and William Kristol. 2000. *Present dangers: Crisis and opportunity in American foreign and defense policy.* San Francisco: Encounter Books.

Kamalipour, Yahya R., and Nancy Snow. 2004. *War, media, and propaganda: A global perspective.* Lanham, MD; Oxford: Rowman & Littlefield.

Kappeler, Victor E., Mark Blumberg, and Gary W. Potter. 1999. *The mythology of crime and criminal justice.* Prospect Heights, IL: Waveland Press.

Karp, David A. and William C. Yoels. 1986. "You can take the boy out of Dorchester, but you can't take Dorchester out of the boy: Toward a social psychology of mobility." *Symbolic Interaction* 9: 19–36.

Kelley, Tina. 2008. "In an era of school shootings, lockdowns are the new drill." *New York Times* March 25, 2008: 1.

Kellner, Douglas. 1995. *Media culture: Cultural studies, identity and politics between the Modern and Postmodern.* New York: Routledge.

———. 2003. *From 9/11 to terror war: The dangers of the Bush legacy.* Lanham, MD; Oxford: Rowman & Littlefield.

———. 2004. "Media propaganda and spectacle in the war on Iraq: A critique of U.S. broadcasting networks." *Cultural Studies<=>Critical Methodologies* 4: 329–338.

Kershner, Isabel. 2009. "Israel shells U.N. site in Gaza, drawing fresh condemnation." *New York Times* January 16, 2009: A1. http://www. nytimes.com/2009/01/16/world/ middleeast/16mideast.html?th&emc=th (accessed January 16, 2009).

Kimmelman, Michael. 2002. "In New York, art is crime, and crime becomes art." *New York Times* December 18, 2002. http://www.nytimes.com/2002/12/18/arts/design/18FEAR. html?ex=1041231425&ei=1&en=14502da3abfe7b7f.

Kingston, Anne. 2002. "You're a goof. Buy our beer: What the Canadian ad awards reveal about us." *Saturday Post* April 20: SP 1.

Knorr-Cetina, K. 1999. *Epistemic cultures: How the sciences make knowledge.* Cambridge, MA; London: Harvard University Press.

Krugman, Paul. 2003. "Who's accountable?" *New York Times* June 10, 2003. http://www. nytimes.com/2003/06/10/opinion/10KRUG.html accessed May 18, 2009

Kuhn, Thomas S. 1970. *The structure of scientific revolutions.* Chicago: University of Chicago Press.

Kull, Steven. 2004. "U. S. public beliefs and attitudes about Iraq. August 20, 2004." Program on International Policy Attitudes. http://www.pipa.org/OnlineReports/Iraq/ Report08_20_04.pdf.

Kull, Steven, Clay Ramsay, and Evan Lewis. 2002. "Misperceptions, the media, and the Iraq War." *Political Science Quarterly* 118: 569–598.

Lacey, Mark. 2009. "In crime wave, an interrupted meal haunts Mexico." *New York Times* January 7, 2009: A8. http://www.nytimes.com/2009/01/08/world/americas/08mexico. html?scp=1&sq=in+crime+wave+an+interrupted+meal+haunts+mexico&st=nyt (accessed January 8, 2009).

LaFraniere, Sharon. 2007. "African crucible: Cast as witches, then cast out." *New York Times* November 15, 2007: A1. http://www.nytimes.com/2007/11/15/world/africa/15witches. html?_r=1&oref=slogin.

Lakoff, George. 2004. *Don't think of an elephant! Know your values and frame the debate: The essential guide for progressives.* White River Junction, VT: Chelsea Green Pub. Co.

———. 2006. "A response to Steven Pinker (Reprinted with the kind permission of *New Republic* Online)." *Powell's Books.* http://www.powells.com/biblio?show=HARDCO VER:NEW:0374158282:23.00&page=authorsnote#page (accessed November 21, 2007).

Lasswell, Harold Dwight, Hans Speier, and Daniel Lerner. 1979. *Propaganda and communication in world history.* Honolulu: Published for the East-West Center by University of Hawai'i Press.

Lemert, Edwin. 1962. "Paranoia and the dynamics of exclusion." *Sociometry* 25: 2–25.

Lewin, Tamar. 2003. "Raid at high school leads to racial divide, not drugs." *New York Times* December 9, 2003. http://query.nytimes.com/gst/fullpage.html?res=9C01E4D9113 DF93AA35751C1A9659C8B63 (accessed July 29, 2008).

Lichtblau, Eric. 2008a. *Bush's law: The remaking of American justice.* New York: Pantheon.

———. 2008b. "Eavesdropping law is likely to lapse." *New York Times* February 14, 2008: 25. http://www.nytimes.com/2008/02/14/washington/14fisa.html?_ r=1&th&emc=th&oref=slogin (accessed February 14, 2008).

Lieven, Anatol, and Rajan Menon. 2006. "The US should express regret for lives lost in Pakistan airstrike." *Christian Science Monitor* January 19, 2006: p. 9.

Lind, Joan Dyste. 1988. "Toward a theory of cultural continuity and change: The innovation, retention, loss and dissemination of information," in *Communication and social*

structure, edited by David R. Maines and Carl J. Couch. Springfield, IL: Charles C. Thomas Publishing.

Liptak, Adam. 2008. "American exception: U.S. court is now guiding fewer nations." *New York Times* September 17, 2008. http://www.nytimes.com/2008/09/18/us/18legal. html?em (accessed January 12, 2009).

Lopez, George A., and Michael Stohl. 1984. *The state as terrorist: The dynamics of governmental violence and repression.* Westport, CN: Greenwood Press.

Luban, David. 2008. "Torture and the professions." *Georgetown Law. Georgetown Law Faculty Working Papers* Paper 69. http://lsr.nellco.org/georgetown/fwps/papers/69.

Lyman, Stanford M. 1989. *The seven deadly sins: Society and evil.* Dix Hills, NY: General Hall.

———, and Marvin B. Scott. 1970. *A sociology of the absurd.* Pacific Palisades, CA: Goodyear Pub. Co.

Lynch, Colum. 2008. "Heroin Afghanistan. United States U.N. finds Afghan opium trade up." *Washington Post* June 27, 2008. http://www.contracostatimes.com/ci_9711841?source=rss (accessed June 27, 2008). Also, *Seattle Times*, June 27, 2008, A10.

MacArthur, John R. 2003. "The lies we bought: The unchallenged 'evidence' for war." *Columbia Journalism Review* May/June: 62–63. http://www.cjr.org/year/03/3/macarthur. asp (accessed May 31, 2003).

Maines, David R., and Carl J. Couch. 1988. *Communication and social structure.* Springfield, IL: Charles C. Thomas Publishing.

Marcus, George E., James Clifford, and School of American Research (Santa Fe NM). 1986. *Writing culture: The poetics and politics of ethnography: A School of American Research advanced seminar.* Berkeley: University of California Press.

Marx, Gary T., and Glenn W. Muschert. 2007. "Personal information, borders, and the new surveillance studies." *Annual Review of Law and Social Science* 3: 375–395.

Massing, Michael. 2009. "Un-American: Have you listened to the right-wing media lately?" *Columbia Journalism Review* January/February 2009: 14–18.

Massumi, Brian. 1993. *The politics of everyday fear.* Minneapolis: University of Minnesota Press.

Matza, David. 1969. *Becoming deviant.* Englewood Cliffs, NJ: Prentice-Hall.

Mboka, Abu Karimu. 2008. *The politics of Chapter VII interventions in violent conflicts: A comparative analysis of Bosnia, Iraq, Rwanda and Sierra Leone*: VDM (Verlag Dr. Müller E.K.) Germany.

McClatchy Newspapers. 2008. "School attack kills 8; Gunman opens fire in a Jewish religious school in Jerusalem; violence could be setback in peace talks." *Newsday* March 7, 2008: A07.

McClellan, Scott. 2008. *What happened: Inside the Bush White House and Washington's culture of deception.* Jackson, TN: Public Affairs.

McLuhan, Marshall, Paul Benedetti, and Nancy DeHart. 1997. *Forward through the rearview mirror: Reflections on and by Marshall McLuhan.* Cambridge, MA: MIT Press.

McQuail, Denis. 1983. *Mass communication theory: An introduction.* London; Beverly Hills: Sage Publications.

McRobbie, Angela. 1994. *Postmodernism and popular culture*. London; New York: Routledge.

Mehta, Suketu. 2004. *Maximum city: Bombay lost and found*. New York: Alfred A. Knopf.

Meyer, Thomas, and Lewis P. Hinchman. 2002. *Media democracy: How the media colonize politics*. Cambridge; Oxford; Malden, MA: Polity Press; Blackwell.

Miller, Hugh T., and Charles J. Fox. 2001. "The epistemic community." *Administration & Society* 32: 668–685.

Millie, Andrew. 2008. "Anti-social behaviour, behavioural expectations and an urban aesthetic." *British Journal of Criminology* 48: 379–394.

Mills, C. Wright. 1940. "Situated actions and vocabularies of motive." *American Sociological Review* 5: 904–913. http://pubpages.unh.edu/~jds/Mills%201940.htm.

Moehle, Kurt A. and Eugene E. Levitt. 1991. "The history of the concepts of fear and anxiety," in *Clinical Psychology: Historical and Research Foundations*, edited by Clarence Eugene Walker. New York: Plenum Press.

Monahan, Torin. 2006. *Surveillance and security: Technological politics and power in everyday life*. New York: Routledge.

Moynihan, Colin. 2008. "Dozens detained ahead of convention." *New York Times* August 30, 2008. http://www.nytimes.com/2008/08/30/us/politics/30arrests
.html?fta=y (accessed September 2, 2008).

Muschert, Glenn W. 2006. "Media salience and frame changing across events: Coverage of nine school shootings, 1997–2001." *Journalism and Mass Communication Quarterly* 83: 747–766. http://www.users.muohio.edu/muschegw/Muschert-Carr.pdf.

———. 2007a. "The Columbine victims and the myth of the juvenile superpredator." *Youth Violence and Juvenile Justice* 5: 351–366. http://www.users.muohio.edu/muschegw/YVJJ296173.pdf.

———. 2007b. "Research in school shootings." *Sociology Compass* 1: 60–80. http://www3.interscience.wiley.com/journal/120185380/abstract?CRETRY= 1&SRETRY=0.

Myrdal, Gunnar, Arnold Marshall Rose, and Richard Mauritz Edvard Sterner. 1944. *An American dilemma: The Negro problem and modern democracy*. New York; London: Harper & Brothers.

Naphy, William G., and Penny Roberts. 1997. *Fear in early modern society*. Manchester; New York: Manchester University Press. Distributed in the USA by St. Martin's Press.

Nelson, Barbara J. 1984. *Making an issue of child abuse: Political agenda setting for social problems*. Chicago: University of Chicago Press.

Newman, Rachel. 2001. "The day the world changed, I did, too." *Newsweek* October 1, 2001: 9.

Newsweek. 2009. "The way we were: Art and culture in the Bush era." *Newsweek* December 22, 2008: 52–56. http://www.newsweek.com/id/174268.

Norris, Pippa, Montague Kern, and Marion R. Just. 2003. *Framing terrorism: The news media, the government and the public*. New York; London: Routledge.

Pearson, Geoffrey. 1983. *Hooligan: A history of respectable fears*. London: Macmillan.

Perlez, Jane, Raymond Bonner, and Salman Masoon. 2009. "An ex-detainee of the U.S. describes a 6-year ordeal." *New York Times* January 5, 2009: A1. http://www.nytimes.

com/2009/01/06/world/asia/06iqbal.html?_r=1&ref=todayspaper (accessed January 6, 2009).

Perry, Tony. 2007. "Defense, jury makeup likely spared Marine from prison." *New York Times* July 23, 2007. http://seattletimes.nwsource.com/html/ nationworld/2003801642_hamdania23.html.

Phillips, Cheryl, Steve Mimetic, and Ken Armstrong. 2004. "Airport-security system in U.S. riddled with failures." *Seattle Times* July 11, 2004. http://seattletimes.nwsource. com/html/localnews/2001976972_tsa11.html (accessed July 11, 2004).

Pinker, Steven. 2006. "Block that metaphor: Review of: "Whose Freedom?: The battle over America's most important idea" by George Lakoff." *Powell's Books*. http://www. powells.com/review/2006_10_19.html.

Platt, Anthony M. 1969. *The child savers: The invention of delinquency*. Chicago: University of Chicago.

Potter, J., and M. Wetherell. 1987. *Discourse and social psychology*. Thousand Oaks, CA: Sage.

Reporters Committee for Freedom of the Press. 2005. "Homefront confidential: Freedom of information." January 5, 2009. http://www.rcfp.org/homefrontconfidential/foi. html.

Revkin, Andrew C. 2009. "Environmental issues slide in poll of public's concerns." *New York Times* January 23, 2009: A13. http://www.nytimes.com/2009/01/23/science/earth/23warm.html?scp=2&sq=less+worried+about+rising+global+temperatures&st=nyt.

Rich, Frank. 2004. "At last, 9/11 has its own musical." *New York Times* May 2, 2004: 1. Sunday Correction Appended Late Edition-Final, Section 2; Column 5; Arts and Leisure Desk; p. 1. http://www.lexisnexis.com.ezprox y1.lib.asu.edu/us/lnacademic/results/docview/docview.do?risb=21_T4207424099&treeMax=true&sort=BOOLEAN&docNo=10&format=GNBFULL&startDocNo=1&treeWidth=0&nodeDisplayName=&c isb=22_T4207425402&reloadPage=false.

———. 2006. "The mysterious death of Pat Tillman." *New York Times* November 6, 2005. http://www.truthout.org/docs_2005/110605Z.shtml.

Roberts, Selena. 2008. "Jocks against bullies." *Sports Illustrated* July 7, 2008: 90. http://www. fannation.com/blogs/post/211157.

Robin, Corey. 2002. "Primal fear." *Theory and Event* 5. http://muse.jhu.edu/ journals/theory_and_event/v005/5.4robin.html.

Romero, Simon. 2008. "Regional bloc assails incursion into Ecuador, but Colombia itself is not condemned." *International Herald Tribune* March 7, 2008: B2.

Rosen, Jay. 2006. "Journalism professors pass an official resolution protesting Bush's anti-press policies." January 5, 2009. http://www. huffingtonpost.com/jay-rosen/journalism-professors-pas_b_26577.html.

Rosenhan, D. L. 1973. "On being sane in insane places." *Science* 170: 250–258. http:// courses.ucsd.edu/fall2003/ps163f/Rosenhan.htm.

Roth, Camille. 2007. "Reconstruction of the social sciences: The case of the knowledge." *Nouvelles perspectives en sciences sociales* 2: 59–101.

Rozen, Laura. 2009. "Hung out to dry: The national-security press dug up the dirt, but Congress wilted." *Columbia Journalism Review* January/February 2009: 33–35.

Russell, Katheryn K. 1998. *The color of crime: Racial hoaxes, white fear, black protectionism, police harassment, and other macroaggressions.* New York: New York University Press.

Rutenberg, Jim and Bill Carter. 2001. "Draping newscasts with the flag." *New York Times* September 20, 2001: C8.

Rutten, Tim. 2007. "Halberstam's beat was his country: Covering war or peace, the writer had 'no alternative but to report the truth.' " *Arizona Republic* April 29, 2007: F4. http://www.calendarlive.com/cl-et-halberstamapr25,0,5387460.story?coll=cl-home-more-channels.

Ryan, Joan. 2002. "Media feeding the fear." *San Francisco Chronicle* October 15, 2002: A23.

Said, Edward W. 1979. *Orientalism.* New York: Vintage Books.

———. 1981. *Covering Islam: How the media and the experts determine how we see the rest of the world.* New York: Pantheon Books.

Sanger, David E., and David Rohde. 2007. "U.S. is likely to continue aid to Pakistan." *New York Times* November 5, 2007: A1. http://www nytimes.co m./2007/11/05/washington/05diplo.html?th&emc=th.

Satterthwaite, Margaret L. (forthcoming) 2009. "The story of El–Masri v. Tenet: Human rights and humanitarian law in the 'War on Terror,' " in *Human Rights and Advocacy Stories,* edited and Douglas B. Ford. St. Paul, MN: West Publishing.

Savage, Charlie. 2008. "Bush warns Pakistan as he defends military strategy." *New York Times*: A10.

Schlesinger, Philip, P. G. Murdock, and P. Elliott. 1983. *Televising 'terrorism': Political violence in popular culture.* London: Comedia.

Schmitt, Eric. 2008. "30 civilians died in Afghan raid, U.S. inquiry finds." *New York Times* October 7, 2008. http://www.nytimes.com/2008/10/08/washington/08inquiry.html?th&emc=th (accessed October 8, 2008).

Schudson, Michael, and Danielle Haas. 2009. "Feet to the fire." *Columbia Journalism Review* January/February 2009: 63. http://www.cjr.org/the_research_report/voting_for_glass_houses_1.php.

Schutz, Alfred. 1967. *The phenomenology of the social world.* Evanston, IL: Northwestern University Press.

Schwalbe, Michael, Sandra Godwin, Daphne Holden, Douglas Schrock, Shealy Thompson, and Michele Wolkomir. 2000. "Generic processes in the reproduction of inequality: An interactionist analysis." *Social Forces* 79: 419–452.

Schwartz, Tony. 1973. *The responsive chord.* Garden City, NY: Anchor Press.

Scott, Marvin, and Stanford M. Lyman. 1968. "Accounts." *American Sociological Review* 33: 46–62.

Shane, Scott, and Mark Gazette. 2008. "Report blames Rumsfeld for detainee abuses." *New York Times* December 12, 2008: A10. http://www.nytimes.com/2008/12/12/washington/12detainee.html?scp=2&sq=the+report+was+issued+jointly+by+Senator+Carl+Levin&st=nyt (accessed December 13, 2008).

Shapiro, Michael J. 1992. *Reading the postmodern polity: Political theory as textual practice.* Minneapolis: University of Minnesota Press.

———. 2002. "Wanted, dead or alive." *Theory and Event* 5. http://muse.jhu.edu/journals/theory_and_event/v005/shapiro.html.

Shattuck, John. 2006. "The legacy of Nuremberg: Confronting genocide and terrorism through the rule of law." *Gonzaga Journal of International Law* 10. http://www.gonzagajil.org/content/view/149/26/ (accessed July 10, 2008).

Shaw, D. L., and M. E. McCombs. 1977. *The agenda-setting function of the press.* St. Paul, MN: West Publishing.

Shirlow, Peter, and Rachel Pain. 2003. "The geographies and politics of fear." *Capital and Class* 80: 15–26.

Silverstein, Ken. 2006. "Revolving door to Blackwater causes alarm at CIA." *Harpers* Sept. 12, 2006. http://www.harpers.org/archive/2006/09/sb-revolving-door-blackwater-1158094722.

Snow, Robert P. 1983. *Creating media culture.* Beverly Hills, CA: Sage.

Soliman, Amani, and Peter Feuilherade. 2006. "Al-Jazeera's popularity and impact." January 9, 2009. http://news.bbc.co.uk/2/hi/middle_east/6106424.stm.

Spector, Malcolm, and John I. Kitsuse. 1977. *Constructing social problems.* Menlo Park, CA: Cummings Pub. Co.

Spencer, D. A. 1996. "Teachers and educational reform." *Educational Researcher* 25: 15–17.

Stack, Megan K., and Raceme Salman. 2006. "Survivors say Marines went house to house in a rage." *Seattle Times* June 2, 2006. A1. http://seattletimes.nwsource.com/html/nationworld/2003031922_hadithatale01.html.

Staff, Editorial. 2006. "Editorial." *Pakistan Observer* January 15, 2006.

Staples, William G. 2000. *Everyday surveillance: Vigilance and visibility in postmodern life.* Lanham, MD; Oxford: Rowman & Littlefield Publishers.

Stein, Howard F. 2000. "The 1999 Columbine High School massacre as American metaphor." *Journal for the Psychoanalysis of Culture and Society* 5.

Stolberg, Sheryl Gay. 2006. "President signs new rules to prosecute terror suspects." *New York Times* October 17, 2006: 20. http://web.lexis-nexis.com/universe/document?_m =289b9c72cc5c7a494198c4f4bd73d559&_docnum=5&wchp=dGLbVzz-zSkVb&_md5=062f8ee8cd924226e7192 0ccbd75d510 (accessed October 31, 2006).

Stone, Brad. 2009. "Report finds online threats to children overblown." *New York Times* January 14, 2009: A 14. http://www.nytimes.com/2009/01/14/us/14cyber.html?scp =2&sq=the+internet+may+not+be+such+a+dangerous+place+for+children+after+a ll&st=nyt (accessed January 14, 2009).

Straziuso, Jason. 2004. "TV stations draw fire for sex stings: Reports set up with assistance of vigilante group." *Arizona Republic* March 7, 2004: A14.

Sullivan, Eileen. 2008. "Homeland Security releases threat report." *Arizona Republic* Dec. 26, 2008: A17. http://www.azcentral.com/arizonarepublic/news/articles/2008/12/2 6/20081226WorldThreatForecast1226.html.

Surette, Ray. 1992. *Media, crime, and criminal justice: Images and realities.* Pacific Grove, CA: Brooks/Cole Pub. Co.

———. 1998. *Media, crime and criminal justice: Images and realities.* Belmont, CA: West/Wadsworth.

Tatman, Lucy. 2001. *Knowledge that matters: A feminist theological paradigm and epistemology.* London; New York: Sheffield Academic Press.

Tavernise, Sabrina. 2009. "Many civilian targets, but one core question among Gazans: Why?." *New York Times* January 20, 2009: A12. http://www.nytimes.com/2009/01/20/world/middleeast/20gaza.html?ref=world (accessed January 21, 2009). Published Jan. 21, p. A12, National Edition.

Taylor, Ian R., Paul Walton, and Jock Young. 1974. *The new criminology: For a social theory of deviance.* New York: Harper & Row.

Thiele, Leslie Paul. 1993. "Making democracy safe for the world: Social movements and global politics." *Alternatives* 18: 273–305.

Topo, Greg. 2006. "Teenagers who plot violence being charged as terrorists." *USA Today* June 5, 2006: 7D.

Turner, Ralph H. 1957. "The normative coherence of folk concepts." *Research Studies of the State College of Washington* 25: 127–136.

———. 1969. "The public perception of protest." *American Sociological Review* 34: 815–831.

Tyler, Tom R. 2006. "Viewing *CSI* and *Threshold of Guilt*: Managing truth and justice in reality and fiction." *Yale Law Journal* 115: 1050–1085. http://www.yalelawjournal.org/pdf/115-5/Tyler.pdf.

Umansky, Eric. 2006. "Failures of imagination: American journalists and the coverage of American torture." *Columbia Journalism Review* September/October 2006. http://www.cjr.org/issues/2006/5/Umansky.asp.

van Dijk, Teun A. 1988. *News as discourse.* Hillsdale, NJ: L. Erlbaum Associates.

van Dijk, Teun Adrianus van. 1985. *Discourse and communication: New approaches to the analysis of mass media discourse and communication.* Berlin; New York: W. de Gruyter.

Van Maanen, John. 1988. *Tales of the field: On writing ethnography.* Chicago: University of Chicago Press.

Victor, Jeffrey S. 2006. "Why the terrorism scare is a moral panic. (The culture of fear: Why Americans are afraid of the wrong things by Barry Glassner)." *The Humanist.* http://www.encyclopedia.com/doc/1G1-148674633.html (accessed March 31, 2008).

Von Zielbauer, Paul. 2007. "Groups rally to aid accused troops." *New York Times* July 22, 2007. http://seattletimes.nwsource.com/html/nationworld/2003800480_abuse22.html.

Wagner, Matthew. 2009. "Rabbinate dispatches 10,000 MP3 players with prayers to boost the morale of soldiers fighting in Gaza." *Jerusalem Post* January 8, 2009: 1 Lexis Nexis URL. http://www.lexisnexis.com.ezproxy1.lib.asu.edu/us/lnacademic/results/docview/docview.do?docLinkInd=true&risb=21_T5544525323&format=GNBFI&sort=RELEVANCE&startDocNo=1&resultsUrlKey=29_T5544525330&cisb=22_T5544525329&treeMax=true&treeWidth=0&csi=10911&docNo=1 (accessed January 15, 2009).

Walker, Jesse. 2002. "Panic attacks." *Reason* March 2002: 36–42.

Warr, Mark. 1987. "Fear of victimization and sensitivity to risk." *Journal of Quantitative Criminology* 3: 29–46.

———. 1990. "Dangerous situations: Social context and fear of victimization." *Social Forces* 68: 891–907.

———. 1992. "Altruistic fear of victimization in households." *Social Science Quarterly* 73: 723–736.

Warrick, Joby. 2009. "2 top al-Qaida figures killed." *Arizona Republic* January 9, 2009: A3.

Waters, Anita M. 1997. "Conspiracy theories as ethnosociologies: Explanation and intention in African American political culture." *Journal of Black Studies* 28: 112–125.

Weiler, M., and W. B. Pearce. 1992. *Reagan and public discourse in America*. Tuscaloosa: University of Alabama Press.

Wilkinson, Tracy. 2005. "Court widens net for 22 CIA agents to EU; Italian prosecutors seek to try the operatives in the 2003 abduction of an imam on a Milan street. The warrants expand the hunt to 25 nations." *Los Angeles Times* December 24, 2005: 3.

Williams, Raymond. 1982. *The sociology of culture*. New York: Schocken Books.

Williamson, Hugh. 2006. "Germany pressed to arrest CIA team." *Financial Times* September 22, 2006: 11. http://web.lexis-nexis.com.ezproxy1.lib.asu.edu/universe/document?_m =d80652d20e771dc3cce2b25851fdad6f&_docnum=4&wchp=dGLbVzb-zSkVA&_m d5=c0dca7191301c7c4f0760353df1a8a41 (accessed October 9, 2006).

Wilton, Katherine, and Paul Cherry. 2007. "Dawson killer eyed 4 schools: Sketches in gunman's car. Dawson shooting details emerge as police describe day of chaos." *Gazette* January 18, 2007: A1.

Witte, Griff, and Colum Lynch. 2009. "U.N. issues call for cease-fire in Gaza." *Arizona Republic* January 9, 2009: A1.

Wolfe, Richard, and Rob Norland. 2003. "Bush's news war." *Newsweek* October 27, 2003: 32.

Wright, Stuart. 1995. "Oral statement for the Congressional hearing on Waco." Washington, DC, Federal Document Clearing House Congressional Testimony. http://www.lexisnexis.com.ezproxy1.lib.asu.edu/us/ lnacademic/results/docview/docview.do?risb=21_ T3580447305&format=GNBFI&sort=BOOLEAN&startDocNo=1&resultsUrlKey=2 9_T3580447311&cisb=22_T3580447310&treeMax=true&treeWidth=0&selRCNod eID=7&nodeStateId=411en_US,1,4&docsInCategory=3&csi=138357&docNo=2 (accessed April 22, 2008).

Wyatt, Edward. 2009. "New era in politics, new focus for '24.' " *New York Times.* http:// www.nytimes.com/2009/01/08/arts/television/08fox.html?_r=1&th&emc=th (accessed January 8, 2009).

Zakaria, Fareed. 2002. "The answer? A domestic CIA." *Newsweek* May 27, 2002: 39.

Zhondang, P., and G. Kosicki. 1993. "Framing analysis: An approach to news discourse." *Political Communication* 10: 55–69.

Zimmerman, Don, and Melvin Pollner. 1970. "The everyday world as a phenomenon," in *Understanding everyday life*, edited by Jack D. Douglas. Chicago: Aldine.

Zinn, Howard. 2003. *A people's history of the United States: 1492–present*. New York: HarperCollins.

Zulaika, Joseba, and William A. Douglass. 1996. *Terror and taboo: The follies, fables, and faces of terrorism*. New York: Routledge.

■ Index